GETTING IN!

The Ultimate Guide to
Creating an Outstanding Portfolio
Earning Scholarships
& Securing Your Spot at Art School

Nancy Crawford, M.Ed

GETTING IN!

The Ultimate Guide to Creating an Outstanding Portfolio, Earning Scholarships & Securing Your Spot at Art School

Published in New York, New York, by Morgan James Publishing. Morgan James and The Entrepreneurial Publisher are trademarks of Morgan James, LLC. www.MorganJamesPublishing.com

The Morgan James Speakers Group can bring authors to your live event. For more information or to book an event visit The Morgan James Speakers Group at www.TheMorganJamesSpeakersGroup.com.

A **free** eBook edition is available with the purchase of this print book.

ISBN 978-1-63047-333-4 paperback
ISBN 978-1-63047-334-1 eBook
ISBN 978-1-63047-335-8 hardcover
Library of Congress Control Number: 2014944802

CLEARLY PRINT YOUR NAME ABOVE IN UPPER CASE

Instructions to claim your free eBook edition:
1. Download the BitLit app for Android or iOS
2. Write your name in **UPPER CASE** on the line
3. Use the BitLit app to submit a photo
4. Download your eBook to any device

In an effort to support local communities, raise awareness and funds, Morgan James Publishing donates a percentage of all book sales for the life of each book to Habitat for Humanity Peninsula and Greater Williamsburg.

Get involved today, visit
www.MorganJamesBuilds.com

Habitat for Humanity
Peninsula and
Greater Williamsburg
Building Partner

To my mom and dad
Patricia and Gary Crawford
The most supportive and encouraging teachers I ever had.

Praise for Getting In!

"**Getting In! is an essential preparatory text** for young artists seeking to present engaging, honest and unique undergraduate portfolio submissions. Perhaps more importantly, **Getting In! also outlines the practical needs necessary for success both during and well after the art school experience.** Crawford's sensitivity toward harnessing and encouraging creative potential is palpable and potent. **I have not read another text that provides such extensive consideration towards developing an artistic practice.**"

QUINN DUKES
Assistant Director, Visitor Services, School of Visual Arts, New York

"Getting In! provides you with a comprehensive and solid understanding of how to successfully apply to art colleges. With all the exercises and practical advice contained in the book, **you receive the best art teacher's step-by-step guide to prepare your application. This book literally covers it all.** Throughout Getting In! Nancy Crawford not only tells you exactly what you need to know to apply to art school, but **also challenges you to think about the shape of your future. I highly recommend this book to all art and design students, their parents, and art teachers...**As a design professor, I hope my prospective students read this book. **If you want to be accepted to your dream art school, Getting In! will get you there!**"

HYUNA PARK
Assistant Professor, Head, Department of Design
Director, The Design Laboratory; Director, BFA Exhibition,
Memphis College of Art

"This book captures Crawford's encouraging voice with integrity, practical strategies, and constructive pieces of advise. As her former art student, I experienced the power of goal setting and self-care. **With her coaching, I achieved my goal to enter the School of the Art Institute of Chicago with one of their top merit scholarships...**Not only was her mentoring the key to my goals as an artist, but also as a person..."

JI SU KWAK
Artist

"All I can say is WOW! **Getting In! will inspire, motivate, and stimulate the creative minds of any young artists interested in pursuing higher education in the visual arts.** As a 23 year Admissions veteran at a U.S. art college, **I was impressed by the brilliant advice and suggestions offered in this book. This book is spot on!..** "Getting In" is geared toward young artists who aspire to attend some of the most prestigious art colleges in the world but the information contained in this book would equally inspire and motivate industry professionals. **If I were a high school art instructor, "Getting In!" would be required reading for all of my students. It's just that good!** Now that I've read it I'm ready to go make some art myself!!!

JONATHON NEELEY
International Student Advisor, Columbus College of Art and Design

"...**I urge you to read this book** with the confidence that it was written by someone who has expertly developed her craft of preparing young people for the exciting world of art study."

PANAGIOTIS PETER SARGANIS
Artist and Art Instructor

"Aspiring artists seeking admission to art school hope to fulfill a lifetime dream. Few have a clear idea of how to prepare a portfolio and many more are unaware of the complexities of becoming an art student. **Nancy Crawford's book is a must have for all aspiring art students not only in high school but also beyond.** With her wealth of experience and expertise, she provides answers to questions all prospective art students ask. **Nancy Crawford delivers far more than expected.** Although preparing a portfolio may be the focal point for seeking a career as an artist, Getting In! goes much further and provides advice on all aspects of becoming an artist while seeking admission to, and participating in, an art school program...**Art students desiring careers in art must read Getting In!"**

RITA L. IRWIN
Professor, Art Education, The University of British Columbia
President, International Society for Education through Art

"**Getting In! fills a much needed resource for today's artists whether they are just starting out or have been artists for many years.** Reading Getting In! inspired me to re-kindle my creative exploration in both my artistic and business practices. Over my 10 years working in the film/vfx industry, I've observed a major lack of originality and creativity in many areas. Much of the guidance in this book could be very useful to many top earning professionals in not only the film industry but in all creative professions. **Nancy Crawford teaches artistic success that is not only professionally rewarding but it is a limitless source of personal growth and joy. Getting In! is a complete guide to helping your creativity flourish and your positive impact on others to expand exponentially.**

I was very fortunate to have Nancy Crawford as a teacher and mentor for several years. Her amazing ability to support and nurture students allows their creativity to blossom in their own unique way. The depth of both her technical and conceptual teaching was in my experience, above many of my post-secondary courses. Learning from Mrs. Crawford in high school put me well ahead of my class mates starting out in post-secondary art school. **Having her as a mentor early on in my life helped me develop a positive working attitude and a strong foundation on which to build my career and become a leader in my industry.**"

JONAH WEST
President/Visual Effects Supervisor
Light Ray Visual Effects www.lightrayfx.com

"We all have our personal reasons for wanting to go to art school and become successful artists. It is often difficult though to come up with a strategic plan that will fuel us with passion and drive us forward with our desire. **With this book in hand, you will excel beyond being accepted into your dream school with a scholarship, you will experience the joy of uniting your ideal life and creative vision with reality.**"

JANE LEE
Artist

"**This is a very useful book for students** who are just starting their portfolio prep and application process, the student who needs a little help in finding inspiration and the right exercises to get them going; or any student who needs some positive encouragement to not give up and keep working hard."

KENNETH YEE
Admission Counselor, Assistant Coordinator of International Recruitment
Maryland Institute College of Art, Baltimore

"Having witnessed first-hand the remarkably diverse results of her students over the years, **her advice is a gift to any young artist seeking inspiration for the portfolio development process.**"

MATTHEW GALLAGHER
Director of Admissions and Student Life, Paris College of Art, France

"Nancy Crawford has been an exceptional art teacher for as long as I have known her. **I have been in awe of her caring, thoughtful approach to art from her early teaching days until now in the full bloom of her professional life.** Nancy's passion for art and education is exemplified in her teaching and now her writing. Her new book does not disappoint. It is written by a teacher who not only cares about her students but, by extension, all students pursuing a career in art. **Getting In! exceeds expectations. It is a must for any student who is serious about living an artful life.**"

KIT GRAUER, PH.D
Professor Emerita / Curriculum and Pedagogy
Faculty of Education / University of British Columbia

Contents

Welcome to Getting In!

We make a living by what we get.
We make a life by what we give.
—WINSTON CHURCHILL

I believe that creativity is the essence of what it means to be human. Creating is as fundamental to our development as learning to think, talk and move. From our first preserved traces as a species on this planet, through to our technologically driven world of today, humans have expressed themselves creatively. Through movement, music, storytelling and mark making we fulfil a deep need to manifest and share our unique way of experiencing life. We have been bestowed with the extraordinary ability to create symbols and metaphors that portray not only the world we inhabit, but worlds we imagine. What an incredible gift!

While everyone has been bestowed with the amazing capacity to create, few will continue to foster this creativity throughout their lives and even fewer will dedicate their lives to the creative process and answer the call to be an artist. This is tragic, for as Henry James wrote so eloquently, "It is art that makes life, makes interest, makes importance... And I know of no substitute whatever for the force and beauty of its process." This book is devoted to the courageous artists of today who have identified their creative passion and are enthusiastic about pursuing it further.

For three decades I have 'lived' in art studios and classrooms, working with people who have a passion for art and creating. These emerging artists were filled with drive and enthusiasm and had dreams of studying at amazing art schools around the world, fulfilling their desire to live and contribute as artists. They came to me with questions, they came to me with concerns, they came to me with hope. It was only natural that I wanted to help them succeed. What I came to realize over

1

the years is that the seemingly daunting task of preparing for art school would often rob the students of the very experiences that their creativity provided and that they ultimately longed for – namely meaning, challenge, excitement, connection and joy. In their place came frustration, anxiety, negative stress and tears. I knew there must be a better way!

John Daido Loori said "Indeed, what is the point of insight if it cannot be given, shared, used in a way to nourish both ourselves and others? Isn't this the perennial question that every artist faces – indeed every person concerned with how to live a truly meaningful life? What is true giving?" This book is part of my answer to that question. One of my major goals in writing this book is to help you keep the joy, excitement, and meaning in creating. I have learned that the only way for you to consistently experience the joy and meaning of exploring and creating while you are applying to art school is to execute a well developed plan. I realize that sounds like a contradiction, but this is just one of the many dualities that you will learn to embrace on this creative path.

Another goal that I have for this book is that it guides you to become thoroughly prepared to apply to art school. I want to help you get accepted to your dream school and I want to assist you in earning great scholarships to help you finance your dreams. The final purpose of this book is that its content and lessons prepare you to thrive and excel during your years in post-secondary and beyond. It's not sufficient for me that you get into art school if you then crash and burn in your first or second year. If carried through, the tools outlined in this book will instill a work ethic that will ensure an outstanding collegiate experience and life as an artist.

And there's more good news! Fortunately, there has never been a better time for you to pursue your dream of being an artist, and preparing to go to art school is simply one of your first big commitments to that end. In his brilliant, New York Times Best-seller, *A Whole New Mind – Why*

Right-Brainers Will Rule the Future, author Daniel Pink outlines how, "The future belongs to a very different kind of person with a very different kind of mind – creators and empathizers, pattern recognizers, and meaning makers. These people – artists, inventors, designers, storytellers, caregivers, consolers, big picture thinkers – will now reap society's richest rewards and share its greatest joys!"

Our advanced world is changing at a staggering rate as a result of several powerful global factors including the population explosion, the onslaught of technology, mass production and consumerism. The Information Age, where the economy and society were supported by 'computer-like' qualities that were logical, linear and sequential in nature is dramatically shifting to the Conceptual Age where invention, creativity, empathy and meaning will be the foundation of both the economy and society. As a result, these factors are changing the qualities, skills and attributes that will be essential for success in this new world. And it's all good news for you!

By reading *Getting In!*, doing the exercises, taking the action steps and creating your art, you will develop the qualities, skills and attributes that will not only guarantee your success getting into art school, but more importantly they will prepare you to thrive in our new world. You will enhance your creativity, build your courage, and have a great deal of fun through the process.

To that end, I have created a powerful framework for you to follow that will keep you on track with the myriad of obligations, responsibilities and deadlines that are a reality of the post-secondary application process. For better or worse – there is a lot more involved with getting into art school than the time spent in your studio.

This book has been organized into 3 parts – The Power of Planning for Art School, The Power of Creating Your Art and The Power of Sharing

Your Art. In Part I – The Power of Planning for Art School you will be engaged with a number of activities that will galvanize your personal reason for creating your art. You will explore your artistic purpose, analyze what art careers you are well suited for, gain essential clarity around the art school application process, create an exciting vision for a creative future and establish some critical routines and rituals to keep yourself healthy, and feeling awesome!

The second part of the book – The Power of Creating Your Art covers the art part! In this section you will explore your creative process, and create powerful and meaningful works for your portfolio. You will also learn how to set up your own practise schedule, create dynamic mentor relationships and annihilate your procrastination tendencies in order to create your art.

The final section – Part III – The Power of Sharing Your Art will help you prepare your portfolio for presentation, along with looking at options for funding your post-secondary art education. You will also develop some effective strategies to help you carry on when the going gets tough, and learn how to respond gracefully with the admission outcomes.

Finally, the book closes with 2 appendices. The first one covers information on how to use the web site www.gettinginbook.com in conjunction with this book to support your creative development. On the web site you will have access to 20+ free downloads and templates that accompany the material in this book. You will also have access to several images and art works created by students - just like you. These images will help you understand the different components of the portfolio along with helping you establish the quality of artwork that is awarded merit-scholarship. There is also a description of a variety of additional resources and programs that might interest you as you create your personal program for artistic growth and development.

The final appendix includes a Recommended Reading List. I realize that your time for additional reading above and beyond school work may be limited between the months of September through June – but I encourage you to slowly create your own personal library of resources that you can utilize now and for years to come.

HOW TO USE THIS BOOK

As the saying goes, "Rome wasn't built in a day", and you won't become the ideal art school candidate and an outstanding artist overnight. Developing yourself and your art is an ongoing process that requires time, energy and effort. Having said that, you can get started immediately, and see significant development and progress in a matter of weeks. In order to create lasting change and progress I have laid out the content of this book to be implemented over a period of 24 weeks.

During that time you will:

- read and understand the entire contents of the book, moving strategically through each section
- identify your reasons to make art
- research a variety of art careers and art schools
- choose the post-secondary art schools you will apply to
- decide what art careers you are well suited for
- understand the 10 key ingredients for Getting In!
- state and achieve your art, education, personal development and community/contribution challenges
- implement 10 strategies to maximize your health and creativity
- set up your studio space
- realize 10 powerful aspects of the creative process
- create a minimum of 12 portfolio range works
- produce a personal series of artworks for your portfolio (minimum of 6 works)

- develop a process rich sketchbook
- establish a supportive community of mentors and peers
- bust through your procrastination tendencies
- build your perseverance
- start preparing your portfolio for sharing and critique
- enhance your creativity using several strategies
- and have one heck of a good time doing it!

Ideally, you would spend a minimum of one and a half to two years preparing for post-secondary art school, but depending on your level of artistic development, passion and energy this process could be intensified to cover a period of months.

The 24 week time line below is merely a suggestion. I have broken down the content of the book so that you can read small sections each week that build synergistically over time. I have also proposed when to take particular action steps and a schedule for portfolio projects. So let's get started!

THINGS TO DO NOW!

1. Read through the table of contents and skim through the book so that you have a general understanding of its contents.

2. Read Chapter 7 from the introduction through to the end of the Range Project Ideas

3. Create one range work

Once this 24 week period is complete you should be able to maintain a solid practice and production routine for your art making while continuing to develop your creativity. With effective self care, this process should be both rewarding and joyous. You will be thoroughly prepared and excited to apply to art school, and you will be delighted with the fun you have had preparing for Getting In!

WEEK-BY-WEEK SCHEDULE AT A GLANCE

	Readings	Action Steps	Portfolio Projects
1	Chapter 1 (all) Chapter 7 *Sketchbook: Finding Meaning in the Art of the Day-to-Day* to end of chapter Chapter 8 (all) including Setting up your studio	All Purpose and Passion Action Steps Review sketchbook guidelines Set up your studio	Range piece #1 Sketchbook work
2	Chapter 2 (all) Appendix 1 (all)	Action Steps page Research 1 Art Career	Range piece #2 Sketchbook work
3	Chapter 3 (all)	Research School #1 Research School #2 Research 1 Art Career	Range piece #3 Sketchbook work
4	Chapter 5 *Introduction and Breathing* Chapter 6 *Introduction and Be Courageous*	Research School #3 Research School #4 Breathing Exercises Courage Action Steps	Range piece #4 Sketchbook work
5	Chapter 4 *Introduction and Vision* Chapter 5 *Hydration* Chapter 6 *Research*	Research 1 Art Career Vision Action Steps Increase water intake Research Actions	Range piece #5 Sketchbook work
6	Chapter 4 - *Challenge Setting* and remainder of chapter Chapter 5 *Nutrition* Chapter 6 *Be Attentive*	Create and write out all Challenges Create nutritional plan Attentive Action Steps	Range piece #6 Sketchbook work

	Readings	Action Steps	Portfolio Projects
7	Chapter 5 *Exercise* Chapter 6 *Be Curious*	Create Challenge Worksheets Create Personal Time line on wall calendar Start exercise program Curious Action Steps	Range piece #7 Sketchbook work
8	Chapter 5 *Silence and Solitude* Chapter 6 *Be Yourself* Chapter 7 *Personal Series*	Create periods of silence and solitude Self-Talk Action Steps Be Yourself Actions Personal Series Action Steps	Range piece #8 Start Personal Series (PS) work Sketchbook work
9	Chapter 5 *Meditation* Chapter 6 *Create*	Meditation Actions Create Action Steps	PS work #1 Sketchbook work
10	Chapter 5 *Sleep & Rest* Chapter 6 *Reflect*	Reflect Action Steps	Range piece #9 PS series Sketchbook work
11	Chapter 5 *Work Hard* Chapter 6 *Rework*	Rework Action Steps	Range piece #10 PS series Sketchbook work
12	Chapter 5 *Play Hard* Chapter 6 *Resolve* Chapter 12 (all)	Build in daily playtime Resolve Action Steps Perseverance Action Steps	PS work #2 Sketchbook work
13	Chapter 8 (all)	Practice Action Steps Mentors/Peer/Friends Action Steps	Range piece #11 PS work Sketchbook work
14	Chapter 5 *Spiritual Life* Chapter 6 *Share*	Set up weekly rituals Share Action Steps	PS work #3 Sketchbook work
15	Chapter 9 (all)	Procrastination Busters Action Steps	PS work Sketchbook work

	Readings	Action Steps	Portfolio Projects
16	Chapter 10 (all)	Start to photo document your works (ongoing process) Start Chapter 10 Action Steps	PS work #4
17	Chapter 11 (all)	Photograph your works Chapter 10 Action Steps (continued) Start Chapter 11 Action Steps	PS work Sketchbook work
18		Photograph your works	PS work #5 Sketchbook work
19		Review Chapter 3 Letter of Recommendation Write your letter and request 2-3	Range piece #12 PS work Sketchbook work
20	Read *Final Thoughts*	Photograph your works	PS work #6 Sketchbook work
21		Photograph your works Verbal/Written Action Steps	PS work Sketchbook work
22		Prepare for interview Verbal/Written Action Steps	PS work #7 Sketchbook work
23	Read Appendix 2	Prepare for interview Verbal/Written Action Steps	PS work Sketchbook work
24		Review Getting In! principles CELEBRATE!	Ongoing art work!

ON A TECHNICAL NOTE

This book was written by a Canadian with an international audience in mind. As a result there are some terms and spellings that may be new or different for some readers. For example, in Canada we use the spelling *colour* and *favourite* as apposed to *color* and *favorite*. Also, students attending high school in Canada are referenced by their grade, such as *grade 10, 11 or 12,* whereas in the United States the terms *sophomore, junior* and *senior* are used.

You will also notice that there are many quotes featured throughout this book, and that each new section starts with a quote. I have loved words and reading all my life and started collecting quotes when I was fourteen. I collect quotes from many sources including songs, movies, poetry, quote sites on the internet, and through all my varied readings including newspaper articles, magazine features, and books. My hope is that you will find some ideas within the quotes that will motivate, inspire, or delight you, as they have for me.

This book's layout is to promote you to make it your personal workbook. Use the margins to write out your thoughts, doodle and draw, brainstorm, create diagrams and images that reinforce your learning, define words you don't understand, and generate your next art ideas. Inspiration and insight can often be triggered in the most unlikely moments, so use this space to capture your ideas - and enjoy the process!

Once you have completed each chapter you will see a diagram that highlights the section you have just completed as part of the Getting In! process. This graphic provides a powerful visual framework to remind you of the key aspects and actions for Getting In! to art school.

GETTING IN! – PUTTING IT ALL TOGETHER

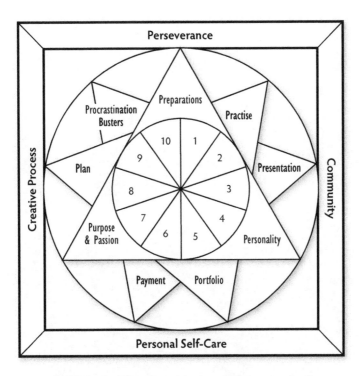

10 KEY INGREDIENTS TO GETTING IN!

1 Post-Secondary Research
2 Application
3 Academic Records/Transcripts
4 Exams
5 Artist Statements and Essays
6 Letters of Recommendation
7 Home Exams
8 Portfolio
9 Declaration of Finances
10 Scholarships & Financial Aid

Part 1

The Power of Planning
for Art School

Chapter 1

Purpose and Passion:
Finding Your Reasons to Make Art

"What is passion?
It is surely the becoming of a person."

—JOHN BOORMAN

When students sign-up for one of my programs or classes the most common question I hear is, "Can you help me create a portfolio?" I usually respond to their question, with a question of my own, "Why do you want to make a portfolio?" Invariably, the answer is, "I want to go to art school." While this answer tells me about their intention to continue their art education and artistic development at post-secondary, I realize that a much bigger, more passionate answer will be necessary to excite and sustain them over the months and years that lie ahead as they strive to realize their goals.

That's what this first section of the book is dedicated to – helping you identify and articulate answers to some of the most important questions for you to consider:

1. Why do you want to go to art school? What are your BIG reasons?

2. What are your gifts, talents and natural inclinations?

3. What are you passionate about?

4. What do you think are some of the greatest challenges and opportunities that exist in the world right now? How can you contribute and serve with your art? Where do your passions and world needs align?

When you create works solely for the purpose of gaining access to post-secondary, your creating can become a means to an end, something to do, a chore. What I want you to do is **expand your vision** and consider your bigger reasons for continuing your artistic education.

It's one thing to draw a picture of a city-scape for your portfolio, it's quite another to think of that drawing as developing your skills in proportion and perspective because you desire to be an architect; an architect who designs sustainable and portable housing available to the masses in an attempt to eliminate homelessness. You can learn to sew, render the figure and work with designing garments because you want to study fashion design at a particular school, or you can do all those things because you have a dream of becoming a world leader in elegant and exclusive eco-friendly design. Why do you want to paint? Do you want your paintings to educate, confront, beautify or perhaps all three? Or perhaps you are a storyteller who plans on delighting and inspiring the masses through your animations. What vision do you think would get you more fired up, excited and motivated to create? I'd like you to think beyond the portfolio, and beyond post-secondary. I want you to be passionate and think and dream of the big reasons for developing your creativity.

I think we are living in a time of incredible opportunity. Our world is in crisis and we need innovative artists, creators and designers in every field of human endeavour who can help to lead the way to a better future. We need creative people who can address issues such as global warming, deforestation, species extinction, sustainability, pollution of our air and water ecosystems, and the plethora of damage created by our current consumerist lifestyle through their problem solving, innovating and creating. We need artists who can inspire us with the beauty they create, and transform our lives through their designs. We need artists who challenge us to think deeply. These creative leaders may compel us to laugh, cry, delight and contemplate. We need to change and artists and designers working together with scientists and business leaders can show us the way. What role do you want to have in this dynamic and exciting future?

At this time ou may have no idea what you want to do with your life and your art, but it's never too early to start thinking about it.

Action Steps

Respond to the following questions in your sketchbook.

1. What are you good at naturally and love to do? (Try to think of everything and anything even if it feels insignificant.) Your list might include things like:

 • Talking with people
 • Cleaning and organizing
 • Working with animals
 • Painting
 • Coming up with ideas to solve problems
 • Helping others to achieve their best
 • Working with 3D materials

- Spending time with people who are hospitalized
- Being around babies or young children
- Caring for the environment
- Helping others who are less fortunate
- Public speaking

You get the idea. Write down as many responses as you can think of.

2. Ask your family and friends for their feedback as well. Sometimes they recognize your talents before you do.

3. In your ideal world, if money was no object, what would you like to do? How would you like to spend your days? How would you contribute or serve?

4. What are 3 of the most important global issues for you?

5. Are there any ways that you feel you could address, help, or improve the situation using some of your gifts or natural abilities? What opportunities exist in the current problems?

6. Write out a new, big, passionate reason why you want to create a portfolio and go to art school. What are you going to do for the world?

Remember, don't get hung up on answering these questions, simply consider the questions and the answers will eventually materialize. In Cameroon there is a proverb that states, "He who asks questions cannot avoid the answers." These questions are important to ask yourself throughout your life because your answers will always be changing. Your gifts and passions, along with your concerns and abilities to serve will change and evolve with you. Thinking about these questions can be incredibly inspiring and motivating. All of a sudden you become aware of both your potential and incredible opportunities to make a difference. That's empowering! As Sarah Ban Breathnach said, "The key to loving how you live is knowing what it is you truly love." When you get clarity around purpose and passion it's much easier to do what needs

doing and to be excited about doing it. Having a clear purpose makes your life happier and more fulfilling.

GETTING IN! – PUTTING IT ALL TOGETHER

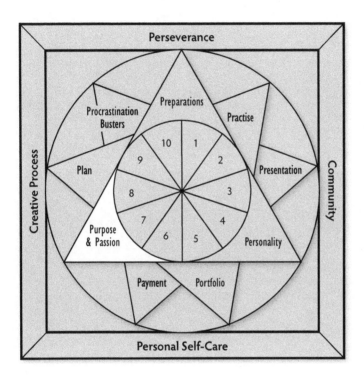

How about creating a fun self portrait using some non-traditional art materials? Draw with something that makes you smile - try wool, spaghetti or paper streamers. What other interesting materials could you use to portray an aspect of yourself? Congratulations! You have just completed the Purpose and Passion section of Getting In! Celebrate!

Chapter 2

Personality:
What Art Careers Are You Well Suited For?

"Watch your thoughts, for they become words.
Watch your words, for they become actions.
Watch your actions, for they become habits.
Watch your habits, for they become character.
Watch your character, for it becomes your destiny."
—Author Unknown

One of the comments that I frequently hear from admission representatives from a variety of art schools is that many students think they want to be animators based on the fact that they like to play video games or watch animated movies. Enjoying an art form is one thing, creating it is quite another. Just because you like to go shopping for clothes does not mean you are well suited to be a fashion designer.

In Part I of this book you've already started to get to know yourself a little better. Now you're going to answer a number of questions to help you identify some of your preferred ways of working, along with identifying some of your distinct characteristics and traits that would make you well suited for particular artistic fields over others. You will also start to explore and research a variety of different art fields and careers to see what areas sound exciting to you and match up with the type of person that you are. Based on those findings you will start to develop your plan including creating an exciting vision for the future along with outlining some specific goals to help you achieve your dreams.

Let's consider an example of an aspiring animator. Animation is a field that requires several skill sets some of which may surprise you. First, there are the more obvious capabilities such as strong rendering skills and the ability to observe and break down movement frame by frame. But did you know that the best animators are the best actors? In my discussions with several animators, they have pointed out that an animator's ability to connect with the viewer, creating resonance with the performance and acting of the figures and objects he or she is animating is of paramount importance. As an animator you also have to have effective verbal communication skills, patience, the discipline to meet rigorous deadlines, the people skills to function well as part of a team, the temperament to take direction and critique, and an affinity for the computer. These skills are in addition to being creative, imaginative, and passionate about the field. If you are a loner, who likes complete control of a project from start to finish, it is unlikely that you would be happy working in a traditional animation studio. If you still have your heart set on animation perhaps you could learn about and create animated films through a fine arts degree with studies in painting, animation and film as an alternative, or perhaps animation will remain something that you enjoy watching and interacting with but you will work in another creative field all together. Your possibilities for creativity and adventure

are endless, so have fun exploring them.

I don't want you to be worried if you have no idea whatsoever as to what you want to do with your art and creativity in the future. Perhaps learning more about yourself and doing some art careers research will point you in a couple of directions to consider, and at the very least it will be fun to learn and imagine. It has also been my experience that students with very adamant decisions about artistic and career fields frequently changed their minds based on their experiences in college or university. I have known several students who were positive they would be fashion designers, only to discover that they were much better suited to and enjoyed other fields such as product and jewelry design. Conversely, I have had students who were going to pursue communication design and ended up as fashion designers. My point is this, don't get too hung up on a field or area of study, just enjoy exploring some of the different options and fields of study available to you, and consider them in light of your personality and preferred ways of working.

Action Steps

Personality: a person's distinctive character or qualities
Characteristics Traits: typical or distinctive features or qualities

1. Go to the www.gettinginbook.com website and refer to the list of characteristics and traits featured in the template section. Circle any traits that apply to you.

2. Using the list in question 1 as a reference define your character. Who are you? (Be honest and include traits or qualities that you feel are both positive and negative.) Write all your responses in your sketchbook.

3. Do you prefer to work with a team or on your own?

4. How do you feel about computers and spending time working on them?

5. Do you see yourself working for a company or business or do you want to be your own boss?

6. What are the strongest aspects of your work ethic? Consider your ability to plan your time, energy and efforts, ability to meet deadlines, promptness, preparedness, resourcefulness, etc.

7. What aspects of your work ethic or character are holding you back?

8. Do you like being given direction or do you prefer self-initiated works?

9. What are your favourite materials to work with and why?

10. Are there any art processes or materials that you dread working with and why?

Hopefully having done the exercises above you will have more clarity and understanding of some of your current dominant characteristics, traits, and preferred ways of working. Having said that, I want you to realize that your personality - your distinctive characteristics and qualities – is a set of skills, which like all skills are learned, fostered and mastered. You might be wondering what I mean by that statement – so let's think about it? If you describe yourself as honest, what do you mean? You mean that you tell the truth and are trustworthy in your actions. If you want to be known as an honest person – you have to act honestly. If you describe yourself as hard working, it's because you exhibit those actions that are demonstrated by hard working people. It might mean that you are prepared, diligent and thorough with your work, and that you do whatever it takes to complete a task and complete it to the best of your ability.

To develop your personality then – you have to decide what kind of person you want to be, and then become that person through your actions. Could you become more creative? – Of course! Could you become more of an expressive, risk-taker, or someone who is more encouraging to others? Definitely! How about becoming more of a compassionate global citizen? You bet! It all starts with a thought – a thought about the type of person you desire to be. As the anonymous quote at the start of this chapter outlines, your thoughts become your words, your words lead to your actions, your actions develop into your habits which ultimately define your character and destiny. Powerful stuff!

Action Steps

1. Make a decision today to develop one ideal quality or trait that you wish you possessed. What quality would that be?

2. What consistent actions would you have to take to embody that quality or attribute? Write the attribute and the actions in your sketchbook.

3. Imagine the person you could become if you consciously set out to develop a new positive quality or attribute each month, or every couple of months or even every year?

4. Write out your TOP 10 list of qualities, characteristics or attributes that you wished you consistently exhibited. Again, consider the actions you would need to take to foster those skills.

The next step in your research is to learn a little bit more about the vast art world and the many exciting opportunities that it can provide. Below is a list of some potential art careers and fields of study and work that you might research more on the internet. Have fun with this!

A couple of sites that you might also want to visit include www.careerjet.ca www.artjob.org, educational-portal.com, www.findyourartschool.com, www.wetfeet.com, www.visualnation.com, and www.khake.com. As internet sites are frequently updated and changed it would be a good idea to do some personal searching for databases that review art careers as well.

PARTIAL LIST OF OPPORTUNITIES IN VISUAL ART

Advertising Designer	Assorted Advertising Careers
Accessory Designer	Animator
Architect	Art Conservator
Art Director	Art Historian
Art Librarian	Art Teacher
Art Therapist	Artisan or Crafts person
Arts Administrator	Arts and Entertainment Careers
Cake Designer and Decorator	Cartoonist
Comic Book Artist	Commercial Designer
Concept Artist	Costume Designer
Graphic Designer	Drafter
Drafting Technician	Entrepreneur in the Arts
Environmental Designer	Exhibit Designer
Fashion Designer	Fashion Merchandiser
Film Careers	Fine Artist (all media)
Footwear Designer	Furniture Designer
Gallery Owner or Curator	Glass Artist
Graphic Designer	Illustrator
Industrial Designer	Interactive Media Careers
Interior Designer	Jewelry Designer
Landscape Architect	Makeup Artist
Medical Illustrator	Multimedia Artist
Mural Artist	Museum Curator
Museum Officer	Museum Technician

Painter

Picture Framer

Print Finishing Artist

Sculptor

Sign-maker

Stained Glass Artist

Storyboard Artist

Textile Designer

Toy Designer

Videographer

Photographer

Potter/Ceramist

Print maker

Set and Exhibit Designer

Sketch Artist – courtroom

Stone Cutter and Carver

Tattoo Designer

Theatre Exhibit Designer

Urban Designer

Web/New Media Designer

Action Steps

1. Choose 3 or more different art careers or fields that excite or interest you to explore and research. Using the internet as a guide, along with books and in-person interviews, describe a typical day for an artist working in those areas. Record all your research in your sketchbook.

2. Identify 3 award winning artists/designers working in the art careers you explored in question #1. What innovations have they created? What have been their most outstanding contributions to their respective fields?

3. Discover and record the most important qualities or attributes for an artist working in those fields to possess. Do you already embody those traits or are you prepared and interested in developing them?

4. Describe some of the educational paths you could take to prepare yourself to work in those fields?

5. Research the financial implications of these careers. What will it cost you to become qualified to work in those fields (including degrees, exams and certification where applicable). You might also want to research the salaries or payment you could anticipate in those careers.

6. Where possible, establish a day or week where you can "shadow" someone working in that field. You can usually set up these brief work-experience opportunities through your school's career counsellor. These first hand experiences, observing and possibly helping artists in action are powerful ways to learn about those careers and get excited about your future.

7. Stop what you are doing and go create something!

GETTING IN! – PUTTING IT ALL TOGETHER

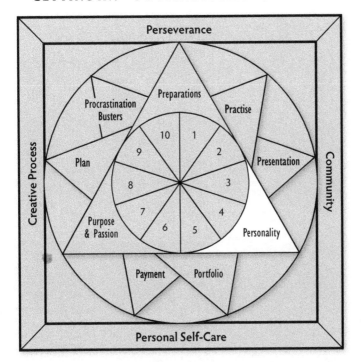

Great, that's another section completed! Hopefully you've learned a great deal about yourself through the process. Now take what you've learned and try to show that in a self-portrait sketch. Make it a quick study - 10 minutes or less. How could you show 2-3 of your dominant characteristics in this drawing? Do it now... quick grab your sketch-book!

Chapter 3

Preparations:
10 Key Ingredients for Getting In!

"You will never get out of pot or pan anything fundamentally better than what went into it. Cooking is not alchemy; there is no magic in the pot."
—Martha McCulloch-Williams

Have you ever baked a cake from scratch? How about a pizza, some muffins or lasagna? I hope so, because it will make this metaphor more relevant.

Let's use making a pizza as our example. The first step in preparing your pizza will be to gather up and prepare your ingredients. You might be making the dough from scratch or have a pre-made pizza crust (thin, thick, stuffed, etc.); some kind of sauce (tomato based, pesto or creamy); a variety of toppings (anything from pepperoni and mushrooms to oysters or broccoli); and then likely some kind of cheese garnish for the top (again, it could be a vegetarian soy product, cheddar,

mozzarella or even feta). The type of pizza you create will be the result of your ingredients, the components that make up your creation. But that's not all that will effect the success or quality of your pizza is it? There are several other variables that you need to consider including: the quality and proportion of your ingredients, the sequence in which you layer and combine them, and finally, the time and intensity with which you bake them.

If you include ingredients that are moldy or stale it is unlikely that your pizza will be tasty, or even edible. Even if your ingredients are fresh but your proportions are off, the pizza could be a disaster. Consider a ham and pineapple pizza with 2 slices of ham and 2 cans of pineapple. Let's imagine now that your ingredients are amazing but you place them on your baking sheet in the following manner: sprinkled cheese, followed by the sauce, with the dough placed on top of that, layered with roasted vegetables. Hmmm?! I don't think I'd want to eat that pizza or wash that baking sheet.

The final step will be to bake your creation, and again there are many variables to consider. A wood-burning oven for 5 minutes might be ideal, but so could an electric oven at 350 degrees for 15 minutes. I'm not so sure though that a pizza cooked for 2 hours at 200 degrees is one that I'd want to be eating. Are you with me?

Creating your outstanding art school application is really no different than creating an awesome pizza. You want to start with the best quality ingredients, combined in pleasing proportions, organized in a thoughtful sequence, prepared with passion over a period of time, to represent your uniqueness and personal taste. The best chefs also create unique and exciting taste sensations by creating special recipes often combining flavors, spices and ingredients in new and innovative ways.

Your 10 key ingredients for creating an outstanding art school application include:

1. Post-secondary research
2. Application
3. Academic records
4. Exams
5. Artist statements and essays
6. Letters of recommendation
7. Home exams
8. Portfolio
9. Declaration of finances
10. Scholarship and financial aid

Just like creating your pizza you will need to consider how you can put all of your ingredients together in a way that is exciting and effective.

Now I know what you might be thinking, "Why would I go through all that effort when I could simply buy a frozen pizza from the store?" Well, those pizzas are mass-produced, likely from questionable ingredients, and lack nutritional value, variety and uniqueness. That's why they taste like cardboard. I'm not interested in working with people who are looking to be average, who are satisfied with the ready-made, or even those who are content to follow the recipes of others. I'm interested in working with you - and you are a chef... a chef in training.

A chef is an artist, and artists are not interested in templates, copying, or 'paint by number' approaches to creativity. Artists are creators, they start from scratch and explore, test, develop, combine, experiment and create. Now is your opportunity to create a masterpiece. Let's head into the kitchen!

Post-Secondary Research

"All large tasks are completed in a series of starts."
—NEIL FIORE

Prior to starting your application process, you will need to do some research to establish what schools you want to apply to. The initial considerations for you to think about and discuss with your family are the types of educational programs available (i.e. public versus private education, college or university programs or specialized institutions), school accreditation, school location, school reputation, cost of tuition and scholarship opportunities. After those major decisions have been considered you can fine tune your selection based on other factors such as:

- opportunities for professional exposure for your work through galleries and exhibitions
- study abroad programs or student exchanges
- internships
- campus employment prospects
- access to career development services that will assist you with attaining work following graduation

It is very important that you come up with a realistic and exciting plan for your educational opportunities. I recommend that you apply to a minimum of 3-4 different schools so that you have some options. My guidelines would include applying to one "Sure Thing" school, one or two "Stretch" schools and at least one "Dream School". So, what are these "Sure Thing", "Stretch" and "Dream Schools"? Well, a "Sure Thing" school is a school that you would likely get into today if you applied. You would meet their academic profile, your portfolio would be accepted, and you could afford to attend with your current finances. A "Stretch" school, as the name implies would be more of a stretch for you to attend. Perhaps your academic scores are acceptable but you are

unsure of your ability to meet their SAT (Scholastic Aptitude Test) or TOEFL (Test of English as a Foreign Language) requirements. You might feel confident with the works in your portfolio, but you would require a scholarship to attend. A "Dream" school is your most coveted school. You would need to produce in all areas above where you are currently achieving and you would perhaps need a major scholarship to attend. If everything fell into place though, this would be your number one school of choice.

Regardless of the names of the schools that fit your criteria, there is something that you need to be very clear about, the school that you attend will not make or break you as an artist. You and you alone are responsible for your ultimate success. Let me say that again, **the school that you attend will not make or break you as an artist. You and you alone are responsible for you ultimate success!** If you are prepared to work, to create and achieve, and you are persistent, you will be successful.

Recognizing that, there is something to be said for putting yourself in the location of greatest opportunity if you have the means to do so, and if you are prepared to live in that city after you graduate. The place of greatest opportunity might be to work with a particularly renowned faculty or program, or attend school in a city that is a hotbed of employment opportunities in your field. For example you might consider going to school in Paris, Los Angeles or New York for fashion design or move to Toronto, Vancouver, New York or several cities in California to pursue animation. This is an added perk for your educational experience, as you have the possibility of starting your network early and getting noticed by people who could help propel your career as an artist. Repeat after me – "the school that I attend will not..."

In terms of actually doing your research you have a number of options. You can visit a campus for a tour, research your schools on-line, or

attend off campus school information presentations or recruiting fairs. Whatever option you choose, you want to be thorough and prepared with a series of questions and criteria.

Below are two web sites that I encourage you to visit that can help you locate and research art schools and programs.

The first site to visit is the National Portfolio Day Association web site at www.portfolioday.net This web site provides links to all of the art schools that are accredited by the National Association of Schools of Art and Design. You can search for schools by name or by majors and concentrations. The web site also outlines the National Portfolio Day schedule of events. National Portfolio Days are special events specifically for visual artists and designers. They are an opportunity for those who wish to pursue an education in the visual and related arts to meet with representatives from accredited art colleges and schools. The representatives review your artwork and offer feedback, discuss their programs and answer questions you may have about professional careers in art. It's a good idea to check and see if your local art school is part of the association, and if they will be hosting one of the portfolio day events. I highly recommend that you attend Portfolio Day events in your final 2-3 years of high school. It gives you an opportunity to get feedback on your work over time, establish relationships with college representatives and learn more about a variety of schools and the programs they offer.

Another site is www.petersons.com. It is an excellent resource of information on college art programs in Canada and the U.S. Simply click on "Art, Music, Dance and Theater Programs" listed under Colleges and Universities. You can locate a school or program by clicking 'Art' on the Program Search menu. You can also search for schools based on degree program, location or name. Finally, you can request information from a variety of schools by clicking on 'Get Free Info.' The school itself receives this message and will mail you a catalogue, application or

information on financial aid and scholarships. There are also links to school web sites.

Action Steps

This post-secondary school research should take approximately one hour for each school. Compile all of your research into the College Research template (which you can download from the web site www. gettinginbook.com) answering the following questions.

1. Name of school/university/college along with contact information (email and phone number)

2. Name of program of study

3. Application due dates (both Regualar and Early Action) Note whether acceptance is binding or non-binding as well.

4. Portfolio due date

5. Portfolio requirements: describe in detail the portfolio that is required for entrance in your chosen school and program. Identify how many works are necessary and any special requirements. Please include any take home exams or additional projects required.

6. Additional information required for complete application: this could include letters of recommendation, TOEFL, SAT or other exam scores, financial statements, grade transcripts, written assignments, etc.

7. What are the financial implications if you are to attend this school? List all anticipated expenses. Include budget considerations such as tuition costs, moving expenses, rent, living expenses, food, telephone, transportation, art material costs, medical insurance, student fees, etc.

8. Are there any forms of scholarship or financial assistance that you can apply for – either through the school or through other agencies that could help you realize your goal to attend this school? If so, what are they and what are the details and deadlines?

Using this gathered information from all of your schools of choice, fill in the College Research Quick Reference Chart. At a glance you will see all your major target dates including application deadline and portfolio due dates, along with a brief portfolio description, additional documents required and other information. This will allow you to keep on track with your critical deadlines.

Another thing that I highly recommend you do is purchase a small accordion folder. Make sure that it has as many envelopes or sections as schools you are researching or applying to. Label each section with the name of a different school, and use this to organize and store all your paperwork. You can also use this to house the materials that each school will send you once you have applied.

Finally, I suggest that you have a personal day-timer or agenda book, along with a large wall calendar in your studio that you will use to help keep you accountable to your timelines and deadlines.

The Application

> *"What are you? What am I? Those are the questions that constantly persecute and torment me and perhaps also play some part in my art."*
>
> —MAX BECKMANN

In sending in your application it is important to recognize that you are establishing your reputation with your chosen schools. You need to be attentive to the details from the start. As a result, you should always prepare a draft copy of the application. The vast majority of schools now

require that you register on-line, but there are still a few schools that prefer a hard copy paper application. Regardless of the format, print yourself a paper copy to fill in first, checking for accurate and complete information and correct spelling. Working from the rough draft fill out the on-line version or good copy to be sent by mail. Usually at this point you will also be required to pay an application fee either by credit card or money order.

When you have completed your electronic application be sure to do a spell check before transmitting it, and remember to take a screen shot for your files. With a paper application, use either a blue or black pen and print legibly and neatly, this is not the place to impress them with the new set of multi-coloured glitter pens that you got for your birthday. Then make a photocopy for your records before mailing. Finally, take care in addressing your envelopes so that they are also legible and neat. You might also use this opportunity to set a creative tone with your application. How can you include some exciting visual content on the envelope itself? Make your application stand out from the start!

Academic Records

> *"Concentration is the secret of strength."*
> —RALPH WALDO EMERSON

As part of your application, schools will require a copy of your high school records or transcripts. It is important to try and have the best transcript that you are capable of, so it is very important not to let any of your courses 'slide' in your junior or senior years. Don't make the mistake of assuming that your 'A' in Art will make up for your "C" in History.

Another factor to consider is what your transcript says about you not only in terms of your work ethic and ability to study and do well at

school, but what it communicates about your interests. I encourage you to load up your timetable with art offerings of course, but to also explore a variety of other areas which might include literature, history, languages, the sciences or physical activity courses. These other areas will stimulate your thinking and development in other ways and ultimately enhance your art making.

Your transcript is an official document prepared by your school and often includes 2-5 of your most recent years of educational experiences. It will also include 1-2 official signatures along with your school seal. Don't make the mistake of assuming that you can show up at your school office and request a series of transcripts to be delivered to you that day or the next. Be sure to give your office personnel at least a week to produce your paperwork – 2-3 weeks would be ideal. The secretaries or counsellors that will produce your forms are very busy people, dealing with hundreds or possibly thousands of students.

It's a very thoughtful gesture to follow up with a thank you card or a small gift to acknowledge their efforts. Your investment in a single flower or a coffee card will make both their day and yours. If you have great rapport with your school office staff – your life will run much smoother and they can be amazing allies. Schools will often require the transcript to be sent confidentially, so be sure to provide a self-addressed envelope with postage if necessary.

Exams

> "Give the world the best you have. And the best will come back to you."
>
> —MADELINE BRIDGES

In addition to transcripts, some schools require standardized test scores for admission. Be sure to review what tests you may have to take includ-

ing the SAT, ACT (American College Testing), TOEFL, Provincial Exams or others. These scores will usually be sent directly to your schools of choice from the testing organization, and that has to be arranged at the time you register or take the exam. Be sure to allow yourself the time to retake the exams and still meet the application deadline if your first attempt does not meet your schools' requirements. The **earlier** that you can get these tests out of the way the better, so that you can focus on your creative work.

Artist Statements and Essays

> *"Somebody's boring me... I think it's me."*
> —DYLAN THOMAS

In addition to your academic records and exam results many schools also require a sample of your writing in the form of an essay, artist statement or statement of intent. As I have already stressed, all of the application components are important and work synergistically to create your overall impression. The artist statement is no exception. This is simply another way for you to demonstrate your creativity, innovation, character and attention to detail. It is also a great opportunity for you to make yourself stand out in the flood of applications by writing something unique, entertaining and memorable. The question is – how to do this? Quite simply Be VIBRANT - not boring!

There are a few givens. Give yourself plenty of time to consider and brainstorm ideas for the specific topic request. Often you are asked to outline your artistic goals, relay a memorable art experience, inspiring moment or explain what and why you want to study at a particular school. Secondly, expect to write and edit several drafts before you complete your piece. Next, arrange to have at least two people review your essay for both the flow of ideas and grammar. A polite request to

your English or art teacher to proofread your piece would be a great idea once you have done your own editing and spell checking. Finally, unless your school requires an online essay consider a creative way to present your essay. It doesn't have to be simply black text on a white sheet of paper. You want legibility to be your first criteria, but then jazz it up. Think about how you could present the piece visually to reinforce your content.

You want the content to reflect you, your passions, ideas and experiences. In order for the writing to be authentic you have to base it on your own experiences and do so in a way that avoids clichés. Some elements I would avoid are being too general and talking about the school and its excellent programs without any specifics. Similarly, I wouldn't mention the city or location of the school and its "rich art community being a dream come true" – they've heard it all before. I would also avoid outlining in chronological order your personal art journey from childhood when you already knew you were destined to be an artist. (Can you hear them gagging?) I would also avoid high drama about all the obstacles you have had to overcome to make it to this point. Finally, references to topics such as drugs, alcohol, or illegal activities should also be avoided. I'm sorry, sometimes I just feel compelled to state the obvious.

How I would approach this is by taking your idea and considering how you could build your story in a way that is relevant to the field that you ultimately want to pursue. For example, if you want to be an animator, how could you turn your essay into an engaging story? Everyone loves a good story, so write one. If design fields fascinate you, consider how your story could be constructed to reflect the design process. An architect builds, a fashion designer stitches pieces together, a sculptor forms - what metaphor could you employ in your writing? If you are unsure of the ultimate field you want to explore, simply embrace the chance to write creatively. Introduce a powerful quote, perhaps by one of your

favourite artists and build your essay around that. Ultimately, have fun with this. Chances are if you enjoy writing it, they will enjoy reading it. If you approach this as a boring chore they will likely pick up on that as well. Your goal is to have them excited about meeting you on the basis of this great introduction.

As always make a photocopy of your finished, edited essay before you mail it or send it in on-line and keep it in your file for reference.

Letters of Recommendation

"It's never too late to be who you might have been."
—GEORGE ELIOT

Most schools require one to three confidential letters of recommendation to be submitted as part of your application. You should choose people who know you well, respect you and your work, and can commit to writing a well-crafted letter by the due date. Some good choices would be your art teacher, an academic teacher, or other school faculty such as your counsellor or principal if you have worked on projects with them. Other options might include your boss if you have a part-time job, or someone in the community who knows you for your involvement with a particular organization such as a youth group, volunteer association or religious community.

When approaching someone to write you a letter of recommendation give them a minimum of two weeks, and provide them with all the necessary forms filled out to complete the letter. Also provide them with envelopes addressed to the schools you are applying to complete with postage. I also urge you to provide each of your recommenders with a one page summary about yourself including your educational and art experiences, work experience, community service, hobbies and interests along with any other additional information that you think

would be relevant. I have included a Personal Summary Template for you to download on the web site.

In recent years I have added a new step to the requests that I receive to write a letter of reference, and it has been highly effective. I have all of my students write their own ideal letter of recommendation at the beginning of their senior year, and I'd like you to do the same.

 Action Steps

1. Write a 1-2 page letter of recommendation for yourself, as if someone else had written it. Write about your ideal self including discussing qualities and attributes as diverse as your work ethic, artistic/creative self, academic skills, communication skills, involvement as a member of the visual art program and larger community such as the school, local community and beyond. You might also address your hopes, dreams and aspirations for the future. As Stephen Covey would say, you are "starting with the end in mind." (This process should take an hour.)

2. Type your letter on the computer and save it as a word document. Print yourself a copy for your sketchbook and one to post in your studio. Refer to this letter throughout the year to see how close you are to your ideal self and targets. You may want to give a copy of your letter to your recommenders as well, and tell them about the process that you went through to create it.

3. Go to www.gettinginbook.com to see a sample letter of recommendation. This is a powerful exercise to connect you with your ultimate vision and goals for yourself, and it will help you make the good decisions that you will have to make along the way to support your plan to become your ideal self.

Home Exams and Portfolio

"I dream my painting, then I paint my dream."
—VINCENT VAN GOGH

Two of the final aspects of your application to art school are also the most important, both for successful admission and access to merit-based scholarships. The development of a personal portfolio and completion of any additional assigned 'home exams' are so critical that addressing them forms the bulk of this book including two chapters, chapter 6 – *Portfolio: The Creative Process - 10 Powerful Aspects of Expression* and Chapter 7 - *Portfolio: The Product.*

Declaration of Finances

"Ideas are a dime a dozen. People who implement them are priceless."
–MARY KAY ASH

Regardless of whether you may be considering studying in a foreign country or are staying in your native country to study, you will likely be required to submit a declaration of finances form as part of your application. This declaration is to demonstrate your ability to cover the cost of attending your chosen school, usually for a minimum of one year. These forms need to be filled out by your parent or sponsor. Typically these forms need to be accompanied by an official bank statement as well. Considering the time it takes to have the documents produced, translated if necessary and mailed in on time to meet the deadlines it is smart to start this process early. Each school has its own unique forms to fill out which are available either on-line or in their catalogue.

There are several sources of funding that you can tap into to help pay for your education costs including merit-based scholarships, need-based

scholarships, grants, loans, and campus work opportunities. These sources will be covered in more detail in chapter 11– Payment: Funding Your Dream.

Scholarships and Financial Aid

"If you don't design your own life plan, chances are you'll fall into someone else's. And guess what they might have planned for you? Not much.

—JIM ROHN

Understanding the variety of options and means that you have to pay for your post-secondary education is critically important. It is another area that warrants it's own chapter based on significance. Be sure to read Chapter 11 *Payment: Funding Your Art School Dream* thoroughly, and get your family members involved as soon as possible.

Putting it all Together

"Success is not to be pursued; it is to be attracted by the person you become."

—JIM ROHN

Researching and applying to art school is an exciting and daunting process. It is a time filled with hopes, expectations, dreams, fears and pressure. Creating an outstanding complete art school application will require a great deal of effort and enthusiasm on your part, coupled with considerable help and support from your family, the secretaries and teachers at your school. This will be an important time to foster excellent communication within those relationships. In addition to fostering great relationships with the people around you, it is also an important time to develop a stronger sense of self. It is a time for you to express

your aspirations, commit to your goals and challenges, work hard, contribute and learn to relax, trust and enjoy the process. If you embrace the guidance in this book, I guarantee that you will astonish yourself with the artist and person you become.

GETTING IN! – PUTTING IT ALL TOGETHER

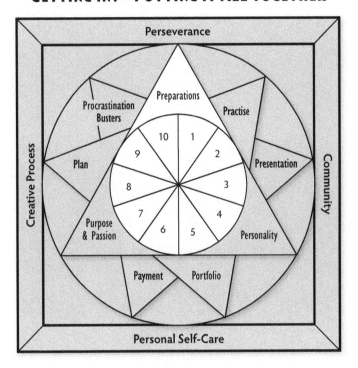

You have just completed the chapter on preparations, and should have a solid understanding of the 10 key ingredients for an outstanding art school application. Now would be a great time to create a piece of art don't you think?

Chapter 4

Plan: Designing A Compelling Vision for a Creative Future

"Nothing happens unless first a dream."

—CARL SANDBURG

In chapter 3 you explored the specifics of each component of your art school application from the initial research, through writing artist statements, and preparing your declaration of finances. With the understanding of what is involved in applying to art school, you can now proceed with clarity to create a powerful vision for your future, set some exciting and attainable goals and challenges and take immediate action to achieve them.

In addition to teaching about art, art history and the creative process there are few areas that excite me as much as teaching how to create a personal vision for the future and how to establish and achieve clearly stated goals and challenges. This is the land of possibility and it's exciting!

In this chapter you will nurture the seeds of purpose, passion and personality that were planted in chapters one, two and three to create an exciting personal vision statement for your life and art. You will clearly envision and describe your ideal art portfolio and set clear targets to create it. At the end of the chapter is a section on creating a personal time line that will help you plan and pace yourself through this art school application process. In addition I have included a checklist for international students to consider.

Vision

> *We lift ourselves by our thought, we climb upon our vision of ourselves.*
>
> —ORISON SWETT MARDEN

Whenever I start to talk about visioning and goal setting I am often met with groans, rolling of eyes, and comments like "Not goals again!" When I ask the students for some explanation about their complaints I learn that they are often confusing visioning and goal setting with setting New Year's resolutions. You know those resolutions to quit your bad habits, get healthy, lose weight, and make this year different. Resolutions are often written under the fog of a hang over, are generated by guilt or desperation, are written down without an accompanying plan, and are then stuffed away in a bottom desk drawer only to resurface months later when you go in there again looking for something. It's like instant failure in a drawer. No wonder they don't want to set goals!

Other misconceptions that surface around creating a vision statement and setting goals is that these are one time processes, and that once articulated and penned are written in stone. Both of these assumptions are false. Visioning and goal setting are ongoing processes that you can use throughout your life to help you create your ideal art, career, rela-

tionships, finances, and contributions. Your vision for the future and your goals will change and transform over time – that's their nature. Some goals will be achieved, others dropped, and still others modified to reflect the changing terrain of your life. Essentially, creating a vision and setting goals are processes that can help you gain clarity to create your ideal life, a life that is rich, exciting and rewarding, a life that makes you want to jump out of bed in the morning excited to get going. As Jesse Stoner Zemel said , "A vision is a clearly-articulated, results-oriented picture of a future you intend to create. It is a dream with direction."

Your vision is just a different word for dream. It is a word that implies clarity. When you have vision – you can see. So the objective here is to dream and envision what you desire your future to look like.

For our purposes, I want you to work with a time line of 1-5 years, and focus on your creative/artistic life along with your life in general. As Peter Drucker has pointed out, most people overestimate what they can achieve in one year, but underestimate what they can do in 5 years. This is the time to think big, let yourself dream, and get excited!

> *"Some men see things as they are, and say, "Why?" I*
> *dream of things that never were, and say, "Why not?""*
> —GEORGE BERNARD SHAW

 Action Steps

Imagine your life 5 years into the future and answer the following questions. Remember, have fun with this, let yourself dream and think big. What would be ideal for you 5 years from now?

1. What are you doing?

2. Where are you living?

3. Are you going to school?

4. Who are you working with?

5. What kind of art are you producing?

6. What skills and abilities do you have?

7. What are your friends like? Who is around you?

8. What is your energy level like? How is your health and vitality?

9. What are you doing with ease that you had been afraid to attempt?

10. What do you do for fun and adventure?

11. What organizations or causes are you involved with?

12. How are you contributing to the world to make it a better place?

Jot all your initial responses in your sketchbook. Spend a couple of days revisiting your thoughts trying to create as clear and compelling vision as you can. Finally, write a short descriptive paragraph to outline your ideal life 5 years from now. Try to use words and phrases that excite you. Write it in the present tense. I believe that Arthur Clarke was speaking the truth when he said, "The only way to discover the limits of the possible is to go beyond them into the impossible". That's what you're doing here.

This is a fun and uplifting process to use throughout your life. Not only does it encourage you to dream about what is possible it can give a powerful sense of purpose and mission to your life and your art-making. I hope that you will use this technique to envision your life in increments of 1 year, 5 years, 10 years, 15 years, 20 years and 25 years into the future. Imagine all that you can achieve, accomplish, contribute and give during that time. To that end, I have included some long term visioning templates for you to download and use on the web site.

In the last exercises you tapped into your powers of visualization for the future by imagining your ideal life and a variety of its aspects 5 years from now. Now I want you to envision something much more concrete and immediate. I want you to create an image of the ideal portfolio of works you have created 8 - 12 months from now.

 Action Steps

1. What format is your portfolio? Is it slides, prints, a CD or DVD, original works, a blog, website or perhaps a combination of the above?

2. How is your portfolio contained? Do you see a large black portfolio case 24″x 36″, or a sleek 8″ x 11″ leather booklet? Maybe it's a stack of CD's in visually stunning cases featuring your artwork and name on the cover, or a beautiful digital format. Picture it!

3. How many works does it contain?

4. What dominant media, techniques and processes are explored?

5. How are the works organized or grouped?

6. How would you describe the content and subject matter of your works including major themes explored?

7. What words would you use to describe your portfolio as a whole? Be as descriptive as you can.

8. What other components are contained within your portfolio? Is there an artist biography, curriculum vitae or résumé, or artist statement?

Don't worry at this point about what you feel you can currently create. Dream big! Let yourself be honest and open about your creative desires, it might surprise you what you imagine.

Again, write a short, descriptive paragraph, this time describing your ideal art portfolio and keep it in your sketchbook. You might also post this in your studio space.

Establishing Personal Challenges

> *"Your vision of where or who you want to be is the greatest asset you have. Without having a goal it's difficult to score."*

> —PAUL ARDEN

Now that you have developed both a long term vision of where you want to be and established some of the things that you want to have accomplished and be involved with, along with a vision of your ideal portfolio it's time to craft the specific steps to create it. Having said that, we are going to use the word *challenge* in place of goals, as *challenges* can offer us greater emotional and psychological impact. Goals can often seem like someone elses agenda rather than a personal desire. When faced with a challenge we often become more creative, we question, we problem solve, we innovate, we are inspired. As a result we will learn to set lofty challenges and rise to them, so let's forge ahead.

Setting challenges is a great way to break a vision or dream down into the smaller stages and steps that will be necessary in order to get there. Your challenges function like maps. They are powerful guides but they are not the terrain. When you are travelling to a specific destination, its great to arrive, but it's the adventures and detours along the way that make the trip worthwhile. Ideally, you want to have an idea of where you want to go with your art, your education and your life, while remaining open to the process, adventures and opportunities of living and all that entails.

Why Set Challenges?

"In the absence of clearly-defined goals, we become strangely loyal to performing daily trivia until ultimately we become enslaved by it."

—ROBERT HEINLEIN

Why set challenges? Simple, it works! Countless research studies have shown a direct correlation between setting personal challenges and enhanced performance in business, creative endeavours, sports, finances and personal growth.

TOP REASONS TO SET CHALLENGES

- Challenges can help you clarify and establish priorities
- Challenges can help you focus your time and energy effectively
- Challenges can fuel excitement and provide motivation
- Challenges can help you establish the steps to achieve your dreams and vision
- Challenges can provide a clear target to shoot for
- Challenges can increase your opportunities to give and contribute

TOP REASONS PEOPLE DON'T SET CHALLENGES

- They don't know the process
- They haven't taken the time to consider what they want their life to be like
- They may feel threatened by the process and don't want to face their fears
- They have a fear of failure
- They don't feel they can spare the time to craft effective challenges
- They feel powerless to change their situation and would rather live with the status quo

SETTING CHALLENGES:

While you can use the process of setting challenges in all areas of your life, (and I encourage you to do so), for these exercises you will be focusing on challenging yourself artistically and intellectually, along with challenging your development as a person and ability to contribute.

Up to this point, all you've had to do is let yourself dream and record those visions. For a lot of people that's a difficult thing to do in and of itself because it's easy to let other people's agenda or marketing dictate to us what we should and shouldn't want out of life. Hopefully, you're feeling a new level of excitement and energy based on your personal vision for the future. The next step is to create some clearly defined challenges and action steps that can move you in the direction of your ideal art and life.

Unlike your vision statement which is more general in nature and is hopefully loaded with descriptive words and phrases that energize you, your challenges will be very clear, concise and specific. Each of your challenges should :

- be **written in the present tense** starting with "I", such as "I create... ", "I learn... ", "I give... ", etc.
- be **specific and measurable**
- be **achievable** with a stretch, they should move you beyond your current grasp
- include a **date of completion**
- use **positive language**, focus on what you want to have or create rather than what you want to quit or stop
- use **exciting words** that appeal to you.

The following example includes an unclear challenge and its edited version.

INITIAL CHALLENGE

I create a portfolio of art works that I use to apply to art school.

Although this may initially seem like a clear and positive challenge, it is lacking in specifics that are measurable, along with a time line for completion.

EDITED VERSION

I create an outstanding portfolio featuring 15+ art works on or before January 15, 2016. It includes 8 thought provoking works exploring my personal series, 4 large scale expressive figurative works and 3+ other works showing my range as an artist. It is well crafted and professionally presented. I feel proud and excited to present my portfolio.

With this degree of clarity you are much more likely to start moving in the direction of your challenge. By becoming this specific, it will also help you to outline what initial action steps you could take.

Keeping your vision in mind respond to the following questions by writing out 2—3 challenges under each heading. (Templates provided on the web site www.gettinginbook.com)

ARTISTIC/CREATIVE CHALLENGES: What do you want to create? Think about your portfolio, your range work, personal series, home exams, and additional projects. How would you describe your art-making process? What role does your art-making have in your life?

EDUCATION CHALLENGES: Where do you want to go to school? When? What level of achievement do you desire? What do you want to learn? What exams/tests do you have to take? What role does learning have in your life and in your art making?

Personal Development Challenges: What do you want to improve? What kind of person do you want to become? What qualities or character traits would you like to enhance within yourself? What new skills would you like to learn? What's something you've always wanted to try but have been putting off? (You get the idea!)

Community and Contribution Challenges: How do you want to contribute? How can you make the world a better place? How could you use your art as a powerful way to contribute?

Now review your 4 lists and choose your top 4—8 challenges that you want to achieve in the next year. Using the template provided, write them out in priority sequence from #1 to #8, with #1 being the most significant challenge.

Finally, take these challenges and for each one of them create an Action Worksheet. (These worksheets are also available for download in the template section of the web site www.gettinginbook.com)

Challenge Action Worksheet:

"The quality of our expectations determines the quality of our actions."

—Andres Godin

1. **Challenge:** Stated in a positive and exciting way using the present tense.

2. **Deadline:** When will you complete this challenge, set a date and write it down.

3. **Action Steps:** Identify the first 3 small steps or actions you could take to achieve it, and then number them in order of sequence from first to last. Don't worry if you have no idea how you will ultimately achieve your challenge, start with the few steps that you can identify and likely that will lead you to the next steps. Working towards

your challenges is both an act of faith and a plan. It requires you to be courageous and take action.

4. **POTENTIAL OBSTACLES:** What might get in your way or set you back as you try to accomplish this challenge? Try to anticipate any roadblocks before they occur.

5. **SUPPORT:** Who or what could you call on for support or help with attaining this challenge?

6. **IMMEDIATE ACTIONS!** What action can you take right now to get started and DO IT! Take some small action every day that will move you closer to your challenge and keep the positive momentum going.

Post your Challenge Action Worksheets in your studio or glue them into your sketchbook. Refer to them weekly to check your progress. When you feel confident with tackling your top 4 challenges add on another and so forth. You can also add new challenges as others are achieved.

> *"Our aspirations are our possibilities."*
> —SAMUEL JOHNSON

Finally, there is another step in the challenge setting process that I think is very important and often over-looked. Rewarding yourself or celebrating when you accomplish either your action steps or larger challenges is a significant part of the process. Positive reinforcement can be an incredible motivator and ideally you want to provide that acknowledgement, praise and recognition to yourself for a job well done. Your 'rewards' could be as simple as acknowledging your progress by saying a few kind words to yourself, sharing your successes with a few close friends, giving yourself a special treat (whatever that might be), or enjoying one of your favourite activities. Before we carry on, write out a list of 10 things in your sketchbook, that you could do to recognize or celebrate your successes.

Creating a Personal Time Line

> *"The key is not to prioritize what is on the schedule, but to schedule your priorities."*
>
> —STEPHEN COVEY

For the exercises in this section you will need your personal agenda book or day-planner, a large square wall calendar, and either a series of different coloured gel pens or a black pen and a series of different coloured highlighter felts. (Yes, *now* is the time for you to use the set of multi-coloured glitter pens that you got for your birthday.)

Starting with your wall calendar, your objective will be to create a time line of the actions you need to take in order to accomplish your personal challenges, to successfully create an outstanding and expressive portfolio, and complete all of your art school application requirements. You might also want to include your other responsibilities on this calendar such as your work schedule if you have a part-time job, sports activities and community involvement.

I would suggest that you start with writing in the major deadlines first including application due dates, portfolio due dates, portfolio interview dates, and scheduled exams. Double check your dates and write them clearly on your calendar. With the portfolio due dates, rather than writing it down on the actual due date I recommend that you back it up 3 days. For example, if a portfolio is due on February 1st I would write it in due on January 27th. This gives you some "emergency days" if a crisis happens at the last minute. I would also give yourself an additional week for your final application package to be couriered (if applicable) or a couple of days to upload it. These two simple steps build in a bit of a buffer and create a lot of peace of mind. As a final note on the subject, submitting an application and portfolio prior to the deadline makes the applicant appear more devoted and mature. Don't you want that to be you?

As you continue to work back from your big deadline dates you can write in the smaller steps like registering for exams and exam dates, and days to photograph your works, etc. Although I have some beautiful scenic calendars hanging on my walls, I use a simple large plain paper wall calendar that has the biggest daily squares I can find for my monthly and long term planning.

Be thorough with researching and recording your dates and deadlines to your wall calendar. I like to colour code my projects so that each of my challenges is recorded or highlighted in one colour. For example my #1 challenge and all of its action steps might be highlighted in yellow. My second challenge and all its actions and deadlines would be highlighted in green, and so on. That way at a glance I can track the time and attention I'm giving to each challenge. Another strategy is to write all your due dates in some eye catching colour like bright red. Once you have crafted your master calendar simply add any new important dates or deadlines as they come up.

It will be important for you to experiment with different approaches and techniques to find a system that works for you. Learning how to keep yourself organized and on top of several due dates and projects is a real skill, and one that will serve you well in your high school years, post-secondary program and with your creative life beyond.

The process of gathering all that information and recording it on your wall calendar will give you a sense of accomplishment and being in control. In turn, the feeling of being in control contributes to greater self confidence and less stress.

Another step to stay on track is to do a weekly review. I suggest you do this sometime on Sunday. Review the week ahead and update your agenda book with your action steps and any deadlines for the coming week. It's also a good time to quickly scan the previous week to make

sure that you handled or accomplished everything you had scheduled for yourself to do. Anything you missed would get carried over to the current week. You should also use this Sunday planning time to quickly scan the weeks ahead and keep yourself aware of the bigger picture. In total this should take no more than 30 minutes per week.

Ultimately, you want to plan and prepare for the big picture but focus on one day at a time. Use and consult your big picture calendar, plan your weeks, but simply focus on one day at a time. Sometimes it's easy to get overwhelmed by considering everything you have to do in a month or even a week, but usually the day-to-day is doable. Remember; don't turn what you love into a chore. This is the path you have chosen. You are an artist. All these deadlines are self-imposed, giving you an incredible opportunity to share your thoughts, ideas, innovations and creativity with others. It's an honour and a privilege. Your deadlines are a part of your creative challenge. Turn it into a game. By looking after the details of your schedule you can create large chunks of sacred time for your art, for exploring and creating. Protect and cherish your creative time. Have fun with it – play, explore, express, and create like crazy!

All of these strategies are meant to help you enjoy your creative time even more. They are meant to help you enjoy the process of applying to art school, a time that for many students is filled with stress, anxiety and a roller coaster ride of emotions. If you will take small steps everyday to address your applications, the seemingly huge job of applying to art school will happen almost miraculously. Now that you've got your schedule on paper – you can focus on your creative work.

International Student Considerations

"Sometimes it's the detours you take that provide the learning you need."

—Tim Kelly

If you are planning to study outside of your country of origin, you will be considered a foreign or international student. Most schools actively recruit and welcome students from foreign countries in order to create a dynamic and diverse mix of world views, perspectives and cultures within the student body on campus. Quite likely your application process will be very similar to students who are citizens of the country you are applying to, but there are a few additional requirements that will be necessary as part of your application. You would be wise to start your application process early and expect it to take a little longer.

1. Start your post-secondary research early. The internet makes this process much easier as you can access school web sites to review application procedures and program details instantaneously.

2. I am assuming that if you are using this step-by-step guide book you are applying to an English speaking school. As a result, if your country of origin is not English speaking you will be required to take a TOEFL test (Test of English as a Foreign Language) to assess your ability to comprehend the English language. You can find out more information and arrange to take an exam through their official web site at www.toefl.org.

3. Make sure that studying the English language is part of your daily and weekly practice. Help yourself to become comfortable with English by surrounding yourself, if possible, with English speakers and listening to English radio or television stations. Having a solid command of the language will be a tremendous asset in both applying to post-secondary and being successful when you arrive.

4. Arrange to have all of your official documents including application forms, transcripts, letters of reference and financial documents translated into English prior to submitting them.

5. Check with each school that you are planning to apply to as to whether or not international students are eligible for scholarships or campus work opportunities.

6. Once you are accepted to a school as an international student be sure to start the process of obtaining the appropriate student visa immediately. Usually, your school will send you an official letter to get the process started.

GETTING IN! – PUTTING IT ALL TOGETHER

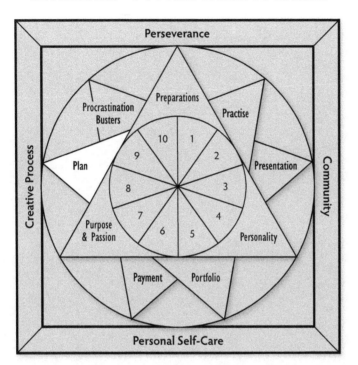

Good for you! That's another section completed. Hopefully, you have designed an exciting and dynamic plan for your artistic development and a clear vision for your creative future!

Chapter 5

Personal Self Care:
10 Ways to Maximize
Your Vitality and Creativity

*"The body is, quite literally, our vehicle for being – for giving,
for loving, for moving, for feeling – and if it doesn't work,
it's fairly certain that nothing else in our lives will work, either."*

—DIANA ROESCH

Indeed, your body is not only your vehicle for being – but also creating. The years that you spend both preparing for and attending art school are incredibly strenuous on many levels – physically, emotionally, financially, intellectually, creatively and spiritually. They are years of great joy and accomplishment, anxiety and frustration. It's an intense time. And in order for you to successfully maintain the energy, enthusiasm and stamina you need to bring your best self to your creative endeavours you have to develop and carry out a plan for personal self-care. Personal self-care implies that you will establish and carry out a varied approach for keeping yourself healthy and thriving before you experience any sickness or loss of energy.

Martha Graham, the renowned dancer and choreographer said, "The body is a sacred garment. It's your first and last garment; it is what you enter life in and what you depart life with, and it should be treated with honour." So the question is then, how do we honour our bodies? In this chapter you will learn about a number of strategies that will synergize to keep you healthy, fit, focused and full of vitality. Some of my students and colleagues tease me about this part of my program – I think it's because they are surprised by someone in a paint splattered smock talking about the importance of breathing, hydration and exercise. What I do know is that when I started teaching this information my students were surprised by the effects. They lost weight, they were happier and less stressed, they had more energy, they didn't catch the dreaded November cold or flu, and they were able to focus and work with greater clarity and creativity. If you are committed to your artistic vision I encourage you to raise your standards and be proactive with creating excellent health through personal self-care.

The key areas I will cover for you to consider are

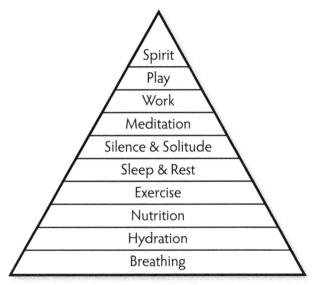

Now don't get me wrong, this in not a diet book, and you will not find pictures in here of how to do a proper push-up. What I will do is make some general recommendations for some simple and effective things that you can do to greatly enhance your energy and vitality. I realize that you are likely already stretched for time so these recommendations will not add to your time pressure but will conversely add hours of energetic time to your day.

Breathing

> *"Improper breathing is a common cause of ill health. If I had to limit my advice on healthier living to just one tip, it would be simply to learn how to breathe correctly. There is no single more powerful – or more simple – daily practice to further your health and well being than breath work."*
>
> —ANDREW WEIL, M.D.

How many **weeks** do you think you could survive without food?
How many **days** do you think you might last without water?
How many **minutes** without oxygen before you would die?

Oxygen is the most critical component to our health and energy. Without oxygen human life is not possible, and without an optimal supply of oxygen to the trillions of cells in your body you will not be able to manifest the dynamic energy necessary for success academically, physically, emotionally or creatively.

Now obviously, if you are reading this book, you are breathing – but how are you breathing? Are your breaths full and deep, what we will refer to as diaphragmatic breathing or are they shallow and short?

Having been a teacher and public speaker for about 30 years I have been

aware of the importance of breathing strategies to sustain voice clarity and reduce tension for a long time. But I wasn't aware of the obvious connection between breath and overall health and well-being until I attended a four day program with Anthony Robbins called *Unleash the Power Within.* During his transformative course, one of the areas we focused on and learned about was ways to enhance our personal energy and vitality. Perhaps not surprisingly, proper breathing formed the foundation of his master principles of a vital life.

Breath work involves learning some simple techniques to learn to breathe more effectively. Breathing well will oxygenate your cells, reduce tension in your neck and shoulders and throughout your body, reduce your heart rate and stress levels, and create a general feeling of well being.

Diaphragmatic breathing is breathing from your belly. It is called belly breathing because as you inhale, your belly expands rather than your shoulders and chest moving. Place one hand over your belly button. Now inhale slowly through your nose one long breath while counting in your head "one...two...three...four...five..." Your shoulders and chest should remain still while your stomach expands. Your lungs will also be flooded with oxygen through this process. Now hold your breath for the same period of time, again counting silently in your head. Finally, exhale slowly through your mouth for the same count.

Repeat this deep diaphragmatic breathing for ten breaths, and repeat this process several times throughout the day, including first thing in the morning, once or twice during the day and once in the evening. You will find that this is also an excellent way to prepare yourself for making a presentation, giving a speech, having an interview or presenting your portfolio.

Another simple way to practice deep breathing is to lie down on your

back and put your sketchbook on your stomach. Practice breathing deeply so that your sketchbook moves up and down with each breath in and out.

There are countless approaches, techniques and ways to experiment with breathing exercises. If you are interested in learning more I recommend that you google some of these key words and see what strikes your fancy.

- Breathing Techniques for Public Speakers
- Pranayama - The Art of Yoga Breathing
- Breathing Exercises for Stress Relief
- Deep Breathing Exercises
- Learn to Breathe Well
- Breathing Relaxation Exercises

In case you were curious, you can survive approximately 3 weeks without food, 3 days without water and 3 minutes without oxygen. Breathe deeply!

Hydration

> *"...water is the primary substance and the leading agent*
> *in the routine events that take place in the human body."*
> —DR. BATMANGHELIDJ

After oxygen, the second most critical element for your personal health and vitality is water. Throughout my life and certainly during my teaching career I have been a strong advocate of drinking water. Then in 2009 I read an incredible book called *Your Body's Many Cries for Water* by Dr. Ferrydoon Batmanghelidj and now I am almost evangelical about water. (Yes, you do get a prize if you can pronounce his name correctly.)

While his book reviews the critical importance of water in the prevention of diseases and medical conditions as diverse as high blood pressure, asthma and rheumatoid arthritis he also explores the importance of water in alleviating stress, depression, headaches, and back pain, shedding excess body weight, and eliminating allergies. Some of the biggest improvements that my students notice when they start drinking more water are enhanced clarity of thought, focus, concentration and creativity.

Dr. Batmanghelidj recommends a minimum of six to eight 8-ounce glasses of water a day. Other estimates that I've read recommend drinking half your body weight in fluid ounces daily. If you weigh 130 pounds, you should drink 65 ounces of water daily.

Contrary to popular practice, you should avoid drinking with your meals as it only weakens your digestive fluids' ability to do their job as quickly and efficiently as possible. When digestion is slowed the toxins that result from the digestive process spend more time in your system creating a toxic and acidic environment. As a result, the best times to drink water are 30 minutes before food consumption and two and a half hours after each meal. You should make water your first drink in the morning and the last thing you drink before bed.

What I encourage my students to do, and that now includes you, is invest in a good quality reusable water bottle. Stainless steel and glass are my preferences, as they do not interact with the water as many plastic bottles do. I also don't want you to contribute to the toxic waste and environmental nightmare we are creating through disposable plastic water bottle use. If you start and end your day with water at home, your water bottle can sustain you throughout the day. If you have good clean water sources available to you at your school or within your community your bottle can be topped up throughout the day from taps or drinking fountains.

Now I think I would be negligent if I didn't address the use of caffeine in its variety of forms in this chapter on self-care. We live in a coffee culture, with a coffee shop on almost every corner. There is also caffeine in some teas, many pops or sodas, chocolate, sports and energy drinks and obviously caffeine pills. When you rely on external stimulants you build both a physical and psychological dependency, which in turn weakens both your body and your mind.

In addition to the caffeine in these products they also usually include high levels of sugar, fat, chemicals and fillers. In order to honour your body you should make every effort to fuel it with enriching sources of hydration and nutrition. Make water your first drink of choice! Then supplement with herbal teas, served either hot or cold. There are many types of strongly flavoured, caffeine free teas that you can explore as alternatives to coffee. Green teas and rooibos teas are also loaded with antioxidants and other elements that are know to assist with nervous tension, allergies and digestive problems.

One of the positive results of lowering your intake of caffeine is that when you do need to use it, on occasion, to enhance your performance to work for long stretches of time or pull an 'all nighter' – a little goes a long way. A cup of black tea works like an espresso, and a double espresso will have you working for hours. And yes – I am speaking from experience! You see, I was never a coffee drinker through high school, my university years or even during the first decade of my teaching. Then, in 1999 I took a sabbatical to study drawing, painting and art history in Italy. By the time I returned I was definitely addicted to espresso – a double, triple or quadruple shot to start my day. This went on for years – 10 years actually. My morning espresso became a powerful ritual and ingrained habit. I must confess that despite my love for the beverage I was uncomfortable feeling dependent on my 'cup of energy' as I called it, and the sweetener that I added to it. After considerable reading about

nutrition, hydration and health I quit. I had a headache for almost 3 days and then it was done.

Now I drink water, with or without fresh squeezed lemon juice, served either cold or hot, assorted caffeine free rooibos teas, green teas and an Americano on occasion. I have more energy throughout the day and I've noticed that the peaks and valleys of emotions and energy that I would experience on a daily basis are gone. My decision was a personal choice to try and enhance my energy levels and overall vitality, and I encourage you to try it out for yourself and see if you notice a difference as well.

Sadly, I have seen students make self care a priority only after experiencing a major health crisis or losing a year of post-secondary experience due to illness or fatigue. I'm thinking of one particular year when I was both blessed and cursed to work with a most exceptional and intensely driven group of young artists. They were incredibly hard-working and would often push themselves to work for days on end with very little sleep, sometimes sleeping only 1-3 hours a night. In order to accomplish this feat a couple of them started to rely on caffeine pills and so called 'energy' drinks. In fact it became quite a studio joke. One night they even created an **In Case of Emergency** box for the studio like the ones that hold a fire extinguisher. The box included a glass front and painted red case. On the front of the glass were the words **In Case of Emergency** and contained within the box, which hung on the wall were a couple of different bottles of caffeine pills. We all had a good laugh over it. Fortunately they all managed to survive the year with no obvious health impacts. Unfortunately though it established in a couple of them a habit of using caffeine like a drug. Caffeine enabled them to work insane hours and remain oblivious to their body's cries for water and sleep.

This resulted in some unhealthy habits that followed a few of them to

college. With the increased pressure and intensity of a rigorous post-secondary program, one of these exceptional young men became sick from the immense workload coupled with poor eating habits, caffeine consumption, lack of rest and exercise along with accumulated sleep debt. These conditions created a weakened immune system which led to sickness which resulted in hospitalization. He decided to cut his losses and repeat first year. And this happened to an amazing, talented and awesome young man! It can happen to you! Fortunately this story has a happy ending. This exceptional young artist got back on track, completed art school and is now living and working as a designer.

Nutrition

> ..."To eat is a necessity, but to eat intelligently is an art."
> —LA ROCHEFOUCAULD

While we're talking about the things we ingest into our bodies I'll continue on with nutrition. This is a huge area of both complexity and controversy, and I want to keep the focus on those things that you can do that will ultimately enhance your energy, brain functioning and creativity. As a result, I have recommended a couple of books for you to consider as you develop your personalized nutritional plan in the *Recommended Reading List* at the end of the book, but my guidelines here are going to be very simple.

If you are looking to create greater energy, focus and creativity, try these simple recommendations and observe how differently you feel and perform. Your body will give you all the information you need if you listen to it carefully.

1. Remember to drink lots of water throughout the day, ideally 30 minutes before and 2 ½ hours after each meal. Drink your water either cold or hot and try adding some fresh lemon.

2. Eat 5-6 smaller meals throughout the day to keep your metabolism

and energy levels more stable. This will mean you will eat every 2-4 hours.

3. Create the majority of your meals (60-70%) from vegetables and fruits. Eating vegetables raw or lightly steamed is ideal. Try adding a salad or vegetable sticks to each of your meals.

4. Consume about 10-20% of your diet as vegetable, fish, meat or dairy proteins.

5. 10% of the content of your meals should be complex carbohydrates such as whole grains, rice, breads, noodles and pasta.

6. Finally, about 10% of each meal should consist of healthy fats and oils. Good options include fish oil, olive oil, flaxseed oil, or Udo's Oil, which is available through health food stores or your regular grocer.

Creating your meals is a lot easier than it sounds. I've included a few ideas below for quick, healthy snacks and small meals that are easy to prepare and transport. There are several other meal and snack ideas featured on the web site. Rather than looking for a chocolate bar and a soda to give you a jolt in the afternoon, try these options instead for sustained energy and mental clarity.

SNACK IDEAS

- Cut up an apple or celery sticks and take along some natural peanut butter or almond butter for dipping.
- Make your own trail mix in larger quantities and then scoop some into a reusable container to take along for the day. You could include any of the following that you enjoy: almonds, walnuts, peanuts, cashews, dried cranberries, apricots, apples, raisins, cherries and mangos, dried banana chips, and coconut flakes or chunks
- Mixed green salad with 1/2 can of tuna flaked on top with a little olive oil drizzled over it all.

76

- Fresh vegetable sticks of an assorted variety with fresh hummus or guacamole. Think of broccoli, cauliflower, carrots, celery, cherry tomatoes, snap peas, fennel bulbs, etc.
- Sushi with wasabi and ginger

As you can see from my guidelines there are several foods and substances that are not on the list for enhanced vitality and creativity. In addition to adding healthy options into your life there are several substances that I would encourage you to reduce or eliminate all together. Those include:

- White sugar – try a natural sweetener instead like stevia or raw agave nectar
- White flour and its products – cakes, cookies, pastries
- Deep fried foods – in fact you might want to avoid the typical 'fast-food' restaurants and try places where you can eat fresh and live foods and control your ingredients.

CHEAT MEALS

If you eat the majority of your meals as vegetables and fruit, along with lean proteins, whole grain carbohydrates and nutritious fats you will notice a huge improvement in your overall feeling of well-being. If you eat those meals spread over the course of the day, eating every 2-4 hours you will fell consistent energy and vitality that will keep you creating and focused throughout the day. You'll probably also lose weight even though you may be ingesting the same amount of calories as before.

This kind of clean eating makes you feel wonderful physically, but may leave you feeling a little deprived psychologically. None of us likes to contemplate a future without ice cream, chocolate cake, or pizza, do we? That's why I'm a real advocate for 'cheat meals.' The goal is to eat clean 90% of the time. As a result, you should aim to have 3 cheat meals or less during the average week. (5 meals a day x 7 days a week = 35

meals x 90% = roughly 32 meals.) Cheat meals allow you to enjoy a piece of your friend's birthday cake at lunch one day, have a relaxing cheat meal on the weekend, and a side of fries when you are really craving them. The trick to cheat meals is to immediately return to your clean eating with your next meal. If you're trying to lose weight, you might limit your cheating to one meal a week as opposed to three. Cheat meals give you a chance to look forward to indulgent foods and provides both your body and mind with some guilt free pleasure!

A NOTE ABOUT "LIFESTYLE"

My main purpose in writing this book is to share with you some of the expertise I have developed over three decades of working with youth and adults and their creative development. My desire is to help you create the ideal conditions to foster your ability to dream big, think clearly, problem solve, create freely and courageously and be incredibly prolific with your chosen modes of personal expression. *Drugs and alcohol inhibit and destroy your potential!* Enough said.

What I want you to consider is that you are preparing yourself physically, mentally, and creatively for an intense endurance event. The success of your portfolio and overall application along with your ultimate achievement at post-secondary and beyond will be the result of the levels of energy, creativity and stamina that you are able to pour on and maintain over the months and years. Establishing effective habits in the area of personal self-care are key. You owe it to yourself to learn and embrace options that contribute to your own health and the overall health of the planet.

Exercise

"Commit to be fit".
—AUTHOR UNKNOWN

Do you want to feel great and have more energy and vitality? Do you want to sleep well and wake up feeling refreshed and excited to start your day? Do you want improved mental clarity and enhanced creativity? Exercise delivers all of these benefits and many more! I've included this important section on exercise for several reasons. First of all, I'm concerned about the decline that I've witnessed in the general health and fitness levels of the people that I've worked with over the decades. I want you to be healthy, fit and strong and live a long life free from pain, medication, disease and other health issues. More immediately though – I need you to have intense energy and vitality for the creative work that lies ahead. I'm a demanding teacher in that I have very high expectations for my students – and that means **you!** In order for me to help you create awesome personal works of art, get accepted to art school and be offered great scholarships you will need to have abundant reserves of natural energy and vitality. That kind of energy can only be fostered through effective, proactive personal self-care including regular exercise.

So before we get into some of the fun ways that you can incorporate more movement and activity into your daily round let's run through some of the benefits that you can expect from increased physical activity.

1. **EXERCISE IMPROVES YOUR MOOD** – physical activity releases various 'feel good' chemicals including endorphins throughout your body leaving you feeling happier and more positive.

2. **EXERCISE REDUCES STRESS AND HELPS YOU MAINTAIN PERSPECTIVE** – those same 'feel good' chemicals also help you feel more relaxed.

3. **EXERCISE BOOSTS YOUR ENERGY LEVEL** – regular exercise improves the efficiency of the various systems of the body including the cardiovascular system and the circulation of blood through your heart and body. The more efficiently the body runs the more energy you have to devote to other areas of your life – like developing your creativity.

4. **EXERCISE PROMOTES BETTER SLEEP** – exercise helps you fall asleep and also deepens your sleep. As a result, a good night's sleep will enable you to concentrate, produce, and feel better. Be warned though that exercise can have a stimulating effect on the body so if you exercise too close to going to bed you might be too pumped to sleep. If that happens try working out earlier in the day.

5. **EXERCISE HELPS YOU MAINTAIN OR LOSE WEIGHT** – it's no secret that physical activity burns calories and the more intensive the activity, the more calories burned.

6. **EXERCISE ELEVATES YOUR METABOLISM** – so that even after you have finished exercising you will continue to burn more calories.

7. **EXERCISE IMPROVES YOU SELF-ESTEEM AND CONFIDENCE** – in addition to making you feel better, exercise makes you look better. The increased blood flow to the skin makes it looks healthier and feel better, and the better you look and feel, the better you feel about yourself and the world.

8. **EXERCISE IMPROVES SELF-DISCIPLINE** – creating and maintaining a regular physical activity program requires self-discipline, which in turn spills over to other areas of your life. You will feel more in control of your life, which also fosters confidence.

9. **EXERCISE FOSTERS INCREASED STRENGTH AND STAMINA** – regular exercise builds or tones muscle and strengthens bone making every physical thing you do easier and more efficient.

10. **EXERCISE ENHANCES CREATIVITY** through improved mental functioning, clarity of thought and ability to focus and be attentive.

OTHER BENEFITS OF EXERCISE INCLUDE:

- Improved digestion
- Reduced risk of heart disease, diabetes, and osteoporosis
- Greater body definition and shape
- Improved flexibility and range of motion
- Increased thirst for water
- Alleviated menstrual cramps and other symptoms
- Improved balance, posture and overall coordination
- Lowered resting heart rate
- Increased bone density
- Improved athletic performance

Besides the numerous benefits of exercise listed above, exercise can be fun! Getting active can be a great way to unwind, relax, play, spend time with your friends and have a blast! If you are at a loss for some things to try consult the list below and see if you can't jazz up your repertoire of activities.

PHYSICAL ACTIVITIES (TO DO ON YOUR OWN OR WITH FRIENDS)

- Walk in nature or on a treadmill listening to some of your favourite tunes or an audio book.
- Jog or run – make it a beautiful location if you can
- Sign up for a class at your local gym or community centre – try a spin class, Pilates, TRX or 'Boot Camp' class
- Take a dance class or go out dancing at night with your friends
- Weight lift – most gyms have personal trainers that will get you set up with a personalized program for free.
- Ski or snowboard

- Tennis, squash or racquetball
- Go for a paint ball adventure
- Roller blade
- Skateboard
- Play a rousing game of ping pong (yes, I'm being serious)
- Go hiking
- Get into martial arts or kick boxing
- Train for an event like a 5K or 10K run, a marathon or a triathlon, then do it!
- Go surfing or wake boarding at the beach
- Horseback riding
- Jump on a trampoline
- Yoga
- Play an organized sport like soccer, volleyball, ice or roller hockey, football, basketball, baseball, rugby, lacrosse or field hockey
- Shoot some hoops with your friends
- Play some full contact, stocking feet, hacky sack soccer - although trust me this can be dangerous!

I guess since I included hacky sack soccer on the list I have to explain with a little story. One of the things that we have done in the past as a visual art fund-raiser is organize a 24 Hour Art-a-Thon. The art students would collect pledges to see how many consecutive hours they could produce art work over a 24-hour period. The money that they collected went to help them pay for an art trip to Italy. Our Art-a-Thons would usually start at 7:00 a.m. and go straight through to 7:00 a.m. the following day. The students were able to break for 5 minutes each hour (basically for a drink or to use the washroom) and we also built in short lunch, dinner and activity breaks throughout the 24 hour period. Usually, around 2:00 or 3:00 in the morning production in the studio would dramatically slow down and many of the students wanted to end their challenge and fall asleep (Okay – so did I!) What we did

instead was drag them from the art studio across the hall into the dance studios with beautiful hardwood floors. We opened the doors letting in cold early morning air, cranked some tunes and played some wild games including hacky sack soccer in our stocking feet – which provided great sliding possibilities. My colleague Peter takes all sports very seriously, so our fun games would usually morph into intense, full contact, no holds barred sports. There was a lot of running, screaming, collisions, laughter, and fun. After 30 minutes of this everyone's energy and enthusiasm were revived allowing us all to paint, draw and create again for several hours through the morning. It was a blast – and I'm thrilled to report that we never had any compound fractures to deal with!

> *"I have to exercise in the morning before my brain figures out what I'm doing."*
>
> —MARSHA DOBLE

From all the reading that I've done in the area of exercise, it seems as if the minimum requirement for exercise benefit is 30 minutes 3 times a week. Ideally I'd like it if you did 30-60 minutes of activity 4-6 times a week. Like Marsha Doble, my personal preference is to work out in the morning before I head into the studio. I like to exercise, sweat and get my metabolism going first thing. Then I can shower and I'm ready for the day – with my exercise behind me. I realize though that I am a 'morning person' and not everyone likes to be moving at 5:30 or 6:00 in the morning. Perhaps doing some fun activity between school and your evening creative work would be ideal for you. Try out a few different times to see what works for you and then build that into your schedule.

While setting aside larger chunks of time to be active is very important, there are many little things that you can do throughout the day to build in more movement. Consider:

- Taking the stairs over an elevator
- Parking further away from your destination and walking a little,

or getting off public transit one or two stops away and hoofing it the rest

- Riding your bike to school or to do errands
- Going for a walk during your lunch break
- Giving yourself a movement break after school before you get into your art again or begin homework
- Doing some simple stretches followed by 20-50 jumping jacks when you're feeling low energy
- Getting a rebounder or mini trampoline and keeping it in your room giving yourself 10 minute bounce breaks throughout your work sessions
- Using a commercial break if you are watching a little TV to move your body – run on the spot, dance around, or stretch.

Just one final reminder, regardless of your level of health it's important to start any new fitness program gradually and build up to longer durations and greater intensity. If you have any health concerns or issues make sure to check in with your doctor first – but otherwise – get moving and have FUN!

Sleep and Rest

> "A good laugh and a long sleep are the best cures in the doctor's book."
>
> —IRISH PROVERB

Probably not surprisingly, the first thing we tend to lose in our personal self-care routine is sleep. As the demands and pressures mount, the hours we spend in restorative sleep tend to decline sparking a vicious circle. The less we sleep, the more we become incapable of keeping up with our creative demands. As our energy level decreases, we become more moody and irritable. When we are not getting enough sleep, our

bodies immune system is compromised and as a result we are more likely to get sick as well. We lose our ability to focus and sustain concentrated effort and as a result we are less productive. As our productivity decreases we have to spend more time working which leads to less sleep, and on and on it goes. Lack of sleep robs us of our ability to enjoy the process of creating and living, and that is a tragedy!

Conversely, let's consider the many benefits of sleep.

1. **Sleep allows the body time to repair itself.** While you are off in dreamland your body is busy recovering from the damage sustained throughout the day including forms of stress, exposure to the sun and other physical elements, along with exposure to pollutants, germs, viruses and carcinogens.

2. **Sleep helps to strengthen your immune system**, giving you a better chance to stay healthy, fit and strong. Getting adequate sleep will help you ward off colds, flues and other sicknesses.

3. **Sleep lowers stress.** Getting a good night's sleep elevates your mood and will help you keep things in perspective. Sleeping helps to lower your blood pressure, which encourages states of relaxation. Stress literally ages your body and mind causing degeneration of your cells and vital organs. It's important to try and counteract its corrosive effects and sleeping well will do that.

4. Studies have shown that **sleep also improves memory**, which is extremely important when you are learning and creating. Along with repairing your body while you sleep your brain remains active sorting, organizing and storing memories.

5. **Sleep enhances your ability to think clearly.** A well-rested brain and body is better able to think, learn, synthesize, analyze and create.

6. **SLEEP HELPS YOU CONTROL YOUR BODY WEIGHT** by balancing the hormone levels that regulate your appetite. Lack of sleep often leads to food cravings for simple carbohydrates and fats, which usually contribute to weight gain and mood swings.

7. **SLEEP HELPS YOU MAKE GOOD DECISIONS AND STAY ALERT** during the day leading to greater personal safety and effectiveness.

Although this section on sleep comes late in the chapter on self-care I don't want you to underestimate its effectiveness in helping you live a more passionate, enjoyable, creative life. Sleeping well will keep you healthy and feeling awesome.

So the question is – how much sleep is enough sleep? Typically, 7-8 hours of sleep seems to be the recommended amount to experience all of the health benefits I've outlined above. I realize that during crunch periods this is next to impossible but if you make an effort to sleep well the majority of nights you will be able to bounce back faster from your periods of sleep deprivation.

During your most stressful periods of portfolio development and application demands, cut out any time wasters and use the opportunity to get some critical sleep instead. Forget about checking your emails, doing random Google™ searches, watching movies, visiting Facebook™, hanging out with your friends, and the like. When it's time to work – work. When it's time to sleep – sleep. These super intense times usually only last for a period of weeks if you've been working diligently all along; your social life should be able to recover with no problems. Alert your friends to your upcoming deadlines and your plan to focus on your work, and if they are good friends they will do everything they can to support you.

Another option to help you cope with rigorous demands is the afternoon power nap. A power nap is a rest or sleep break that lasts for 20

minutes to an hour. It usually happens in the middle of the afternoon or early evening. When I went on my sabbatical to study in Italy I fell in love with the afternoon siesta and tried to import it with me on my return to Vancouver. Sadly, my school was not too receptive to the idea, but I still try to nap whenever I get the chance. Sometimes I'll take a quick nap when I get home from work and it can add several productive hours to the end of my day, which is a real bonus. If you aren't used to napping, or are feeling run down – give it a try – but be sure to set an alarm. An intended 30-minute nap at 4:00 p.m. that has you waking up at 3:00 a.m. is **not** useful.

Silence and Solitude

> *"Silence is the great teacher, and to learn its lessons you must pay attention to it. There is no substitute for the creative inspiration, knowledge, and stability that come from knowing how to contact your core of inner silence."*
>
> —DEEPAK CHOPRA

Our next aspects of personal self-care are deceptively simple seeming but often the most challenging to implement. For high achieving, action oriented individuals living in today's bustling technology driven world, carving out some daily time for silence and solitude can seem particularly challenging if not downright impossible. I have often found that there is huge resistance in this realm, but I guarantee you that if you can embrace and implement regular periods of silence and solitude into your life, the benefits will be extraordinary both in terms of your overall enjoyment of life and the transformation of your art making. Rollo May recognized that, "Obviously if we are to experience insights from our unconscious, we need to be able to give ourselves to solitude."

The first point to acknowledge is the different realms of silence – having

both an external and internal character. Let's start first with external silence, the easier of the two to attain. When I ask students to identify the types of 'noises' that typically disturb their silence they can quickly generate a list that includes sounds like: the radio, computer, TV, traffic sounds, human voices talking, laughing or shouting, construction sounds, emergency vehicles, appliances buzzing, dogs barking and so on.

Open up your sketchbook and create your own personalized list of external sounds that frequently disturb your silence. Next to that list I want you to brainstorm a list of ways that you could create 30 minutes to an hour of quiet time each day. Where would you go to be in the most tranquil environment as possible? Would you go for a walk in a nearby park where the only sounds are those of nature? Would you work silently in your studio with no music playing being careful to eliminate as many external distractions as possible? If you live in a busy city centre, securing some silence might be next to impossible, but you can usually do a lot to help create a tranquil space and some time to create.

One final note about external distractions, if you are one of the myriad of people today who are rarely without a headset on, do yourself a favour and unplug. Being wired for sound cuts you off from powerful sensory information while separating you from the community around you. My goal is to have you live directly and passionately, connecting, listening and responding to the world.

It's rather ironic, but as I am writing this passage on silence the roof on our townhouse is being replaced. Right above my head two guys are making a terrible racket prying off the old shingles with a crowbar. This is followed by loud thuds that literally shake the house, the sounds of footsteps and then, alas, an electric staple gun. Today is particularly

noisy as the landscapers with their lawn mowers, electric trimmers and leaf blowers have joined the roofers and are creating quite a cacophony. I am reminded that while it is sometimes impossible to escape external noise we can create our own peaceful centred space by embracing the spirit of silence and focusing on a silence that emanates from within.

> *"It is when I seem to be doing the least that I am doing the most."*
>
> —LEONARDO DA VINCI

Achieving internal silence is much more challenging than attaining external silence. Some of the noise that disturbs internal silence includes: worry, negative self-talk, being overly critical, dwelling on the past, rehearsing the future and judging others. These states rob you of your concentration, focus, positive energy, creativity, enthusiasm and passion for life along with your ability to be truly present with what you are doing. When you are not present with your creative endeavours they will feel shallow, laboured or superficial. You owe it to yourself and your artwork to create chunks of time where you can be alone and in silence. Take Ralph Waldo Emerson's advice, "Let us be silent that we may hear the whispers of the gods."

SELF-TALK- THE INNER GAME

> *"Evidence is conclusive that your self-talk has a direct bearing on your performance."*
>
> —ZIG ZIGLAR

Before I wrap up this section on silence I want to address the concept of self-talk – negative self-talk in particular. Since I can remember I have always been aware of an inner guiding voice. As a very optimistic and up-beat person it was quite a surprise to me when I started paying close attention to the barrage of negative sentiments that my inner voice would express. The realization that was the catalyst for change

was recognizing that if anyone else in my life said the things to me that I was saying to myself, silently in my head, I would disassociate myself from them immediately! My self-talk included put downs, name-calling, doubt and expressions of fear. My negative self-talk was robbing me of joy, delight, and opportunities to grow and change. Recognizing this habit was enough to start changing it.

Action Steps

"Once you replace negative thoughts with positive ones, you'll start having positive results.

—WILLIE NELSON

1. Tune in to your inner voice and start recording in your sketchbook what you hear.

2. If your self-talk is negative, start to rewrite the script. Your inner game will ultimately make or break your performance, so it is very beneficial to address it early and consistently. Record your 'rewrites' in your sketchbook as well.

EXAMPLES:

NEGATIVE SELF-TALK

"I am such a slow worker, I'll never get this project finished."

REWRITE

"I am a thoughtful, meticulous artist and I complete my works on time."

NEGATIVE SELF-TALK

"You're such an idiot, I knew you would embarrass yourself if you tried that."

REWRITE

"I am courageous and am always trying new things. Failure doesn't embarrass me, it propels me to try again."

Our experience of everything in life ultimately depends on how we think about it. I'm not suggesting that you should always be happy – you need to be real, to assess the truth or reality in a situation, but lose the toxicity. Negativity only breeds more negativity.

Meditation

> "No great work has ever been produced except after a long interval of still and musing meditation."
> —WALTER BAGEHOT

You might want to consider meditation as a great ritual to support your creative life. This would give you an opportunity to focus on breathing, silence and solitude in one powerful activity.

In addition to the psychological and emotional benefits of meditation there are several physical benefits as well. Meditation is an excellent way to relax. Meditating will teach you how to deal more effectively with stress, which will be a tremendous asset as you prepare for college.

There are an infinite variety of ways to meditate, and I encourage you to try a few different approaches to find one that works for you. Most of the time I do a very simple breathing meditation, which I have described in the following Action Steps, but I also enjoy walking meditations, and spending time meditating in nature.

A great little book that I think is a wonderful resource for those new to the practice is *Meditation Week by Week: 52 Meditations to Help You Grow in Peace and Awareness* by David Fontana. I have used this book

as a guide with students in the past and they always had great things to say about it. I encourage you to give meditation a try and then record the date, time and details of your meditation sessions in your sketchbook along with a quick reflection on what you notice. Consider how the process of meditation affects you and your art over time. In his book David Fontana outlines that, "Meditation is thus a form of mental spring-cleaning, or if you prefer, a form of mental purification. It rests and relaxes the mind, develops powers of concentration and awareness, helps us deal with daily challenges with greater equanimity, and assists us to operate more efficiently and effectively".

But it goes much further than this. In a real sense, most of us are strangers to ourselves. Fontana claims that, "Faced with the hectic pressures of modern living, we have little time for self-reflection, and even less time to experience who we are – what lies behind the surface activity that occupies so much of our attention. So meditation is also a path toward self-knowledge."

Try one of the 3 Action Steps below and then return to your art making.

Action Steps

1. Sit or lay down in a relaxed and comfortable position, resting your palms up and open to the sky. Close your eyes. Now simply focus on your breath. You might concentrate on your breath as it flows over the area between your upper lip and nose, somewhere within your nose, or perhaps on the back of your throat. Simply become aware of the rhythm of your breathing - in and out. If thoughts or ideas enter your mind - acknowledge them and let them drift away as you refocus on your breathing. Sustain this focus starting with one minute intervals, gradually increasing your time of con-

centrated breath mindfulness. Becoming aware of your breath is the foundation of all meditation practices.

2. You could try the exercise above with a subtle variation. With each out breath you could say the word "One" or "Om" either silently in your head or out loud.

3. How about trying a walking meditation for a change? Walking meditation is an active form of meditation where the experience of walking becomes your focus. Like all types of meditation practice there are countless variations so experiment with it to find an approach that appeals to you. To do this exercise it's best to be outdoors, perhaps in a park or field near your home, although you can also use this meditation walking through the halls of your school or at the mall. Stand in a comfortable position and become aware of your weight transferring through the soles of your feet into the ground below and deep into the earth. Become aware of your balance. As you begin to walk, focus on your normal pace keeping your attention on your feet. Feel the movement from your heels through your toes. What sensations do you detect in your feet, your socks and shoes? As you continue to walk slowly shift your focus up from your feet to your ankles. Again, what sensations or feelings occur to you? After several minutes of walking shift your focus again to your lower leg, then to your knee, the muscles in your thighs, hips, pelvis, belly, chest, arms, neck and head. Maintain a few minutes of focused attention on each body part as you walk. Relax but stay focused. Finally, focus on any emotions or thoughts that occur. Don't judge or edit - simply notice. To complete your walking meditation, come to a natural halt and simply stand for another minute or two noticing your weight again as it is distributed over the soles of your feet. Take a few deep breaths, bow to the earth, and smile!

Work

> *"In sports and in life, too many factors are outside of our control. The only thing we can control is the action we take. A long-term strategy will lead you toward ultimate success. Keep showing up. Stay present. Stick to the plan.*
> —STU MITTLEMAN

What do I mean when I say "Work"? I mean, when it's time to work - WORK! It never ceases to amaze me how many distractions, procrastinations, and disruptive activities gobble up valuable working time.

One of our greatest challenges is to create chunks of uninterrupted time for our creative endeavors and then to use that time effectively. Too often I see students squander valuable production time with conversations with friends, incessant fiddling with an iPod™ or other piece of technology, trips to the bathroom, snack breaks and random meanderings about the studio. I recognize this behavior because I'm guilty of it myself. I am pleased to report though that it is easy to make positive changes in this area.

Learning to focus and concentrate while working alone and even while working in a communal studio space, are essential skills for any artist. This will also be a tremendous asset to you when you start post-secondary. Strive to discipline yourself to use your creative time effectively. Get in the habit of entering your space and immediately get yourself set up and start working. Don't get involved with conversations, or wait for others to get started; take initiative and lead the way. Knowing in advance what you are going to do really helps. This is one area that really benefits from pre-planning. Your leadership in this area will likely also inspire your friends. Remember, when it's time to work – really work. That way if you use your work time as it is intended, you create more time to relax and play, guilt-free and without stress!

Play

"Improvisation, composition, writing, painting, theater, invention, all creative acts are forms of play, the starting place of creativity in the human growth cycle, and one of the great primal life functions."

—STEPHEN NACHMANOVITCH

It's surprising to me how many young people I've met that have temporarily lost their innate ability to play. I say temporarily because once they start infusing each day with some playtime the joy, release and creativity it provides soon make it irreplaceable and indispensable.

Perhaps it shouldn't come as a surprise though, because as we grow up we are encouraged to do just that, "grow up". Somehow that phrase implies that we should become more serious, spend more time working, and less time playing. Somehow we start to regard play as frivolous and silly, equating playtime with wasting time. We couldn't be further from the truth!

Far from being reserved for children, play is an extremely important activity for humans of all ages. While we often think of play solely as an activity, play is an emotion, an essence, or state of mind. Play can amuse, entertain, delight, divert, occupy, relax, distract, explore and pleasure.

While I am a strong advocate of play for everyone, I feel it is essential for artists and creators. Besides bringing greater joy and levity into your life, play enhances energy levels and is proven to reduce stress leading to greater longevity. As if these benefits coupled with the sheer fun of play weren't enough to convince you to 'lighten up' a little, play is a powerful way to stimulate your imagination, risk-taking and curiosity, all of which are critical aspects of creativity.

When we are engrossed in play we experience a sense of freedom. With

our guards down there is more room to experiment and try new things. During play we can laugh at our mistakes, pick ourselves up off the floor with ease and try yet another approach.

There is also a very curious phenomenon associated with play; particularly play that follows periods of intense focus and concentration. Research and personal experience seem to indicate that ideas abound and problems are solved with ease when the mind transitions from one mode of thinking to another.

Rather than working all day on a painting project or task, break your work periods up with periods of play, activity and movement. These mental breaks inserted every 90 minutes to 2 hours are a great way to help your mind shift its focus. When you relax and play often the answers and solutions you've been struggling to attain magically pop into your mind.

Below are some suggestions for play activities if you're feeling stuck. I'd also love to hear from you about some of your favourite ways to let loose and lighten up. You can email me at nancy@gettinginbook.com

PLAY ACTIVITIES

- Revisit some of your favourite childhood board games just for fun. Try checkers, chess, the Game of Life™, Monopoly™, Boggle™, Scrabble™, etc.
- Put on some great tunes and dance or draw to the music
- Set up an ongoing puzzle project that you can play with when the mood strikes
- Play some card games. Perhaps a little penny gambling would be fun and wouldn't break the bank.
- Play Pictionary™ and draw the wackiest images
- Run around outside playing a rousing game of tag or hide-and-go-

seek. Scream and shout as you run.

- Play with little children and their toys - the younger the better. Perhaps revisit some of your old toys.
- Utilize the playground equipment at your school or local park and swing, slide, hang on the monkey bars, play hopscotch or spin.
- Play memory games using special decks of image cards or trays of objects.
- Go to a beach or sandbox and build some elaborate castles and constructions. When you are done, jump on them.
- Play hackysack, badminton, ping pong, shoot some hoops, or throw a frisbee.
- Rake up a pile of fallen autumn leaves and then run and jump in them.
- Run through puddles creating huge splashes with your feet. You get the idea!

Spiritual Life

"Making art is the closest I get to God."
—RHONDA ZWILLINGER

In addition to maintaining your physical and intellectual well being it is important to know what personal routines or rituals you need to maintain in order to feel grounded, centred and spiritually connected. Make sure that you identify and protect the time that you need to connect with spirit. For some it may be as simple as time spent each week walking in nature, while for others it may mean attending services at a local temple, church, mosque or synagogue. Consider the role that prayer and meditation will have in your daily or weekly schedule and be rigorous in ensuring that you maintain those rituals that keep you healthy, happy, connected and contributing.

GETTING IN! – PUTTING IT ALL TOGETHER

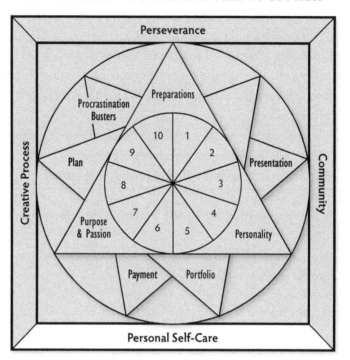

To create lasting change, slowly implement these strategies and prepare to be amazed by their synergizing effects. You will soon be filled with incredible vitality, energy and passion that will help you achieve your artistic and creative dreams.

Part 2
The Power of Creating
Your Art

Chapter 6

Portfolio:
10 Powerful Aspects
of the Creative Process

"The job of the artist is always to deepen the mystery."

—Francis Bacon

At last you have arrived at the portfolio section; the area I love the most! All the work that you have done up to this point including clarifying your purpose, creating a plan and making thorough preparations, along with establishing a proactive personal self-care routine has all been created to support you and your ability to create your art.

Your portfolio is the key component to both acceptance to art school and merit based scholarships. Your portfolio will also be a crucial aspect to your success in attaining a job upon graduation or establishing gallery representation. My goal is for you to have an awesome experience as you develop your portfolio. By that I mean that I want you to grow, change, explore, express and create deeply and authentically, producing works that you feel proud of. I want you to develop your portfolio over a series of months so that you can delve deeply into yourself and your creative process developing pieces that express who you are and what you care about, value and love.

In this chapter you will explore 10 powerful aspects of the creative process, while in chapter 7 you will learn what makes a powerful visual art portfolio including the creation of range works, how to evolve a personal series (PS), ways to develop a process rich sketchbook along with consideration of distinct portfolio requirements and home exams. We will also look at a variety of ways that you can foster and enhance your creativity.

The Creative Process: 10 Powerful Aspects of Expression

"'Creativity' may be the nearest one-word definition we possess for the essence of our humanity, for the true meaning of 'soul'".

—MATTHEW FOX

Presumably this book has found its way into your hands because you are creative. Not only are you creative, but you have decided to foster and develop your creativity, to base your life and career on creativity and the joys and perils that accompany such a path. As a result I think it is important for us to spend a little time considering the creative process – the process through which we engage our creativity and give voice to our experiences of life. In his inspirational book *The Zen of Creativity*, John Daido Loori writes "Creativity is our birthright. It is an integral part of being human, as basic as walking, talking and thinking. Throughout our evolution as a species, it has sparked innovations in science, beauty in the arts, and revelation in religion. Every human life contains its seeds and is constantly manifesting it..."

Over the next few pages we will explore ten states of being and doing I feel are essential for creating in a powerful and authentic way. If your experience is like most people's you will immediately identify areas of your creative process where you feel confident and secure; these are the

areas where you are currently experiencing great success and enjoyment. Review of the aspects of the creative process in this manner will also help you identify areas where you get stuck or bogged down. It might also help you to realize areas of your process that you have overlooked or abandoned.

Creating and the creative process are unique to each individual. Although there are no right or wrong ways to create, each artist needs to identify and foster those rituals, strategies and habits that will support and enhance their ability to create in ways that are authentic, meaningful and enjoyable. If you will open yourself up to the experiential, non-linear and transformational creative process, your life will become an extraordinary adventure.

The 10 aspects you will explore include powerful states of being and dynamic actions. They include: courage, research, attention, curiosity and authenticity. Along with these you will review your process of creating, reflecting, reworking, resolving and sharing.

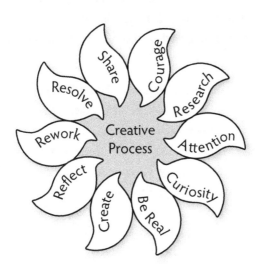

Be Courageous

"In playing ball, as in life, a person occasionally gets the opportunity to do something great. When that time comes, only two things matter: being prepared to seize the moment and having the courage to take your best swing."
—HANK AARON

The most fundamental requirement of a creative life and creating in general is courage. Courage is required to trust, courage is required to be honest and true to your experience, and courage is required to begin. When faced with a blank canvas, a design problem, or a rectangular block of clay, starting can be the most daunting task in the world. We have to temporarily let go of our expectations, hopes and aspirations to bring ourselves fully to the process of creating. We have to be willing to take creative risks – to appear foolish or incompetent to ourselves and others, to express what is true for us even when the truth may be uncomfortable, to risk being unique in a world that tries desperately to have us conform. You see sadly our world is set up to reward those who fit in, comply, adapt, obey, mimic, accept, adhere to and play by the rules. Artists challenge the status quo. They question, dispute, research, examine, listen, challenge, debate, express and stand out. That requires courage.

In his brilliant book *How to Argue and Win Every Time,* Gerry Spence sums it up beautifully when he says " The power of community norms creates boundaries of mind and spirit that stand intolerant of challenge. Early on we have been molded into walking, lumbering, labouring, mostly trouble-free machinery. We have been assembled and fabricated into well-behaved students, predictable consumers, and obedient citizens. Most of what is feral has been domesticated. We suffocate in an amorphous glob of sameness." An amorphous glob of sameness is the result when the forces of the media, institutions, the dominant cul-

ture, our upbringing, and our own limiting beliefs encourage us to dress a certain way to be "trendy", eat and drink certain foods to be "cool", act certain ways to be "accepted", aspire to certain jobs because they are "prestigious", and think and express certain ideas because they are comfortable and acceptable. How boring is that? For our lives and our art to be dynamic, there has to be contrast, diversity and individuality. International best selling author Susan Jeffers encourages you to "Take a risk a day, one small or bold stroke that makes you feel great once you have done it".

Action Steps

"What lies behind us, and what lies before us, are tiny matters compared to what lies within us.

—RALPH WALDO EMERSON

1. To build your courage eliminate any excuses that you are currently using that undermine your ability to have the life of your dreams. Mine your thoughts and "self talk" for any excuses you hear yourself using. Record them in your journal and then rewrite the limiting belief as a new positive affirmation. Then implement it!

2. Do the same thing with any excuses you hear yourself verbalizing.

3. Imagine what could be possible if you removed one of your limiting beliefs. Just imagine. Write down what you could achieve if you abolished the belief.

4. Write these words by Leonardo da Vinci on an index card and keep it by your bed. "Obstacles do not bend me, every obstacle is destroyed through rigor." Start and end each day by embracing that thought.

5. Choose one of your most challenging projects or problems. Brainstorm 50 – 100 solutions or ideas to advance your progress.

6. Try one new thing each day.

7. If you are normally very quiet and reserved in class try speaking up – ask questions, answer questions or voice your opinions.

8. Reflect on your life and art making. In what ways do you play "small"? What steps could you take to start showing up larger in both realms?

9. What medium have you always wanted to try despite the fact that it scares you? How could you experiment with this?

10. Challenge yourself to work larger or loosen up your mark making.

Research

"To me, seeking knowledge is like opening doors. And I know the doors are everywhere."

—GEROGES ST.-PIERRE

"Dig Deeper!"

—SHAUN T

It was challenging to know where to put this section on research, as it is so critical to the creative process and life as an artist. Researching is a dynamic process of engaging, investigating, exploring, searching, studying, inquiring, learning, reading, probing, questioning and examining the topics, ideas or concepts that intrigue you in order to learn, grow and draw new conclusions. Learning is a thrilling process, and artists are continually and constantly learning about themselves, others and the world around them. This kind of learning and research requires an open mind, passion, patience and diligence.

Action Steps

"It is harder to see than it is to express. Seeing takes time; it requires patience."

—ROBERT HENRI

1. Using your sketchbook as a place to store all your research, identify a concept, idea or topic that intrigues you.

2. Define your topic - consult a dictionary.

3. Create a mindmap covering a double page spread in your sketchbook, writing your topic in the centre of your page. Write out as many related ideas as you can think of branching them off your central idea. Continue to build your web over the coming weeks and months.

4. Write out a list of synonyms of your topic.

5. Write out any antonyms for your topic.

6. Collect 6-10 quotes about your idea.

7. Write a poem about your concept.

8. Research 4-10 books and/or articles written about your topic. Simply list them for now.

9. See if you can find any current events that connect with your topic. Continue to add all of this research to your web.

10. Create a list of experts that you could interview about aspects of the idea you are researching. Gather their contact information and connect with them.

11. Discuss your idea with family and friends, listening to their views and ideas.

12. Read deeply and widely about your topic.

13. Write 2-3 similies about your idea.

14. Write 2-3 metaphors about your concept.

15. Ponder your idea when you are relaxing.

16. Is there a course that you could take that would help you understand your topic on a deeper level?

17. Is there some volunteer work that you could do to help you delve deeper into your idea?

18. What subjects or objects could you use in your art making to represent your investigation as it develops?

19. What art materials come to mind when you contemplate your topic?

20. Write out as many questions as you can think of regarding your concept.

21. Highlight 3 of the most interesting questions and keep digging deeper into those questions.

22. What are your personal experiences with this topic or idea? Why is it relevant to you?

23. Draw your ideas.

24. List other strategies you could use to learn about your topic.

25. Be open to learning in a variety of ways and from a variety of sources. Share your learning and excitement with others. Post your findings on a variety of online forums and initiate a conversation!

Be Attentive

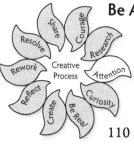

"The only real voyage of discovery consists not in seeking new landscapes, but in having new eyes."

—MARCEL PROUST

A big part of the reason for fostering solitude and silence as part of your self care routine is to help you become more attentive – to your external surroundings, your various forms of research, and the stirring of your soul. Being attentive implies being open to experience sound, taste, touch, smell, and sight; being aware of the rich sensory world that surrounds you and the myriad of responses that the senses evoke. It means being open to resonance – that flicker of a feeling that attracts you to one thing over another. Resonance is a spark, a fleeting sensation that helps you identify the things that beckon to you. Resonance encourages you to look a little longer, listen more intently, wonder and question. As I like to say to my students, "Notice what you notice!"

It's very easy in our fast paced world of sensory and technological overload to lose our ability to be attentive. Our overstimulation leads to an inability to focus and concentrate, and we lose sight of ourselves and our genuine experiences in a blur of days that pass seemingly without our notice. Sarah Ban Breathnach said, "an artist is merely someone with good listening skills who accesses the creative energy of the universe to bring forth something on the material plane that wasn't here before." When you are attentive, you listen both to what is said and what is unsaid. Attentiveness generates curiosity, wonder, amazement and a sense of the mysterious. Attention is the fuel for your art making and an exciting life.

Almost 500 years ago Leonardo da Vinci lamented that the average man "looks without seeing, listens without hearing, touches without feeling, eats without tasting, moves without physical awareness, inhales without awareness of odour or fragrance, and talks without thinking." What a tragedy! Each day we are served up a cornucopia of sensory delights and experiences that remain for the most part unnoticed or under appreciated. Our goal as artists is to tune into the incredible senses that we have been blessed with and to refine and develop them. The result

will be an enhanced experience of life and rich perceptions that we can draw from to create our works of art. Notice what you notice.

 Action Steps

"In a way nobody sees a flower really, it is so small, we haven't the time –and to see takes time, like to have a friend takes time."

—GEORGIA O'KEEFE

1. Choose one common scene out of your daily round and describe it in detail including as much sensory information as possible. What have you tended to overlook in the past, and how has your new awareness enhanced your experience? Now create an art piece to celebrate the scene.

2. Become a connoisseur of a particular food or beverage – (this could be anything: apples, tea, chocolate, rice, etc.) Start your own on-going research of your chosen item. Learn and savour it as much as you can. Compare and contrast. Enjoy! How could you document this research visually in your sketchbook?

3. Read Diane Ackerman's book *A Natural History of the Senses,* and record some of your learning in your sketchbook.

4. Go with a friend or two to a restaurant to try a new type of ethnic cuisine. Perhaps you could try Indian, Vietnamese, Italian or Thai food. Record any new spices or taste sensations that you experience. After you've finished your meal, sketch your view of the table complete with your friends, restaurant context, dirty dishes, crumpled napkins, etc.

5. Attend a symphony or musical performance. Close your eyes during the performance to focus on the sounds and texture of the mu-

sic. Record how this changes your experience. Bring your sketch-book along and draw with your eyes closed, moving your hand to the music.

6. Have a section in your sketchbook labelled "What I Notice", and record your thoughts and reflections. What catches your eye, sparks your interest, delights?

Be Curious

"The important thing is not to stop questioning. Curiosity has its own reason for existing. One cannot help but be in awe when he contemplates the mysteries of eternity, of life, of the marvellous structure of reality. It is enough if one tries merely to comprehend a little of this mystery every day. Never lose a holy curiosity."

—ALBERT EINSTEIN

Anything can be interesting if you'll give it a try, so learn something new! Explore! If you are excited about life and are open to its many possibilities I guarantee you that your life and your art will become richer, more interesting and fun.

I want you to imagine that you are a renowned explorer or archaeologist setting off on your latest adventure. Your quest is to find hidden and buried treasure in distant lands. Ironically, you are both the explorer and the distant land laden with riches beyond compare. Your job is to dig, explore, study, investigate and discover. Being curious is a very active state filled with uncertainty and surprises that will require you to be patient and diligent. Making new discoveries takes time but it is both thrilling and rewarding. As the French writer Andre Gide wrote "One does not discover new lands without consenting to lose sight of the shore for a very long time." I think that he is right. We must be

prepared to let go of the comfort of our old ways of doing things to explore new possibilities.

Action Steps

"Do not go where the path may lead, go instead where there is no path and leave a trail."

—RALPH WALDO EMERSON

1. Write out a list of at least 25 topics or ideas that you are curious about.

2. Choose one item off your list and get started. Research it, try it, draw or paint it, experiment with it and have fun.

3. Record what you did and your response to the action in your sketchbook.

4. Write out another list of 25 everyday objects or items. The items on your list should include objects that seem rather boring or banal and are readily overlooked. Examples might include items like:

 • A partially used tube of toothpaste
 • Tea bags (preferably used)
 • Discarded pieces of technology – an old cell phone, computer or MP3 player

5. Referring to your list, choose one of those items or objects to work with for a week. Research it, brainstorm, and create 20 small images in your sketchbook within that week. Really push your idea generation.

6. Choose one of your small-scale studies to work up as a range piece for your portfolio.

7. Then choose another item off your list and repeat the process.

8. Identify something that you have always been curious about but were afraid to try – then TRY IT!

9. Keep your sketchbook or journal with you at all times to write down any thoughts, ideas or questions that cross your mind.

10. Read at least 30 minutes a day, and try reading in a genre or field that is completely new to you. Perhaps you could read poetry or some artist biographies.

11. Learn one new word a day and try to use it 3 times.

12. Start to plan a trip to a destination that you have always wanted to explore. Research it online or visit your local travel agent to gather information. Eventually, you may go there – but for now just be curious.

13. Drive, walk or take the bus to a part of your city or town that you never visit. (Make sure that the area is safe to stroll, and perhaps bring a friend along.) Go for a walk in the area, using a digital camera and your sketchbook to document your adventure.

Be Real, Be Yourself

> *"Be yourself. Everyone else is taken."*
> —OSCAR WILDE

What a simple request – just be yourself. It's a simple request that is deceptively challenging. Discovering who you are, what you aspire to be and what you value are the questions that you will live throughout your life. Who we are is a dynamic, diverse, changing, unique bundle of hopes, dreams, predispositions, habits, loves, values and beliefs. Your identity is not static. Who you are changes over time, changes through circumstance, changes with the decisions that you make and the thoughts you encourage, and changes with the level of consciousness you bring to your daily life. Author Sue Bender explains that, "Listen-

ing to your heart is not simple. Finding out who you are is not simple. It takes a lot of hard work and courage to get to know who you are and what you want."

Don't concern yourself with trying to be unique or original – concern yourself with being real and authentic. Learn to trust and value your own experiences and opinions heeding the advise of Irish poet and novelist James Stephens, "Originality does not consist in saying what no one has ever said before, but in saying exactly what you think yourself."

By the very nature of your being – you are unique. No one in this world has ever been or will ever be just like you. Think about that! You are unique physically, intellectually, emotionally, and spiritually. You have had a set of life experiences that are also unique. Your goal is to identify and foster that uniqueness – those things that make you – YOU! Success and personal development writer Orison Swett Marden said, "The golden opportunity you are seeking is in yourself. It is not in your environment; it is not luck or chance, or the help of others; it is in yourself alone."

Hopefully, you are beginning to realize the synergistic connection between all the aspects we've considered so far. Being yourself requires you to be courageous, attentive and curious. It requires you to tune in, identify and honour your unique take on the world, and to express yourself using your unique skills, abilities and gifts to tell your story honestly and with passion.

 Action Steps

"The ultimate end of human life is to become everything you are capable of becoming."

—ABRAHAM MASLOW

1. Buy an ink pad from a stationary or dollar store. Create a large-scale tonal self-portrait using your inked fingerprint as your medium. (Your fingers might be blue or black for a few days but it will be worth it!) You might look at the finger print portraits created by Chuck Close as inspiration.

2. Put your fingerprints somewhere on the first page of your sketchbook as a reminder of your unique nature, and to reinforce your quest to preserve that uniqueness.

3. Use your signature as a point of departure for a series of abstract works. Write your name as you normally sign it. Using a photocopier, enlarge your signature several times larger. View find 3 different abstract compositions within your signature and work these linear compositions up using your favourite media and techniques.

4. Each morning when you rise create a 5 minute gesture drawing of yourself in your sketchbook, bed head and all.

5. Try drawing using various body parts to hold your medium. Draw with each hand, your feet, your mouth, the crook of your elbow or knee.

6. Create a self portrait using your hair as a medium. (Don't shave your head to get your materials together, simply collect your hair trimmings over time.)

Create

"I am always doing that which I cannot do, in order that I may learn how to do it."

—PABLO PICASSO

The first five aspects that we have covered so far are very psychological in nature and are sometimes difficult to detect. It's not always easy to know at a glance if someone is being courageous, attentive or true to him or herself. These are very personal states that manifest both internally and externally. Ultimately, these states influence everything that we do – from the art that we create to the quality of the relationships we have with ourselves, others and the world.

Although all 10 aspects are active and dynamic in nature, your ability to create, reflect, rework, resolve and share will separate you from the masses who never manage to rally their creative impulses into action, leading lives that are tragically unfulfilling. As David Salle has pointed out "It's easy to be an artist in your head." Thinking like an artist is not enough, an artist has to summon their courage, curiosity, observations and authenticity to produce and ultimately share their thoughts, ideas and expressions with others. Joseph Conrad knew "An artist is a man of action."

The production phase is the doing - the drawing, painting, stitching, sculpting, weaving, and designing. It's the time to do, to create with wild abandon. It is through our self-initiated creating that we conquer our fear and build the bridge between others and ourselves.

Action Steps

"Anything worth doing is worth doing poorly – until you learn to do it well."

—STEVE BROWN

1. Set up some regular time in your schedule to simply create. Leave the critic outside the studio and just go at your artwork as if it were play. Draw, paint, sculpt, sew, take some pictures...you name it.

2. Change things up with your creating. If you usually only work with 2D materials such as drawing media and paint, experiment and create with some 3D materials, work with clay, plaster, or found objects.

3. If you normally work seated at a desk, try standing to create your next piece of work.

4. If you never work with your non-dominant drawing hand - give it a try.

5. Give yourself some fun creation deadlines. Purchase a series of small post-it note pads in assorted sizes and colours. They might range in size from 1.5″ x 2″, to 3″ x 5″ pads. Starting with your smallest pad, turn each piece of paper into a mini artwork. Complete the post-it note pad in one day. How can you display your collection in an interesting way? Challenge yourself to complete one post-it note pad per day for one week. Wow! That will be about 500 - 700 mini works in a week - awesome and fun!

6. Don't get hung up on your work being permanent or enduring, simply create. Draw on a steamed up mirror, in the sand on the beach with the tide coming in, or with pebbles in the dirt. Photograph your creations just for fun.

Reflect

"I cannot expect even my own art to provide all the answers – only to hope it keeps asking the right questions."
—GRACE HARTIGAN

As you explore your creative process you will notice that there are times to create and times to reflect and rework the pieces that you start. Each of these aspects should be kept separate so that they don't cancel each other out. One of the most effective life skills you can learn is how to leave your inner editor and critic outside of your creating space or studio until you intentionally call on them. Your goal should be to create freely and openly, tapping into your creative flow or intuitive wellspring. While you are working and producing you will be thinking, questioning and making an infinite number of decisions, but these decisions will often be taking place on a subconscious level. That is a natural part of the creative process.

Reflecting is when you break out of the flow of creating to stand back from your work and look at it objectively. This is the time to question how things are evolving and working. This skill requires you to try to see your work as others will see it, not as the creator. This is not easy to do at any age or any stage of artistic development. The tendency is to be either overly critical of your efforts or narcissistic where you fall in love with your every mark. The reflecting phase is an important time to question the things that happened during the production or creation time and revisit your initial idea or concept. Assess whether you have supported or enhanced your idea through the way you have handled colour, texture, scale, and the other elements and principles of design. Evaluate your composition, your mark making – essentially everything that you see going on in your image.

At this phase you may want to include others as well to hear their assessment and critique. Try to distance yourself from the work emotionally. If you equate yourself with the work, any negative comment or critique will feel like a personal attack. Instead, try to view the work as separate from you and seek out those people who will give you honest feedback. Your goal is to grow, learn and improve in order to take the work to a higher level.

Action Steps

1. Choose a piece of work that you currently have underway and spend a few minutes studying it. See if you can assess whether the piece is working effectively or not. Ask yourself a lot of questions.

2. Ask 2 people to give you some feedback on that same piece of work. Rather than asking them what they think of the piece, ask them for 2 suggestions to strengthen or improve the work.

3. Self reflection is a real skill. You can build this skill by reflecting on your efforts in several areas of your life including your art making, relationships with others, or your work ethic as a student or employee.

4. In addition to being self reflective, make it a practice to seek out the critique of others who you trust and admire. This is an incredible way to enhance and speed up your growth and development.

Rework

> *"There is only one way to succeed at anything and that is to give everything."*
>
> —VINCE LOMBARDI

Cycles of creating and reflecting are always accompanied by periods of reworking. Reworking is a catch-all term that might mean refining, adding to the work, subtracting or editing out, starting over, or abandoning it all together. The point is to be open to any and all consequences. Reworking a piece is like editing a piece of writing for any spelling or grammatical mistakes along with checking for flow of content and understanding. Reworking your art is the visual equivalent. The fine line is to learn when enough-is-enough and avoid the tendency to overwork your pieces. John Daido Loori describes the process beautifully when he says, "The editing process begins with reconnecting with the feeling, the resonance, that was present during the creation of the work of art. Then, we slowly and deliberately remove the unnecessary elements, without disturbing the feeling of resonance. If the resonance weakens, we've gone too far."

Action Steps

1. Choose one work that you currently have underway. Brainstorm a list of 6 different ways you could rework the piece to give you 6 very different results.

2. Look around your studio for some of your in progress works. Take a few minutes to re-evaluate each one, deciding how it could be reworked.

3. Rather than thinking of what you could add to a piece to complete it - see what you could edit out or remove to strengthen the work.

4. Don't be afraid to abandon or destroy a really bad piece of work. Write it off as part of the learning process and reuse the paper, canvas or materials.

Resolve

"The reward of a thing well done is to have done it."
—RALPH WALDO EMERSON

Our ninth aspect of the creative process is resolve. This phase implies completion – one of the trickiest aspects of the entire process. Most of us start projects. We start drawings and sketches with visions of grandeur for clothes we will sew, products we will design, characters we will animate and sculptures we will carve. If your portfolio or studio is anything like mine it may already be cluttered with half finished paintings and numerous assorted projects that we claim we will finish 'one day.' But that day never comes. Why is it so difficult sometimes to finish things?

I think that part of the challenge in completing something is that it is a process of closing the gap between the work as we envisioned it and the reality of what we have created. Stating that we are done somehow implies that we are content to let the work stand as it is – and that is scary. Sometimes if the work falls short of our expectations we don't want to admit that we are unworthy or unable to make the piece everything that it could be.

Another reason that finishing a project is challenging is that we can run out of inspiration, motivation or enthusiasm for the work. When the rush of the new thing is over, it can be challenging to maintain and intensify our interest or passion for the concept or the work itself. The ability to stick with an idea and dig deeper, pushing yourself to explore and produce is a sign of maturity. Responsibility, and commitment can be subtle but powerful themes that emerge from your work, showing your ability to carry through an idea from "spark" to finish.

Some of the main reasons students have told me that they didn't complete things include:

- They lost interest along the way
- They were too stressed to work due to their procrastination
- They let obstacles break their determination
- They gave up because they didn't feel they had the ability to 'pull-it-off'
- They felt overwhelmed by too many desires and interests
- They lacked focus or prioritization
- They had fear around calling a project complete or done because they were worrying about the final phase of the creative process cycle – the sharing– and were already fearing rejection or negativity.

I think that one of the most powerful antidotes to not completing things is to shift your focus from the project itself, to what you have learned and how you have grown through the process of creating it. Regardless of the success of the piece itself there is always learning that has taken place. Celebrate your learning, growth, experimentation and risk-taking and then immediately re-engage with the process of creating, moving quickly to your next piece. Focus on progress, not perfection!

Action Steps

1. Choose one piece of work that you currently have underway, and brainstorm 3 different ways that you could resolve or finish the work.

2. Draft up a quick list in your sketchbook that includes some of the reasons why you have left things unfinished in the past. Are there any works that you need to go back and complete?

3. In addition to new works that you are creating, jot down a quick list of all your unfinished works and what you need to do to complete them. Target one piece a week to fully resolve. This will feel great, and is a real self confidence booster.

Share

> *"The secret to living is giving."*
> —ANTHONY ROBBINS

So what's next? You've had the courage to spend time in solitude and silence, being attentive and curious to the flashes of resonance and inspiration that are continually whispering to your soul. You've taken action and produced deeply, honouring your unique ways of viewing, understanding and portraying the world. You've taken time to reflect and rework your pieces, listening to critique and feedback from yourself and others. You have arrived at a place where you can say, "It's done"... so now what?

Now, is the scariest step of all – sharing with others. This sharing is a form of communication between you and your intended audience. Some works are simply for practice, some works are simply for fun to keep you playing and experimenting – but for the vast majority of your works there will be an audience and an intended outcome. That audience may be an admissions representative from a school that you are applying to, your family and friends, your art teacher, a prospective client, a gallery owner, a scholarship committee, the general public, or someone who is interviewing you for a job.

In order to share your works effectively, additional steps need to be taken following the completion or resolution phase. Some of those steps might include:

125

- Preparing the works for viewing including cropping, matting or framing
- Preparing the works for hanging or exhibition
- Titling the works where appropriate
- Preparing an artist's statement or design brief to accompany the works
- Photographing or documenting the works for your portfolio, a web site, or other electronic presentation
- Organizing your portfolio for effective flow and sequence

Many of these steps will be expanded on in chapter 10 on Presentation: Multiple Modalities for Sharing Your Work.

Action Steps

"When you cease to make a contribution, you begin to die"
—ELEANOR ROOSEVELT

1. Brainstorm 3 exciting ways you could share your latest series of works with a larger audience.

2. Brainstorm a quick list of what you need to do to get your works ready for sharing. Then get going!

3. Create some external deadlines for yourself by organizing some exhibitions of your work. These exhibitions might be within your school or at a local café or gallery that is interested in showing your work.

4. Give yourself a deadline to upload your works onto a digital or virtual gallery, personal blog or website.

5. Have some postcards or gift cards printed featuring your artwork. The point is to get your work out there in as many ways as you can.

Getting In! – Putting It All Together

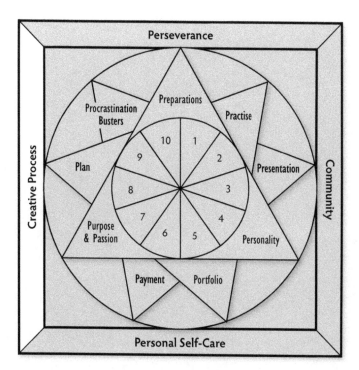

You are an amazing, unique, creative spirit - why don't you go to your studio and make something!

Chapter 7

Portfolio: The Product
– What is a Visual Art Portfolio?

*"Every artist dips his brush in his own soul,
and paints his own nature into his pictures."*

—HENRY WARD BEECHER

A portfolio is a collection of works that reflects the person who created it. It reflects your technical mastery, conceptual abilities, work ethic, interests, thinking, problem solving skills, idea generation and personality. A portfolio can mean many different things to different schools, so it is very important to review each school's specific portfolio requirements. Generally, a portfolio will consist of eight to twenty works and be submitted either in slide form, as digital files, original works or prints.

The media, techniques and processes used in the portfolio works are virtually limitless, as are the themes and ideas explored. The most important considerations are that the works are original, meaning not copied from magazines or other sources; that they are personally relevant reflecting your ideas, concepts or 'take' on the world; and that they demonstrate your thinking, problem solving abilities and creativity.

Developing a portfolio of works takes time. It's not something that can be thrown together quickly, and should ideally be thought of as an ongoing process where works are developed and created, added to your portfolio, and then replaced by stronger works that are created at a later date. Your portfolio should always be in a state of flux being edited and updated at regular intervals throughout your high school years, college program and professional life as an artist.

You might also discover while preparing for your college applications that you need to create multiple portfolios, each a little different than the next reflecting the specific criteria for each school. I encourage you to start building your portfolio as early as your grade 10 year. Your junior years of high school are an ideal time to build your technical skills including:

- The ability to draw a variety of subjects from direct observation
- Render light and shadow effectively to create the illusion of three-dimensional form
- Draw in proportion
- Render perspective
- Work effectively with colour, understanding colour theory and colour mixing
- Work with a variety of image development strategies
- Create expressive and varied mark making
- Understand and demonstrate powerful compositional strategies
- Comprehend and work with the elements and principles of design and

- Start exploring topics, ideas and concepts that are personally exciting and relevant

Your senior years are ideal for continuing to hone your technical skills while expressing authentic and meaningful ideas in powerful series of works.

Action Steps

Collect any works that you have already created that you feel are portfolio quality. List the works in your sketchbook and respond to the following questions.

1. What does this collection of works communicate about you? (List 5 things that the body of work says about you – either artistically/creatively, technically, conceptually –as a thinker, or about your work ethic.)

2. Are you excited about what your works say about you? Why or why not?

3. List 5 things that you want your portfolio to say about you. For example:
 - Bold – takes creative risks
 - Willingness to embrace a challenge
 - Innovative
 - Outstanding technical mastery
 - Highly creative as evidenced through media experimentation, compositions and subject matter
 - Prolific – generates a lot of work
 - Care and attention to detail
 - In depth visual investigations – deep thinker
 - Advanced problem solving skills, etc.

4. List 2 of your current strengths that will help you with your artistic aspirations and goals for the future. (These may be either character traits, artistic skills, or work habits.)

5. List 2 of your weaknesses that inhibit you from producing your best works. (Again, these may be either character traits, artistic skills, or work habits.)

6. How can you continue to improve both your strengths and weaknesses? Write out 3 actions that you can take to improve both your areas of strength and weakness.

Range: Finding Meaning in Artistic Diversity

"Art is idea. It is not enough to draw, paint, and sculpt. An artist should be able to think."

—GORDON WOODS

Just as the name implies the range section of your portfolio should show your breadth and range as an artist. This is the place to explore a wide range of materials, techniques and processes, along with diverse subject matter.

The works in this section should show:

- Strong technical skills
- Powerful compositions
- Proficient use of a range of media (minimum of 3 different)
- Evidence of strong observational work
- Innovative ideas (in all of the listed areas)
- Your diverse interests
- Originality

Although this section of your portfolio often consists of art class projects, try to include some self-initiated works that relate to your interests

and ideas as well. Even with a set class assignment I encourage you to come up with ways to personalize the project to both meet the criteria of the assignment and to reflect your unique take on the piece.

Below are some lists of different media, techniques, processes and approaches that you might want to consider as you create your works. The key will be to combine these in interesting and unique ways to express yourself creatively. You will also find an outline of several image development strategies that you could use to evolve and refine your image making and idea development. Finally, you will find Range Project ideas broken down into 10 different subject categories.

Media, Techniques and Approaches

> *"When I am working on a problem, I never think about beauty. I think only how to solve the problem. But when I've finished, if the solution isn't beautiful, I know it's wrong."*
>
> —BUCKMINSTER FULLER

For an extensive list of media, techniques and approaches that you might want to explore through your art making, please refer to the www.gettinginbook.com website on the art materials page.

Image Development Strategies

> *"Nothing is interesting if you're not interested."*
> —HELEN MACINNESS

Just as the name implies image development strategies are a variety of approaches you can consider and work with as you develop your personal imagery. When I'm feeling blocked or stuck I'll read through the lists below and ideas will start to flow.

These strategies can become very powerful if you use them to support and reinforce the ideas and concepts that you are developing. When you look at artwork, see if you can initially identify the image development strategies that the artists have selected to work with. Secondly, articulate how these strategies enhance the images and push the ideas. Understanding these strategies adds to your artistic vocabulary and competence.

If you go to the web site you will find all of these terms on a handy mini-poster that you can download and post in your sketchbook and studio.

CHANGE YOUR PERSPECTIVE OR VIEWPOINT

Aerial bird's eye, above, eye level, below, looming, under, diagonal, x-ray, interior dissection, fish eye, multiple views, cubist approach, askew, tilt, profile, make symmetrical or asymmetrical, silhouette

CHANGE YOUR SCALE

Enlarge, create life size, magnify, diminish, miniaturize, shrink, change relative scale - one object to another

MANIPULATE YOUR IMAGE

Weave, combine or juxtapose, crop, beat, enclose, distress, disguise, wrap, burn, superimpose or layer, evolve, blur, give it soft focus, personify or animate it, obscure, hide, erase, paint over, reveal, manipulate it's texture, emboss, add to it, distort, isolate, 3-dimensionalize, simplify, repeat, freeze, fragment, dip, view find, view through a filter, view through a microscope, stylize, pixilate, mosaic, symbolize, use text, put it into words, change its colour, twist it, make it uncomfortable or comfortable, crease, fold, twist, crumple, tear, chip, open, impress, smear, rotate, suspend, heap, scatter, enclose, bury, dilute, and shock or surprise.

Range Project Ideas

1. FIGURE DRAWINGS – NUDES, DRAPED OR CLOTHED

One of the most thrilling and engaging subjects to draw is the human body. It is also the most challenging. It is incredibly challenging in part because we can immediately recognize any problem with our works due to our familiarity with the subject. We have lived all of our lives studying human bodies and interpreting their gestures and movements. In a split second we know if our proportions are off, limbs are distorted or if the figure looks like it is floating or teetering precariously. Drawing the figure well takes practice – **lots of practice.** This ability to render ourselves is worthy of our attention as it is a unique gift. Humans are the only living creatures bestowed with the ability to depict their resemblance. How wonderful! The ability to render the human form is so valuable that one of the main summer programs that I offer each year is called *The Human Figure Intensive* – a two week program where participants work from the human skeleton, plaster casts depicting the muscles of the body, and a variety of male and female models. I encourage you to seek out and attend any figure classes you can find.

My tips to you would be to:

- Work large – 18″ x 24″ paper minimum
- Work with the entire figure from head to toe before you start drawing view-found segments or details
- Use a bold mark making material such as charcoal, graphite sticks, india ink or large felt markers
- Be bold and make strong marks – a bold misplaced mark is always preferable to a timid, tentative mark. Just keep drawing until you think you've captured the line or contour. (If incorporating mis-

placed lines into the drawing was good enough for Michelangelo
– it's good enough for you.)
- Ground your figure so that it doesn't appear to be floating, suggest the base or drapery under the figure along with a shadow
- Reference the space that you are drawing in, including the light stands, easels, other artists, studio equipment, etc.
- Avoid placing the figure in the centre of the page – consider your composition

If you don't have access to a figure drawing class working with nudes, don't let that be an excuse not to work with the figure. You live in a world surrounded by people. Draw your family and friends. Draw at school. Go to an airport, shopping centre or café and draw people in context. Organize a Saturday session with a couple of your art friends and take turns drawing one another. Perhaps you could be curled up with a good book, or sprawled out on the couch watching TV. While you rest and relax, your friends draw, and then you switch it up. Remember to draw the surroundings or context.

2. PORTRAITS AND SELF-PORTRAITS

Along with your figurative works it's always a good idea to include a portrait or self-portrait in your portfolio. This is an ideal opportunity to communicate something about yourself or the person you are depicting beyond physical appearance. It is a chance to express character, individuality, emotions, hopes and thoughts. There are many ways that you can tell a story by considering the following factors:

- What the person is wearing
- The environment the person is in
- Placement of the face or figure on the page
- Perspective taken of the face or figure

- Expression and body gestures of the figure
- Objects the figure may be holding
- Scale of the figure to its surroundings
- Media used
- Colour scheme of the piece
- Techniques or processes used (gesture, tonal, expressive, etc.)
- Approach taken with the face or figure (representational, abstracted, distorted, animated, simplified, etc.)

Try to avoid creating a boring, centered, head on view of a head or figure with a vacant expression. Remember -tell a story.

3. STILL LIFE WORKS

Too often when students hear that they should include a still life in their portfolio they set out to gather up a few things, often fruit, vegetables and flowers, or a couple of ornate bottles and they set them up in some contrived manner on a piece of drapery. They do this because they have seen other people do this. If you think about it – if it's not moving, it's a still life. Forget about setting anything up! Simply look around your environment and draw segments of your life and collections of your stuff. Share with your viewers what you value, treasure, collect or hoard. Show us how you live. Another idea might be to create some 3D objects using clay or sculpy and draw from that!

- Draw the cluttered mess on your desk just as it is and do your homework in another area while your piece is in progress.
- Open up one of your drawers and draw the dresser or desk along with the drawer and its contents. The drawer you choose and how it is organized will communicate something about you – which is the whole point.
- How about drawing your bedroom floor and the chaotic piles of

clothes and shoes that are tossed about? (Yes, I know they are there!)

- Draw your closet, the contents of your purse or knapsack, the inside of your locker, your bathroom counter with its myriad of lotions and potions.
- Draw one of your "collections".

With all of these still life works remember to consider your composition and perspective. Try to take an interesting view on your scene creating drama, surprise or delight.

4. DRAPERY AND COSTUME

Even though drapery could be listed under still life explorations I'm creating a separate category for it. Learning to draw drapery; the folds and creases of different materials is a great skill to have in your artistic repertoire, and a powerful way to add drama, mystery, intrigue and symbolism to your work. Again, see what creative ideas you could come up with to work with the following:

- Clothes and jackets
- Bathroom towels and face cloths
- Bedding and linens, pillows and quilts
- Cloth bags, purses and soft luggage
- Flags or banners
- Tents, awnings, and tarps
- Rags (clean or dirty)
- Kitchen cloths and tea towels
- Sports uniforms, work out gear and bags
- Work uniforms or outfits that carry meaning or significance.

As you are working on your ideas, analyze the drapery studies of Leonardo da Vinci for inspiration and delight. He created breathtaking

works using both silverpoint and tempera paint on linen. Again, try to use fabric and drapery to tell a story. Consider what ideas you can portray or symbolize using cloth.

Once you feel you have some comfort working with drapery you might want to explore the exciting and dynamic world of costume. If you think about it, we dress in costume everyday by choosing certain pieces of clothing from our wardrobes and combining them in particular ways. This in turn communicates to others something about our personality, personal taste, social status and culture. Like it or not, how we package ourselves speaks volumes.

Take some time to consider some different images you could create focusing on costume to help you communicate your ideas.

- Look around your school and local community to see how different groups create identity through shared dress patterns. Simply notice, reflect and journal in your sketchbook. How do the stereotypical goths, punks, skaters, jocks, business people or teachers dress? What interests or intrigues you? Can you get someone or a group of people who dress differently than you to pose for a dynamic portrait? What do they want their dress to communicate? What does their dress communicate to you? What do you want to communicate to others about this?
- Can you arrange to sketch on the sidelines of a dance practice, theatre rehearsal or sports event? Check out the pastel drawings of Edgar Degas for inspiration.
- Go to a costume museum or fashion show and draw on location.
- Consider how uniforms are an important aspect of many careers and professions. Think about arranging a drawing or photography session at a fire hall, police station, hospital, grocery store, gas station or cattle ranch. How can you tell a story by how you compose

and portray these individuals in uniform?

- Design your own costume for a super-hero that you create from scratch. Consider form, function and context in your image.
- Could you organize an art adventure with a couple of friends to attend a circus, Cirque du Soleil performance, an opera, ballet or musical? Remember, have fun with this!

5. INTERIOR SPACES

Once again, I want you to consider how you can tell a story with this piece. Where do you hang out? Where do you spend your time? What are your important places and spaces? How can you depict this environment in an interesting way to express something about how that place makes you feel?

- Will you draw your bedroom, kitchen or family room?
- How about drawing in an unlikely room of the house such as the bathroom, crawl space, furnace room or garage? These spaces are great for textural diversity.
- What about working with your classroom or studio space at school?
- Inside the public library where you study?
- One of the alleyways or downtown streets in your city? (Depending on your city this may or may not be a good idea – use your common sense.)
- Outside the 7/Eleven® (Just joking – although it could make for an interesting piece.)

6. LANDSCAPES - THE NATURAL ENVIRONMENT

Spending time in nature is a great way to reconnect with the natural rhythms, patterns and energy of our ultimate home – planet Earth. It is also a powerful way to observe the incredible beauty and diversity of

the natural world. Under the broad category of landscapes you could consider beachscapes, jungles, forests, river scenes and skyscapes among others. Again, work with a landscape that is relevant to you. A series of works depicting the view outside your bedroom window over the course of the seasons could be incredibly powerful. To this end you could look at Monet's paintings of haystacks, water lilies or the Rouen Cathedral that were created during different times of the day and different times throughout the year. Try as much as possible to work from direct observation over photographic reference, even if it means you start with a quick sketch or painting that gets worked up in more detail in the studio.

- Spend a day at the beach with your friends. Build some sand castles or structures near the waters edge and then record your creations and their demise through a series of works.
- Choose a landscape that has personal significance for you. Over the course of the next 12 months depict your landscape a minimum of 4 times highlighting its change through the seasons.
- You may want to create a piece that explores pollution or environmental devastation in your area. What emotions do you want to convey?
- Change or alter your usual perspective on your local landscape. How does it change if you lay on the ground and look at it from a worm's eye view? How is it different from an aerial perspective? What about a microscopic detail?
- How about depicting a natural force? How could you share your experience of a windstorm, fire, movement of water currents or waves or a torrential downpour of rain?
- Could you make a sound recording of a space or place and respond to that with a visual piece?

7. LANDSCAPES - THE BUILT ENVIRONMENT

In this category of subject matter I want you to focus on the man-made or built environment. This will give you an opportunity to show your handling of perspective and space. It is also an excellent way for you to share information about where you live, along with some of your travels.

- Choose one of your favourite streets in your town or city. Consider how you could render it to express what it is you love about it and its architecture.
- Working at the base of a tall structure, create a piece that celebrates its verticality.
- Find an abstract composition in the reflection of windows and paint it in large scale format.
- Create a work that not only shows where you live, but how you feel about your home.
- Use your travels (near and far) to generate works showing a variety of different environments.

8. ANIMALS

Since the beginning of time humans have been fascinated with animals and depicting them through art. Their forms and movements – so unlike our own - are both delightful to observe and challenging to draw.

Where students tend to go wrong in working with animals as subjects is that they tend to work from photographs rather than life, and they overlook the importance of personal experience and relevance. You may think that giraffes are incredibly interesting and amazing, but unless you've seen a giraffe first hand and had experiences with giraffes, it is unlikely to be a great subject for you to explore.

Fortunately, even if you don't have your own pet there are many ways to explore, observe and render animals in a variety of ways.

- Visit an area near where you live where birds tend to congregate. This might include crows in a tree, pigeons in a park, or ducks and geese in a pond. Fill individual sheets of paper with multiple studies of the birds trying to capture their varied movements and gestures.
- Take a day trip to a local zoo or aquarium and spend several hours recording particular creatures and their surroundings. Again, fill multiple pages with assorted studies.
- Working with your own pet, the pet of a friend, or at your closest pet store try to depict a sleeping animal from a variety of perspectives.
- Perhaps you have a natural history museum in your city where you could go to study an assortment of animal bones, skeletons or taxidermied animals. If not, visit your school's science lab instead to see what preserved insects or creatures they have that you could study and draw.
- Create you own collection of dead insects including flies, bees, wasps, dragon flies, spiders (okay, maybe not spiders), and draw them under magnification.
- Document one of your dissections from biology class. Let your lab partners use the gloves and scalpel – you can use your pencils and sketchbook.
- From your assorted studies of animals create your own fantasy creature combining the qualities and attributes from a minimum of 4 different animals. Give your creature an appropriate environment and a great name!

9. Plants and Natural Objects

Has it ever occurred to you how fortunate we are not only in that we share this planet with an immense variety of plant life, but also in that it sustains us?! I think that's a pretty good reason to spend some time contemplating and creating with plants in mind.

While animals form the largest of two kingdoms, containing over a million species - most being too small for your eyes to see – plants make up the second largest kingdom or highest form of classification. Unlike animals who cannot make food, plants are the only life form who can produce their own food. Plants are unique in that they contain a special green pigment in many of their cells. This pigment, called chlorophyll, allows plants to make food using energy from sunlight, water and carbon dioxide gas. As a result of this process plants produce almost all of the oxygen that both humans and animals breathe. Plants also provide excellent food sources, and other key resources that make life on Earth possible.

Although new plant species are being discovered every day, all fit into 4 main groups including: nonvascular plants (mosses, liverworts and hornworts), ferns, gymnosperms or cone plants and flowering plants.

- Ferns are an ancient family of plants, pre-dating both land animals and dinosaurs. Scientists believe that they were well established on Earth for over 200 million years before flowering plants appeared. Search your community for these noble plants and create a piece to honour them. Be sure to include references to the wet sheltered contexts where they thrive.
- Some of the oldest and largest plants on Earth are coniferous plants, commonly referred to as evergreens, due to the fact that their leaves, in the form of needles, remain on the trees throughout the year. Rather than having flowers or fruit conifer seeds appear on cones. Collect a series of cones and create a symbolic work using the cones as your subject.
- Basic plant structure includes the root system – made up of those parts below ground, and the shoot system – parts that are above

ground. Create a series of work both representational or abstract using roots as your point of departure.

- Purchase a seed package from a local nursery or plant store and try growing your own plants. Document the entire process along with plant growth.

- Visit a local farm and depict the fields in their various seasons including planting, growth and harvest seasons.

- Create a series a works focusing on the image development strategy of magnification referring to seeds, seed pods, bulbs or dried flowers as your subject matter.

- Flowering plants form the largest and most diverse category of plants including over 270,000 species. While some plants are obvious members of this group due to their readily apparent blossoms, consider sunflowers, tulips and roses – other flowering plants such as maple trees, ivy and grasses are less obvious. What personal stories can you relay using flowering plants as your subject?

- Spend time under the protection of one of your favourite flowering trees. It might be a maple, oak or chestnut tree, among others. What new perspective could you depict?

- Create your own terrarium and draw the changes that take place over time.

- Dissect one of your favourite fruits and create.

- Expand your nature studies to include all natural objects. Working with objects of your choice, (shells, rocks, coral, wood, etc.) do a series of sketchbook studies before creating one larger scale work.

10. ABSTRACT OR NON-OBJECTIVE WORKS

Although you may have created abstracted, stylized or distorted works based on some of your studies of any of the nine different subject categories that I've just outlined, you might choose to create a series of works that are either abstract or non-objective from the start, focusing on your mark-making, expression and overall composition isolated from subject matter.

- Choose 4 pieces of music that radically differ from one another based on key, tempo, mood and instrumentation. For example, you could work with pieces that are classical, hip hop, jazz, rap or techno. Tape 4 sheets of paper to the wall. Organize your drawing or painting media on a small table nearby. Different types of graphite including powdered graphite, water-soluble graphite and assorted graphite sticks and pencils work really well for this. Play each song first, listening to it with your eyes closed. Feel the movement and rhythm of the piece. Play it through a second time drawing to the music. Avoid drawing images, simply make marks that respond to each piece of music. Each drawing or painting should look and feel radically different than the last.

- Tape some heavy weight paper on the wall and assemble a variety of mark making materials. Approach your drawing surface as if you were either a boxer, baseball player, or ballerina. Don't edit as you paint - just let yourself go. Play. Paint with the movements of your entire body. What other roles could you assume? Look up the performance drawings of Tony Orrico and Boxer/Painter Ushio Shinohara for inspiration.

- Again, tape up some heavy weight paper on the wall. Using a dark medium - graphite, charcoal or conté, mark up the page for a set number of minutes. Start with 2 minute intervals. Draw freely for 2 minutes. Avoid drawing recognizable objects, making inter-

esting marks and tonal areas instead. Then step back from your drawing and observe it. For the next 2 minutes obscure parts of what you have drawn. You might erase it, sand it, or paint over it with white gesso or acrylic paint. Invent some new ways to obscure or erase parts of your image. Again, stand back and observe. Alternate the process of drawing/revealing and obscuring in 3, 4, and 5 minute intervals. Repeat this process until the drawing is complete for you.

What Not to Include

"It's better to fail in originality, than succeed in imitation."
—HERMAN MELVILLE

Now that you have a good idea of a number of works that you could create for the range section of your portfolio I'll just quickly mention what you want to avoid in your portfolio submission.

DO NOT INCLUDE:

- Works that are copied from magazine images or other photographic references such as celebrity portraits, music stars, etc.
- Works that aren't original – such as copies of cartoon or animated characters, or works that seem derived from those sources such as Manga or Anime figures. Challenge yourself to create your **own** characters.
- Melodramatic portraits that include glassy eyed, tear stained faces.
- Things that are bleeding – these tend to be cliché or simply gross, unless they are handled very sensitively.
- Copies of other artists work. While you can learn a great deal from doing copies of master works, consider these as practice exercises rather than portfolio works.
- Stereotypical or cliché handling of ideas or themes. Challenge yourself to come up with something that is unique to you.

Personal Series (PS): Finding Meaning in Artistic Depth

"As you begin to pay attention to your own stories and what they say about you, you will enter into the exciting process of becoming, as you should be the author of your own life, the creator of your own possibilities."

—MANDY AFTEL

Undoubtedly there is no other aspect of your college application that is as critical, challenging and ultimately rewarding as creating your personal series as part of your portfolio. Unlike the range section of your portfolio, which is often teacher-directed and shows your range of artistic abilities, your personal series demonstrates your ability to delve deeply into one idea or concept and express it through a series of works (usually 8—20 depending on the school) that are visually unified. Your range section is a group of stand-alone works whereas your PS is a series of works that form a collection.

To create your personal series **you** have to make the decisions. You have to initiate the idea or concept, research it and develop the concept making decisions about subject matter, media, techniques, processes and scale. In order for the series to be powerful all your artistic decisions need to reinforce your central idea. It is through this self-initiated series that you will communicate:

- Your ability to work independently
- The depth of your thinking
- Your ability to problem solve
- The degree of your resourcefulness
- Your artistic skills and mastery
- The degree to which you create honestly and authentically
- How prolific you are and

- What interests you as an idea to explore visually

The most common mistake that students tend to make when they set out to develop and create these works is that they try and think of something profound to say. They want to impress people with a grand and important seeming concept or issue. The idea or concept for your personal series is nothing that you have to 'think up' – you simply have to tune into your own life experiences. You have to discover what you are already thinking about, what concerns you or makes you curious, what you're already involved with or what experiences you have had.

The second most common pitfall is to mistake your subject for a concept. Working with the human figure might be your subject, but what you want to express about the human condition is your concept. Self-portraits are a popular subject, but what you want to divulge about yourself is the idea. Landscapes, animals, objects and items are all subjects – what you want to say about life and your experience with it, is where your work becomes real, authentic, personal and meaningful.

Action Steps

To get you reflecting on the areas that are relevant or important in your life respond to the questions below in your sketchbook. Do these exercises in silence and solitude. Responding to these questions will also help you be more prepared for your portfolio interviews with art colleges!

1. List a minimum of 3 things that you are passionate about and briefly describe why.

2. List a minimum of 3 things that revolt or disgust you and briefly describe why.

3. List a minimum of 3 things that worry you and describe why they are a concern. These might be personal, political, environmental, social, etc.

4. List a minimum of 3 things that you are curious about, but currently know very little or nothing about. What peaks your curiosity?

5. List your hobbies or favourite past-times and briefly describe what interests you about each of these activities.

6. List any groups or associations that you belong to. This could include volunteer organizations. Describe why you are involved with these groups and how these organizations enhance your life or develop you as a person.

7. List any items or objects that you feel dependent on and use on a daily basis. Describe the dependency and how it affects you.

8. Briefly write about three of the most defining moments or experiences of your life. What happened and how did it change you as a person? What did you learn from going through these experiences?

9. List your travel experiences and describe how you were transformed through those travels.

10. Reflect on your childhood. Where there any special or unique events that helped shape you into the person you feel you are today?

11. What is your favourite art medium to work with and why?

12. What are your favourite subjects to work with in your art making and what appeals to you about those subjects?

13. Beside each of the subjects that you listed for question #12, write out 3 possible concepts that you could explore using that subject as your point of departure. Also write what materials or media you think you would use to work up those pieces.

14. Who have been the most influential people in your life to date and how have they influenced you?

Answering these questions is a good start, let's carry on. Another major mistake that students make when starting this work is they want to plan out the whole series before they start – and it just doesn't work that way. You have to trust the process and open yourself up to trying your first piece and letting it inform you as to where you need to go, and how you might need to change or modify your ideas.

As you learned from exploring the aspects of the creative process outlined earlier in chapter 6 your first objective is to tune into yourself and the world around you. Unplug yourself from all the technology that keeps you separated from direct experiences of sensory information and turn off the sources of media that try to tell you what is important and what you should value and be interested in. Instead, go directly to the source of life and live fully. Don't be a spectator – participate. Try to be present and attentive. You will notice that inspiration can come from anywhere including the most unlikely of places.

When something catches your interest, a spark, an idea, a subject, a thought or word, add it to an ongoing list in your sketchbook entitled *Things that Resonate with Me.* How about making a zine out of your list? Then, take a spark of an idea and embrace it. Agree to let yourself surrender to and explore the idea for an hour, a day, a week or more. Just be open to the possibilities. Trust. You don't need to know where it's going to go, or how or if it can be developed, just trust and surrender.

Next, take that resonance and delve deeply into it. Research or excavate your subject using the variety of techniques I outlined earlier in this chapter. Create, create, and create. Try to work in a state of flow where you leave your internal critic outside of the studio. After you have worked for a period of time get back from your work and reflect. This

is the time to ask yourself what is working and what is not. This is the time to critique and question.

Based on what comes up during your analysis of the piece, you can now edit, refine or improve the existing piece trying to get it closer to where you want it. This might be a good time to try something new based on your observations. Perhaps your choice of subjects is working well to tell your story, but the scale needs to be larger and the medium needs to be in black and white as opposed to colour.

This cycle of creating – reflecting – reworking – reflecting – resolving and back to creating is an ongoing process. With each piece you get closer to expressing the essence of your idea. As a result, almost without exception the first works you produce - exploring your initial idea, will not be included as part of your final series. Learn to let them go! They function as the initial seeds of inspiration as you get closer and closer to expressing your concept in the most powerful way.

Another common trap that can snag you is the tendency to give up on your idea when you feel that you have run out of things to say about it. I've known some students who were really excited about an idea for one or two works. Then they decided that the idea wasn't that great after all and jumped to a new 'better' idea for one or two works. Amazingly that new wonderful idea was not that great either and on and on it went until they ended up with a lot of work for their range section of the portfolio, but no in-depth personal series. When the creating got challenging they gave up and jumped to the next idea. Don't let that happen to you! Let me be very clear – the idea or concept that you choose to work with is not the most important factor – what you do with it is! You can turn any spark of an idea or interest into something either profound or trivial and superficial, based entirely on how you work it up. That is your challenge! Don't labour over your idea; invest your time exploring and developing it.

The desire to abandon an idea is often an indicator to dig deeper. Research, read, sketch, explore, question, discuss, brainstorm and experiment with both images and words, but don't abandon. There is always more to be had, and if you push yourself through to the next level another world opens up.

Developing powerful, meaningful ideas and expressing them visually is a very challenging process. It calls for the highest levels of thinking, reflecting, creating, comparing and contrasting, analyzing and synthesizing, along with a plethora of artistic skills. Fortunately, developing your conceptual skills, like your artistic skills and all skills for that matter, simply requires practice. As you start working with ideas and developing them into small series of works, repeating this process over and over again, it will become natural and effortless.

One of the activities that I do with my art teaching colleagues each year is choose a simple, banal-seeming item or object for the students to work with. Some of the things we have selected in the past include apples, a piece of macaroni, a paper clip, a clothes peg, safety pin and keys. Each student is given one item or object. Their first task is to create 100 small-scale works (either 4" x 4" or 6" x 6") exploring their object in a variety of ways using a minimum of 10 different media. This part mirrors the range section of the portfolio in a way. They might create with graphite, paint, wire and mixed media working in a representational manner, abstractly or symbolically. This part of the assignment is a time to experiment, explore, play and research. As they conduct their visual research they need to start addressing what their personal connection is to the item or object. They need to think about what they want to say about the object, essentially depicting their concept. Their next task is to produce either a small series of unified works or a stand alone piece exploring their concept. What they create never fails to amaze us!

For example, one year we gave each of the senior students a mini cupcake that I bought from the local grocery store. It was quite an amusing experience because all I had in my shopping cart was 5 trays of 12 mini cupcakes. They were the little vanilla cupcakes with a dollop of white swirled icing and some multi coloured candy confetti on top. When I got to the till, the clerk looked at my cupcakes and asked if I was having a party. I replied that the cupcakes were for an art project to which she gave me a rather strange look. I explained that I was going to dry them out and give one to each student, which they were then going to use for artistic inspiration. She expressed her concern that the cupcakes would go mouldy, but I assured her that with likely no 'natural' ingredients and loaded with preservatives, chemicals and dyes, mould would not be a factor. Sadly, I was right and three weeks later when we started the project the cupcakes looked exactly the same as the day I bought them. They had oozed oil through their bases for about two weeks and that was it. Even the students were fooled about their freshness and asked if they could eat them. I told them that they could, but that they had been purchased 23 days earlier and had been sitting in the studio since then. Oddly enough there were no takers.

Using this initial cupcake as a springboard for idea generation the students created some spectacular works exploring a variety of themes that were personally relevant to them including the following:

- The lost art of baking
- Beauty and deception
- Family history
- Childhood memories
- Eating disorders
- Form over substance
- Junk food and its poisons
- Starvation

- Fast food and the loss of the sacred act of eating
- Consumerist society
- Deception – what you see is not what you get
- Mass production and machine made goods
- Celebrations
- Innocence
- Decadence
- Artificiality
- Cultural icons

As you can see from the diversity of the topics, the cupcake itself was only a point of departure to express ideas. Some of the works were photorealistic, some were completely abstract, while others were expressive and symbolic. The pieces they created included sculptures, wall hangings, paintings, and drawings using materials as diverse as knitted wool, rusted nails, icing, oil paint, and mixed media.

Action Steps

1. Look around your room and write down a list of 10 different objects.

2. Beside each of those objects write down 3—4 possible themes or concept that you could explore using that object as your point of departure.

3. Choose a simple everyday item to work with as your subject. It doesn't have to be from that initial list.

4. Create 50 -100 small-scale studies of your object (either 4" x 4" or 6" x 6").

5. Research your object thoroughly creating an extensive web of ideas. Research its history, composition, creation and use.

6. Reflect on your personal connection to the object. What do you want to express about this object or something that it could represent?

7. Create 1—3 larger scale unified works exploring the concept you have chosen to work with. Keep your media consistent for all the works.

Strategies for Artistic Depth with your Concept

"How much has to be explored and discarded before reaching the naked flesh of feeling."

—CLAUDE DEBUSSY

- Define your concept (consult a dictionary)
- Write out synonyms for your concept (consult a thesaurus)
- Brainstorm any opposites you can think of for your topic, turn your idea inside out
- Research all facets of your idea consulting books, magazines, Google™ and other internet sources, interview experts, see what other artists have done with this idea, write out your own observations
- Record your personal experiences with the concept or idea, consider why is this an important idea for you to explore
- Mind-map, brainstorm and cluster your ideas (these approaches will be explored at the end of this chapter)
- Divide and subdivide your topic
- Create a simile for your concept using *like or as*
- Create a metaphor to describe your topic
- Play some mental aerobics – consider using a variety of image development strategies to explore your idea

- List all the attributes or qualities of your idea
- Change your language in expressing your concept – perform it, dance it, sing it, play it, photograph it

In the image section on the web site www.gettinginbook.com I have included a few student examples of personal series. Rather than showing the full series of works I have shown only a couple of examples from each series. Under the images are a brief write-up that notes the media, subject and concept explored.

Aside from looking at other student series I encourage you to keep an ongoing list in your sketchbook of professional artists from a variety of fields whose work you admire. Record their name, subject matter, media, approach or process along with the concepts or ideas they are exploring.

Also, be sure to download the Record of Artworks templates from the www.gettinginbook.com web site. These forms provide spaces for you to record and keep track of your artworks as you create them. You can monitor both your range and personal series works, along with any home exam pieces you need to create. Each form provides a space to track your progress with each piece including a description of the work, medium and size, along with noting when the piece has been started, completed and finally photographed for your portfolio.

Sketchbook:
Finding Meaning in the Art of the Day-to-Day

"By drawing the world around us, we learn to see it. By using our imaginations, we learn to feel truly alive. Combine these things and the possibilities are endless. Drawing occupies a unique place in every artist and creator's life, be they a child discovering their vision and dexterity; a sculptor, fashion designer, architect, or engineer; a composer notating a musical score; a cartographer charting the land; or a quantum physicist trying to see for themselves the fluctuations of our universe."

—SARAH SIMBLET

Unlike your portfolio, which usually includes more finished or resolved works; a sketchbook demonstrates your process. More and more schools are requesting sketchbooks as part of the visual component of the application, and with good reason. Your sketchbook should show evidence of:

- The depth and range of your thinking
- Project research (visuals and text)
- Idea development
- Thumbnail sketches and compositional planning
- Brainstorming
- Media experimentation
- Things that inspire you
- Written reflections and critiques
- A record of your daily activities through quick drawings and other studies

Don't underestimate the value of a great sketchbook! Some of my past students have been accepted to schools on the basis of their sketch-

books alone as they demonstrated all the qualities or aspects that the schools sought in their applicants. You can show a great deal of creativity, innovation and character in this personal working space so use it well. You might look into the Sketchbook Project based in Brooklyn, New York for inspiration. It has the largest sketchbook collection and is an amazing resource.

Below you will find a handy checklist of some of the dos and don'ts of sketchbook development.

Do:

- Use both sides of the page
- Use the full page
- Show evidence of brainstorming and idea generation
- Show thumbnail sketches and compositional studies (a minimum of 10-20 for each specific piece that you are working up)
- Be original
- Use it as a workbook and have it with you at all times to record your ideas, inspirations, or surroundings
- Include your research
- Experiment with different media
- Include written reflections
- Include images, words or anything that inspires you
- Have it reflect you and your interests
- Draw daily (even for 10-15 minutes)
- Personalize it
- Have it at least ¾ full before you include it with your portfolio

Don't

- Don't use one side of the page only
- Don't draw exclusively in the centre of the page
- Don't copy from magazines images

- Don't make it "pretty" or look good for your friends
- Don't be worried about keeping it neat and tidy
- Don't leave out your research and written reflections
- Don't be superficial
- Don't copy other people's work (including cartoons or animated characters)
- Don't only use a few pages in your sketchbook and
- Don't keep it at school

I have also included a section of sketchbook images in the photo gallery on the web site to show you some well-developed pages.

Brainstorming and Mind Mapping

"The nature of the work is to prepare for a good accident.
—SIDNEY LUMET

Your sketchbook is the ideal place to keep a record of your ideas. Rapid techniques of idea generation are referred to by several names including brainstorming, webbing and mind mapping. For the purpose of this book I use these terms interchangeably, even though they mean slightly different things.

A brainstorm is defined by *Oxford's Dictionary of Current English* as a pooling of spontaneous ideas about a problem, etc. Brainstorming is a way to quickly generate a wide range of ideas, thoughts and associations related to an identified topic or idea. While brainstorming is usually considered to be a group activity, it can also be done individually.

Webbing your ideas or 'mind mapping' is a technique for generating and organizing your ideas that originated with Tony Buzan. I find it very useful to use this approach with creative idea generation as it encourages you to use your whole mind, write key words, draw and doodle and freely associate in a non-linear fashion.

160

The technique of mind mapping is very simple.

1. Start with an image, symbol or word representing your topic and draw it in the middle of your sketchbook page.

2. Print any key words that come to mind when you think about the topic.

3. Connect these key words to your central idea using lines that radiate from the centre.

4. For each key word consider any related subtopics and branch those off using lines connected to the key word.

Using different coloured pens and pictures or doodles of your ideas is a great way to reinforce your ideas in memory. Printing as opposed to writing is also thought to be easier to read and remember. Using this technique it is easy to generate 50-100 ideas and related topics in a matter of minutes. This is also a powerful way to organize your ongoing research around a particular theme or your personal series of works. You can view some samples on the web site in the image section under sketchbook development.

Action Steps

1. Create a web around the topic of applying to art school and see how you do.

2. Brainstorm a specific art idea or concept

3. Create a mind map to organize the range section of your portfolio

4. Create a mind map for your personal series

Program Specific Requirements

> *"All glory comes from daring to begin."*
> —ALEXANDER GRAHAM BELL

The vast majority of art schools require a general portfolio for admission to the foundation year of their programs. As the name implies the foundation year is foundational for all the specialized programs that begin in second year. Regardless of whether your goal is to study painting, product design or animation your first year will be identical in terms of the courses you will take. Typically your first year will include courses such as:

- Drawing I & II
- Art History I & II
- English / Humanities
- 2D Design / Painting
- 3D Design / Sculpture
- Media & Culture among others

Following the foundation year you select your major and commence your specialized program of study. There are however a few schools that have direct entry programs that require specialized portfolios. Rather than applying to foundation year, you apply to enter a specific program such as Illustration, Graphic or Communication Design, Fine Arts, Product or Industrial Design, etc. Each program requires a distinct portfolio of works that highlight some of the important skills for that field. Some of the schools that do not have a foundation year and require specialized program portfolios include the School of Visual Arts and the Fashion Institute of Technology both located in New York, Art Centre College of Design in California, Sheridan College Institute of Technology in Ontario and the San Francisco Art Institute (SFAI). For those of you interested in photography programs that bypass the

foundation year these are offered at several institutions including the Parson's School of Design and the School of Visual Art in New York and the Emily Carr University of Art and Design in Vancouver, British Columbia.

Again, my best advice to you is to research each of your school's portfolio requirements carefully and then compile a master list of works that you need to create. I would approach the specialized portfolio requirements in a very similar manner to the home exam assignments. (See following section.)

1. Brainstorm and mind-map to help discover your story, experience, or approach

2. Thumbnail sketches – do lots of compositional planning or initial studies

3. Experiment with your media

4. Prepare rough drafts where necessary

5. Edit and refine as you go

6. Seek feedback and critique throughout this process, ultimately making your own creative decisions.

7. Work freely, bringing your best ideas and concepts through to completion

In addition to producing the artwork to apply to these schools I think it is important to prepare yourself for your school based interview, portfolio review or artist statement in this field.

Action Steps

In order to help get you prepared for these programs, respond to the following questions in your sketchbook.

1. Write and reflect about why you want to be a/an _____ (i.e. fine artist, transportation designer, architect, etc.)

2. Research what a typical day includes for someone working in that field.

3. How and why are you well suited to this field?

4. What are your goals and aspirations as a/an_____?

5. Identify and research a minimum of 3 artists currently working in your chosen field whose work inspires and interests you. What is it that you admire in their work and why? Consider the social and environmental aspects as well as the technical and creative aspects. Collect and print some images of their work and glue them in your sketchbook along with your reflections, critique and analysis of their works.

6. Who have been 3 of the most influential artists/designers who have worked in this field worldwide?

7. How can you show your passion for this field, and become more knowledgeable about it? How can you become more involved with this field or profession now?

Home Exams and Additional Assignments

"Where the spirit does not work with the hand there is no art."

—Leonardo da Vinci

One of the things that you need to be very clear about throughout the process of applying to art school is honesty. You need to be honest with yourself about your current abilities and performance and you need to be honest with how you present yourself.

So let's be honest. Getting into art school and getting scholarships is a competition. You are competing with yourself to produce the best quality work you are capable of, and you are competing against others for the limited number of spots available and access to financial support. The goal is to keep the competition healthy by doing your very best, pushing yourself to excel and then accepting the outcome, having faith that the situation will unfold as it was meant to be. Essentially, you need to focus on the things you can control and stop worrying about the things you can't.

Home exams are a way for schools to level the playing field for comparison purposes. All applicants are given the same criteria to address and respond to visually. Unlike the rest of the portfolio that will widely differ from person to person in terms of media, scale, and subject matter, the home exams often involve some creative parameters such as size restrictions, material usage or content.

These assignments are an incredible opportunity for you to really stand out among your peers by creating a highly creative, innovative and personal response. These assignments should not be rushed or left to the last minute when you feel the rest of your portfolio is done.

Action Steps

1. Record the criteria for each take home piece or drawing assignment on a separate page in your sketchbook.

2. Brainstorm the topic, including your personal experiences and stories concerning the topic.

3. Also on that page write down a list of the most cliché responses you could think of for that project. Identify what the obvious visual responses would be and either write them down or sketch them out. AVOID these stereotypical traps at all costs!

4. Write down what qualities you want this piece to express about you – get clarity.

5. Write down what qualities you know your schools of choice are looking for in a successful applicant. Do you feel you embody those qualities and have you addressed them in these works? Clarity and honesty are powerful forces and the best allies!

After you have clarity around what you want to express in the take home assignments start to develop pages of thumbnail sketches to work out powerful compositions. Ask yourself lots of questions as you refine your ideas. How can you shock, surprise or delight through an innovative use of perspective? What angle or perspective reinforces your idea or concept? How can you use an intriguing light source to create drama or excitement? How can you push your medium in a novel way? What interesting story do you have to share? What creative risks can you take?

Before you start on your large-scale rough draft I encourage you to get some feedback on your ideas and thumbnail sketches. Show them to your art teacher or tutor and discuss them with your trusted art buddies – but definitely get some input.

Following your planning sketches it may be necessary for you to create a rough draft to scale before transferring it to good copy paper. Your rough draft is a great place to work out any issues of proportion or perspective along with refining the composition. Your choice of rough copy paper is important because it needs to withstand a lot of erasing. Again, before moving on get some feedback and critique. It might also be that your piece will be created in a very loose, spontaneous way that requires little in terms of pre-planning; everything hinges on your concept and process of expressing it.

Finally, you can transfer your rough draft onto your chosen support using either graphite paper or a light table. Your choice of support - paper, canvas, vellum, etc. – will be based on each schools criteria for the assignment. Hopefully, along the way you've been doing some experimenting with your media to really explore how you can work with your materials in a way that both reinforces your idea and is visually exciting.

For example, a number of schools that require home exam assignments also require that you work in graphite. Don't simply be content to grab your standard pencil and start drawing until you've explored the range of possibilities. There is powdered graphite, water-soluble graphite, graphite sticks in all sorts of shapes, sizes and tonal ranges. You can play with combinations of these forms of graphite too, which makes your options virtually limitless. Have fun with this, get messy, and play! Remember if you have a great time creating it, that emotion will likely transfer to the viewer.

I recommend that you start your take home assignments in the summer before your senior year. That gives you lots of time to think, plan, experiment and create. It's also a very good idea for you to complete these works before any National Portfolio Day events that you will be attending in your senior year. That way you can get some feedback from the admission reps before you actually send the works in. If need be you

can always redo a piece based on your discussions to strengthen your application.

TAKE HOME ASSIGNMENTS AT A GLANCE

- Level the playing field where everyone is required to respond to the same criteria
- Are set up for comparison
- Dictate creative boundaries (possibly size, medium, subject matter, etc.)
- Challenge your problem solving abilities
- Challenge your thinking skills
- Challenge your creative, imaginative abilities
- Challenge your technical art skills and abilities

Show all your idea generation, brainstorming, media experimentation, thumbnail sketches, compositional planning, etc. in your sketchbook.

More Ways to Enhance Your Creativity

"The biggest tragedy in America is not the great waste of natural resources - though this is tragic; the biggest tragedy is the waste of human resources because the average person goes to his grave with his music still in him."
—OLIVER WENDELL HOLMES

In this final section of the chapter on portfolio development I will outline a few more strategies that you can experiment with to enhance your creativity. The topics that you will explore include:

- Cross-fertilization
- Embracing dualities and ambiguity
- Restoring play – learning to 'lighten-up'
- Being bold and valuing your mistakes

168

Cross-fertilize

"Life is either a daring adventure or nothing."
—HELEN KELLER

Now don't let this rather scientific term scare you off. Cross-fertilization is simply a strategy that you can use to help you create in an innovative and exciting way. Cross-fertilization occurs when you are open to inspiration and ideas from other fields and disciplines.

For example, some of the greatest innovations in design are inspired by nature. Consider Velcro. This famous fastener was invented by Swiss engineer George de Mestral, who was inspired by the burrs that stuck forcefully to his dog's hair. Rather than focusing on the 'problem' he observed the burrs under a microscope noting the tiny hooks on the burr's spines that caught on any looped material such as clothing, hair or fur. His observation led to invention.

Would you believe that they've designed cooling systems for buildings that reduce energy costs by 90% mimicking how African tower-building termites construct their mounds to maintain a constant temperature? Or how about wind turbines fashioned like the flippers of humpback whales? Or an innovative bottle cap for a water bottle that was inspired by plumbing pipes?

 Action Steps

1. Do some research in the area of biomimicry. Sketch out some of the innovations that have resulted from this field along with a brief description in your sketchbook.

2. Use this research as a point of inspiration to do some of your own biomimicry design work.

3. One of the attributes of highly creative people is the ability to think divergently, to come up with many diverse, original and elaborate ideas. One of the ways to do that is to find the connections or synergy that exists between two or more seemingly unrelated objects or ideas. By combining, juxtaposing or adapting aspects of one onto the other, or creating something completely new you can build your creative muscles, and have great fun in the process. Test your ability to cross-fertilize by choosing two random words from the dictionary and generating some ideas from the pairing.

4. Do a redesign of a product that you use regularly despite its design flaws. See if you can redesign the product letting nature be your guide. Draw your ideas in your sketchbook.

5. What other areas could you look at for ideas and inspiration? Consider everything from foot ware and fashion to food and film.

6. Look to other art forms for cross fertilization possibilities. Research and learn about different types of dance, musical forms, dramatic presentations and styles of writing.

Embrace Duality and Ambiguity

"Don't play for safety. It's the most dangerous thing in the world."

—HUGH WALPOLE

Another key attribute of highly creative people is the ability to embrace uncertainty, to keep an open mind and remain creative and productive during periods of ambiguity or confusion.

Fostering creative development and ultimately thriving as an artist is a tumultuous, challenging and exciting path. It requires us to face our fears, doubts, and insecurities head on. It compels us to question our thoughts, ideas, emotions and ultimately our existence. It brings us face

to face with a world riddled with perplexing dualites. I would argue though that by embracing our creativity and cultivating our comfort with the unknown or ambiguous we have the opportunity to live lives that are richer with sensory experience, complexity, beauty and joy. Get comfortable with the uncomfortable!

Action Steps

1. Try to abolish absolutes from your vocabulary... words like always, never, can't, must, have to, etc. Write down a series of words that you could use in place of absolutes.

2. Write down as many dualities as you can imagine (absence and presence, life and death, fragility and strength, etc). Look for evidence of these dualities in your life and try to hold the tension between the opposites.

3. Identify an area in your life where you are currently experiencing some anxiety, stress or worry. Perhaps you are dealing with a problem at school, a health issue or a relationship dilemma. Brainstorm how you could turn the negative or stressful situation into a neutral or positive experience. What are the hidden opportunities or benefits embedded in the circumstance?

4. Spend some time observing moving clouds, a burning fire, or peeling paint on a floor or wall. Look for forms to emerge from the shapes, patterns and textures. Sketch what you see.

5. Work from a place of intuition – trusting the process. Start a work without knowing what you want to create. Watch what happens.

6. Contemplate the beauty that exists in forms as they decay, wither or die. Create a piece to celebrate that beauty. Research the works of Eva Hesse for additional inspiration.

Be Bold and Value Your Mistakes

"No great performance ever came from holding back."
—DON GREENE

"In order for you to profit from your mistakes, you have to get out and make some."
—AUTHOR UNKNOWN

Have you ever watched any TEDTalks? TED stands for Technology, Entertainment and Design (how's that for cross-fertilization?) and it is a nonprofit organization devoted to 'Ideas Worth Spreading'. While it started in 1984 with an annual conference bringing together people from the fields of technology, entertainment and design, it has become much broader in its scope. There are now conferences held around the globe covering a vast array of topics.

If you go to www.TED.com you can now watch hundreds of TEDTalks for free, online, and they are all approximately 20 minutes in length. Watching and listening to TEDTalks is a great way to learn, grow and expand your thinking.

One of the talks I highly recommend that you watch is by Sir Ken Robinson, who addresses education and creativity. As you might have guessed by his title he is British. He has a great sense of humour and many powerful things to say. In his talk he relays this great little story of a grade one teacher who was teaching an art class. She let the students draw whatever they wanted, and then wandered around the classroom talking with each student to see what they were doing. She approached one little girl and asked her what she was drawing. The little girl responded that she was drawing God. The teacher was taken back and said to the little girl, "But nobody knows what God looks like", to which the girl quickly replied, "Well, they will in a minute."

It's a cute story but it points to a more serious truth. As Robinson says "If you are not prepared to be wrong you will never create anything original, new or unique". You see the sad fact is that we have been brought up believing that mistakes are bad and are something to be avoided. Our problem is that we want to get things right, and we want to get things right – right away! In order to foster your creativity you need to become much more comfortable with making mistakes, experimenting, and taking creative risks.

Have you ever heard of an artist named Leonardo da Vinci? I thought so. Well, despite the fact that he died almost five hundred years ago, he is considered to be one of the most, if not **the most** creative individual who ever lived. Not surprisingly, he was also one of the most curious, risk-taking, and adventurous people who ever lived.

So it begs the question... did Leonardo ever make mistakes? **Yes!** You bet he did. There were numerous mistakes, mishaps and failures. There were paintings that crumbled off the wall shortly after being completed because he was experimenting with new paint recipes, there were failed attempts to fly, and a failure of his plan to connect the Arno River in Florence to the sea. But I think my favourite series of Leonardo's mistakes is told here in the words of Michael Gelb from his book *How to Think Like Leonardo da Vinci*. I refer to this as Leonardo's fabulous fiasco to automate the kitchen of the Duke of Milan, Ludovico Sforza.

> Asked to preside as head chef for a major banquet, Leonardo created a grand plan for sculpting each course to be served to the more than two hundred guests. The dishes were designed as miniature works of art. Leonardo built a new, more powerful stove and a complex system of mechanical conveyor belts to move plates around the kitchen. He also designed and installed a massive sprinkler system in case of fire. On the day of

the banquet everything that could go wrong did. Ludovico's regular kitchen staff weren't capable of the fine carving that Leonardo required, so the maestro invited more than a hundred of his artist friends to help out. In the vastly overcrowded kitchen, the conveyor system failed, and then a fire broke out. The sprinkler system worked all too well, causing a flood that washed away all the food and a good part of the kitchen.

Now that's a series of mistakes! I'm still howling with laughter imagining 100 artists in one kitchen! What a mess! The reason I mention some of Leonardo's mishaps here is to point out what is possible if you don't fear mistakes. You see the list of da Vinci's accomplishments dwarfs his list of mistakes. He was so incredibly successful because he tried so many things. He just kept on learning, and studying and observing and drawing. When he made a mistake, he simply picked himself up and carried on. Success rarely arrives without some failure first - so you need to recondition yourself to be bold, value your mistakes and keep trying.

Action Steps

1. Choose one small thing that you could do each day that pushes you just outside of your comfort zone. Try it.

2. Make a big mistake and then LAUGH about it instead of cursing.

3. Identify a phone call that you have been putting off...and make the call.

4. Post this saying in your studio or some other prominent place. "The more I know, the more I don't know."

Play— "Lighten Up"

> *"Every child is an artist. The problem is how to remain an artist once he grows up."*
>
> —PABLO PICASSO

> *"You've got to keep the child alive; you can't create without it."*
>
> —JONI MITCHELL

Earlier in this book, in chapter 5, I wrote about the importance of play in maximizing your health and creativity. At that point I outlined some of the myriad of benefits of play, and some play activities you could try to instill more levity, pleasure and creativity in your days.

What I want to touch on here is the essence of the quotes above. I want to explore with you those childlike qualities that are essential for us to maintain as we grow and develop as artists and creators. What are those elusive qualities? I would argue that they are a sense of wonder, uninhibited creating - where there is joy in the process without judgment - and an ability to be in the now, absorbed and attentive.

Don't get caught in the traps of seriousness, stress, superficiality, or 'coolness'. Knowing what you want out of life is a huge step towards achieving it. I encourage you to connect, observe, explore, engage, create, play, experiment, make a mess, inspire, delight, energize and love!

Below are a couple of quick reference checklists that you could consult which outline both the obstacles to developing your creativity and ways to enhance it.

Ways to Enhance your Creativity Checklist

- Work in your sketchbook daily recording your thoughts, ideas, sketches, etc.
- Spend time in silence and solitude
- Spend time in nature, breathing fresh air and moving your body
- Develop your curiosity – read a lot, learn about a variety of different subjects
- Research your observations
- Travel
- Rely on yourself
- Spend time with young children and really play with them
- Write
- Spend time working rigorously on your artwork, developing your ideas
- Take time to relax and play, alternating periods of focused work with down time
- Build your sense of adventure – try one new thing each and everyday – even a small thing
- Be spontaneous
- Be bold, take creative risks and then laugh when you make a mistake

Obstacles to Developing your Creativity Checklist

- Buying into societal conformity
- Being too busy
- No time for relaxation
- Fear of criticism
- Fear of looking foolish
- Being constantly "plugged in" – being disconnected from your environment
- "Techie time wasters" – spending too much time in front of the TV, on the computer, phone, Facebook™ or chat rooms
- Lack of focus
- Sterile environment or overly stimulating environment
- Negative stress
- Too much routine
- Shopping (as a hobby)
- Negative self talk
- Multitasking
- Perfectionism

GETTING IN! – PUTTING IT ALL TOGETHER

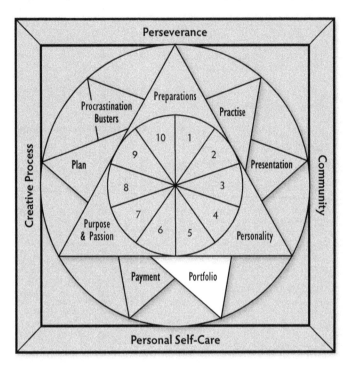

Chapter 7 was intense! You learned about image development strategies, media, techniques, processes, brainstorming and mind mapping, along with powerful ways to enhance your creativity. You were introduced to a ton of ideas for helping you to build the range section of your portfolio so that it reflects you as the unique and interesting person that you are. Most importantly, you learned about how to identify and develop a personally meaningful and rich series of works forming your personal series. Finally, you reviewed a number of ways to use your sketchbook as a place for daily practice, and to record the myriad of activities and events in your life. You could spend the rest of your days exploring and developing the ideas presented in this chapter – and I hope you do! Now, back to your creating.

Chapter 8

Practise, Practise, Practise

"Creativity is a habit, and the best creativity is a result of good work habits. That's it in a nutshell."

—Twyla Tharp

"Inspiration is for amateurs the rest of us just show up and get to work."

—Chuck Close

A few years ago I saw an interview conducted by Charlie Rose featuring abstract painter Brice Marden. The interview was conducted during a huge retrospective that Marden had at MoMA - the Museum of Modern Art in New York, exhibiting over 100 works that he had created over four decades. What struck me about the interview was his response to a couple of questions about his start as an artist. Among several other questions, he was asked "Why did you become an artist" and "Did you feel you had something special?" He responded that he was initially drawn to the romantic notion of being an artist where "Nobody can tell you what to do." He went on to say that he didn't have any outstanding attributes

or qualities that marked him as an artist - but the idea of being an artist appealed to him, so he made a decision. He said "I wanted to paint, I wanted to learn how to paint." Brice Marden made a **decision** to be an artist, a painter. It's that simple. Everything has the potential to change when you make a decision. Have you decided?

Making a decision is the first step. Your decision then needs to be reinforced with commitment - a commitment to learn, to persevere and to practise.

Sadly, the idea of 'practise' hasn't been marketed very well. We tend to get hung up on the repetitive nature of practise, seeing it as a boring and tedious series of exercises, something we have to do in order to improve our skills. We overlook and undervalue the immense value of practise. If you change your thinking around the roll of practise in your life as an artist, everything will change.

In my opinion, practise needs a new PR agent, and it may have found it in Twyla Tharp, one of America's greatest choreographers. She has written a fabulous book called *The Creative Habit – Learn it and Use if for Life*, which you will find in the Recommended Reading List in Appendix 2. Contrary to the notion that creativity is a gift bestowed by the gods, she believes that creativity is the product of preparation and effort. We share the belief that creativity is available to anyone who wants to achieve it, and that the key to manifesting it is to make creativity a habit, and habits require practise. In this chapter we will look at the importance of setting up a studio space, creating a practise schedule including what and how to practise, along with establishing mentors and a supportive peer group.

Setting up your Studio

"I have done some really good work under the worst circumstances and some pretty awful stuff in a well organized, pristine studio."

—SHIRLEY ERSKINE

A crucial but often overlooked physical aspect of creating your artworks and developing your portfolio is having a space to work at home. The space doesn't have to be large but it needs to be conducive to doing your work. By that I mean you need to be able to make a mess and leave it that way while the work is in progress. That means that the kitchen table is out!

The space doesn't have to be large; in fact there may be an area of your bedroom that you can use providing there is adequate ventilation and access to fresh air. You might take over a space in the basement or garage, or even revamp a closet. This is the perfect time to get creative. Some of the components that make for an effective studio space include:

- A flat desk or angled surface
- Wall space or a free standing easel
- Good lighting
- A comfortable chair
- Storage for art materials and supplies
- A book shelf for resources

In addition to the essentials, I want you to personalize your studio space so that you are inspired and motivated to go there. By making the space inviting you will be more inclined to go there more often and spend time there creating.

Some of the ways that you can personalize your studio space is to feature:

- A bulletin board with pictures of your mentors (I'll discuss this more later) and images that delight or inspire you
- Inspirational quotes
- Groupings of objects that you love
- Your vision statement and challenges, along with practise schedule (see below)
- A wall calendar to track your projects and due dates
- A small sound system so that you can play music that compels you to work

 Action Steps

"I think of my studio as a vegetable garden, where things follow their natural course. They grow, they ripen. You have to graft. You have to water."

—JOAN MIRO

1. Create your studio space as an assignment

2. When you are done, photograph the space, print the image and glue it in your sketchbook

3. Write a few reflections around the image as to why this is an awesome space for you to create

Practise Schedule

"The routine is as much a part of the creative process as the lightening bolt of inspiration, maybe more. And this routine is available to everyone."

—TWYLA THARP

I am very fortunate to have spent many years teaching at an outstanding visual and performing arts school, The Langley Fine Arts School, located in Fort Langley, British Columbia, Canada. It is a unique school in many ways. First of all, the school teaches students from grades one through twelve. It offers the full academic spectrum of courses from physics, chemistry and biology, through languages, history, psychology and literature. In addition to the academic course offerings, each student at the senior level (grades 9—12) selects one art major to focus on including creative writing, dance, drama, music, photography, or visual art. Outside of their 'major', students can also take elective courses in the other arts areas. It is an incredibly supportive and inspiring place for students to learn, grow and share. In fact, the school motto is "Explore, Create, Inspire".

My reason for sharing this is that I have learned a great deal through my proximity to the other arts areas. When I arrive at the school in the morning I walk past the music rooms which often have practises or rehearsals going on, and then carry on past the dance studios that are usually in full swing with music blaring and dancers warming up, before I enter our school gallery and into my art studio.

What strikes me about the performing arts areas is the culture of practise that somehow seems to have skipped over visual art. I will often hear the music students take a single line of music and repeat it dozens of times until it flows. They practise notes and scales and phrases that don't remotely resemble music but are ultimately the path to it. They spend hours practicing the same piece of music to perfect their performance.

In the dance studios, the dancers do a thorough warm up and there again they start in on an intense practise routine and schedule. They will take one movement or motion and repeat it over and over again. I will often witness groups of them practicing together without music,

correcting, refining and strengthening their moves. Through this process of breaking the dance down into its fundamentals and repeating them over and over again they enhance their ability to communicate effectively with their audience when the performance time comes.

In visual art things seem a little different. We create a piece and then move onto the next. We draw or paint a still life, landscape, or portrait and then we're done. We might do several works, but each piece is its own product. What I'd like you to think about is how you can learn from the other arts areas? How can you break your artistic development and your artworks down into their fundamental components and then practise each of those areas.

Tharp says, "If art is the bridge between what you see in your mind and what the world sees, then skill is how you build that bridge." If she's right, and I believe she is, then one of the most important actions you should take is to assess your current skills, getting a read on both your well developed skills and those that need improving. The more well developed skills you have, the more freedom and range you will have as an artist. Not only will your works show technical mastery but you will be able to span the gulf that exists between your initial ideas and what you are capable of producing.

One of the myths surrounding skill development and practise is that too many exercises will somehow destroy your creativity. I think this myth was likely fostered by some lazy slackers who were looking to rationalize their lack of discipline. While it is true that great technique does not equal great art, there can be no great art without great technique. Skill development through practise is a critical part of the path to outstanding creativity and art production, but it is not the end product.

Another myth about skill development through practise is that once you become a recognized artist (i.e. well represented, award winning,

rich, famous, celebrity status) you can stop practising. This myth couldn't be further from the truth. If you want to be outstanding and stay that way you have to be prepared to practise longer, practise harder, and practise more strategically than your peers.

As I write this section of the book, I am reminiscing about the 2010 Winter Olympics that were hosted by my hometown of Vancouver, British Columbia. They were 2 weeks of festivities, concerts, cultural programs, hundreds of thousands of visitors from around the globe, and of course athletic competition. While I am not a huge sports watching fan on most occasions I really enjoyed taking in some of the Olympic action and learning about the athletes and their stories of struggle and success as they pursued their dreams of "going for gold".

Canada, as a country, performed amazingly well, winning more gold medals in the Winter Olympics than any other country has every achieved. Given the small size of our population, only 33.3 million people, this is a tremendous achievement! To put this in perspective, the population of the State of California is 36.8 million. (Both of these are 2008 statistics.)

I reference the Olympics because I feel that embedded within these games and competitions are thousands of inspiring stories; stories that can motivate each and every one of us to aspire to our personal best.

I will share with you one story as an example to illustrate this point. Can you imagine how much time Tessa Virtue and Scott Moir (age 20 and 22 in the 2010 Olympics) spent training both individually and together in order to win a gold medal in ice-dancing? They are the youngest couple to achieve such a feat! Let's try to imagine what their training might include. They would have to work on a myriad of skating skills, strength training, cardiovascular endurance, balance, poise, speed, dance skills, choreography routines, along with fostering "ice

presence" and dynamic rhythm and tempo. They would also have to be experts in self care including maintaining intensive training, competition diets and outstanding nutrition, getting regulated and monitored exercise, establish effective sleep routines, and hopefully achieve some life balance.

They would also have to maintain and care for their equipment, and learn about the latest in equipment innovation. In addition they would have to develop exceptional team building and communication skills in order to work well together. This dynamic duo started skating together when she was 7 and he was 9.

Finally, and perhaps most importantly there is the intense psychological training that would have to be fostered for such success. This would include elements like creating a powerful vision of success and winning, dealing with self doubt and criticism, overcoming performance anxiety, learning to ignore all distractions, along with developing effective strategies to deal with the pressures, stress and anxiety that inevitably comes with pushing yourself to be the best you can be, and the best in the world. What vision! What commitment! What dedication!

So let me ask you this, do you want to "go for gold" creatively and artistically? Do you want to be recognized as one of the best in the world? Do you want to be in the top 10% of your field? I sure hope so! I also hope that you are prepared to work for it because to be outstanding requires diligence, perseverance and strategy.

So what can you and I learn from these young ice-dancing stars? I think we can learn 4 powerful lessons.

1. We can learn the importance of creating a compelling vision of success.

2. We can learn to establish and maintain a rigorous practise and training schedule.

3. We can learn to find a great coach who will help us achieve beyond where we could reach on our own, someone who will hold us accountable to a higher standard, and

4. We can learn to create an encouraging group of supporters, peers and fans to help us on our creative journey.

Let's consider each of these points in turn.

If you read chapters 1 and 4 of this book then you should have developed a very clear and compelling vision for your creative and artistic future. If you didn't complete those exercises, or if your vision has expanded, NOW would be a good time to go back and rewrite those vision statements and challenges. Remember DREAM BIG! "Go for Gold"!

Points 2 and 3 go hand-in-hand. It's no secret that most people who excel and become the best in what they do work with coaches and trainers. Regardless of whether we're talking about Olympic or professional athletes, business executives, singers, dancers, actors or artists; people grow, develop and perform significantly better with great coaching and guidance.

Somehow it's comforting to know that you don't have to travel the road alone. I encourage you to get yourself some help, find yourself an excellent coach or trainer. Fortunately as an art student you have many options. First of all you could approach your art teacher to see if they would be willing to give you some additional help in establishing your practise and training schedule. You could also ask if they would periodically review your work and give you feedback.

You could also look for an artist in your community who would be willing to work with you in this capacity. This might be something that you could set up through your school or a family connection.

You could try to find a student who has graduated from a school that you are trying to get into to work with you as a coach. You might also look for opportunities to work with the faculty at your post-secondary schools of choice.

Finally, I offer a number of resources and programs that could support and coach you through your artistic development and post-secondary application process. For example, purchasing this book was a major step in attaining some coaching advice. For more details you can read about these resources in Appendix 1 and on the www.gettinginbook.com website.

The bottom line is this, if you are serious about your success you need to get serious about getting some coaching and creating an effective practise and training schedule. I've given you a few ideas as to how you can get started, now use your creativity and devise a plan that will work for you and your budget.

The fourth and final lesson that we can learn from our Olympic athletes is the importance of establishing a community of supporters, peers and fans. The remainder of this chapter will deal with those very topics as you explore how to create a supportive community of mentors, peers and friends.

Just before we get to that though – one last comment about Virtue and Moir... and I guess a final lesson from them too. When they were expressing their gratitude, they had a long list of people to thank. As you might imagine they thanked their families, special friends, their coaches, and the people who helped them to maintain their gear - the people that helped to provide that cutting edge. The surprise group on their list of thanks was their competitors. They said it was the outstanding achievements and effort of their peers that helped to push them to work so hard. They went as far as saying that without the great

competition from the other skaters they wouldn't have achieved such success themselves.

So, here's my wish for you. The next time you find yourself angry, frustrated or jealous over someone else's abilities, achievements and success, change your perspective and give thanks instead. Use the excellence that surrounds you to propel you forward, to take your training to the next level, to push yourself just a little bit harder to achieve your personal best! Remember, ultimately you are in competition with yourself, to grow and develop, create, share, inspire and contribute.

To help you start to practise strategically I have included a couple of resources that you can access and download from the web site. They include a template to assess your current skills and a partial list of artistic, character based and work ethic skills for you to consider developing as you put together your personal practise schedule.

Practise areas will vary widely for each person. Perhaps you need to focus on the quality of your lines, colour mixing, or drawing with perspective or in proportion. What about working larger scale or with more force or energy?

While initially you might think your practise schedule needs to be more technical or mechanical in nature, I encourage you to think about the conceptual component of your work as well. You might also consider your character development and work habits. Perhaps you need to practise your brainstorming skills, idea generation, or image development strategies. Maybe you need to practise more patience and slow your creative process down, or speed it up if you always work slowly and methodically? Or do you really need to focus on being prepared everyday, being on time and ready to go, showing more initiative and turning in all of your assignments on time and completed to the best of your ability?

While you are practicing you are experimenting, exploring, rehearsing, redoing and repeating – you are not creating "art". Your sketchbook is an ideal place to contain your small 2D work and studies. The products of your practise time will not hang on gallery walls, and are for your eyes only, but if you can maintain an effective practise schedule I guarantee it will yield huge results!

Action Steps

1. Create a list of your current skills using the template available on the web site. List your well developed skills in the left hand column and the skills that need improvement on the right. I have also included a partial list of skills on the web site that you can refer to, to help you identify the areas where you could focus your practise and training.

2. Choose 2—3 areas that are your highest priority areas to practise. Those are the areas that, were you to improve them, all of your art making would be enhanced.

3. Next, commit to practicing each of these areas for a minimum of 30 minutes, 3 times a week.

4. Write your practise schedule on your wall calendar in your studio space. Also record your practise times into your agenda book or day-timer and treat these practise sessions like you would an appointment.

5. When you feel you have mastered an area or made significant progress you might want to add a new area of focus.

Mentors

"Success leaves clues."
—ANTHONY ROBBINS

What is a mentor? Well, according to *Oxford's Dictionary of Current English* a mentor is "an experienced and trusted advisor". So in order for someone to be your mentor they would have to have had certain life experiences that you could relate to, they need to have lived it, 'walked the talk' as we call it today. You would need to have confidence in the individual in order to trust them as reliable, and finally, you would have to be willing to let them communicate with you. You'd have to be open to their teaching.

Now you might question why it's important to establish mentors at all. Why not go and try things out on your own, with no guidance or support? Well, you can, that is definitely one approach. But having mentors can dramatically speed up your progress. If you have a desired outcome – like learning to be more creative for example – you could stumble around on your own trying to figure it out or you could simply search out the most creative people that have ever lived and study their lives. Learn from them; research what they did and what they avoided. By studying their lives and adopting some of their practises you have an incredible opportunity to enhance your life dramatically and quickly.

I think it's important to establish a personal mastermind group with a series of mentors that you select. Mastermind groups were first outlined in detail in Napoleon Hill's famous book entitled *Think and Grow Rich*. In his book he describes how a mastermind is "two or more minds working actively together in perfect harmony toward a common definite object." Essentially, I want you to gather a group of people who will

assist, inspire and motivate you to achieve your best. They may provide vital skills or knowledge that you lack, and in return, your responsibility is to offer your skills, expertise and support to them. Your mastermind group should include the people that you will regularly check in with to discuss your struggles, progress and questions. When I say that you will check in with these people it might be a face-to-face discussion or it might be a consultation through an imaginary talk. For example, 2 of my mastermind mentors include Leonardo da Vinci and Michelangelo Buonarroti, two Renaissance masters who died almost 500 years ago. Also in my mastermind group are contemporary people who are outstanding in fields that I am passionate about, a couple of close friends who are also artists, my husband, brother, sister and parents. The way that I learn from Leonardo and Michelangelo is through studying their lives, art, inventions and writing; while I learn from some of my other mentors by watching them in action and listening to their advice.

Some of my mentors I talk with in person on almost a weekly basis, while others I talk to on the phone once a month. Other mentors are present in my life only through visual reminders that I post in my studio and around my home. I have their works, or powerful quotes on my walls to inspire and motivate me. I will also try to imagine how they might act or create in my situation.

Let me be very clear, you are not creating a fan club here, you are creating a powerful group that will support, encourage and push you. Your mentors should be strong enough to speak the truth to you, even when it might hurt – essentially giving you a kick-in-the-butt when you need it. They should also celebrate with you when you achieve your goals, push through your fears and do your creative work.

If you are already clear on a chosen field or area within the visual arts that you are passionate about and dedicated to such as photography,

architecture, art history or sculpture, it would be a great idea to have one of your mentors a person from that field whose work you really admire. Research them. What was their path? How did they get started? Where did they go to school? What was their creative process? Using the internet, several of my students have actually contacted their distant mentors and established on-line relationships with them.

Action Steps

1. Create a personal mastermind group of a minimum of 3 and maximum of 10 individuals that inspire and motivate you to achieve beyond your present level of success.

2. Once you have created your mastermind group of mentors put up something in your studio work space that will remind you of each of those incredible, inspiring people so that they can encourage you as you work. When you feel blocked, frustrated or depressed consult with your mentors. Imagine what they would do if they were in your shoes. If they were in the room with you – what would they say or do? Don't underestimate the power of great mentors – they can have an enormous impact.

3. Organize time in your schedule to regularly consult with your mentors and follow through on your action plans.

Peers and Friends

"Keep away from people who try to belittle your ambitions. Small people always do that, but the really great make you feel that you, too, can become great."

—MARK TWAIN

As I've just outlined, mentors can be a very powerful force in your life that can dramatically impact your artwork and ultimately your success. Another group that can also have a significant impact on the trajectory of your life, art and success is your peer group – the people that you choose to surround yourself with on a day-to-day basis.

My advice to you is to choose this group very carefully. As the old saying goes, "Birds of a feather flock together." Ultimately, the people that you spend your time with are who you become. In both subtle and overt ways your peers and friends impact the time, care and attention that you pay to your academics, artwork and college applications. They can either support your decision to paint on the weekend developing your personal series of works, or make you feel like a loser because you're missing the party on Saturday night. Your senior and college years are times when you need to be very attentive to the consequences of your decisions and actions.

If you do not have a very supportive group of artists in your school who share similar goals and objectives, create an on-line community of peers that can encourage you. Art making can often feel like a very solitary endeavour – but it doesn't have to be that way. In fact, by developing an 'art buddy' or small group of supportive creatives you can raise the bar for each others standards and successes while having a lot of fun.

One year, a group of 5 girls in my class started having what they called "Art Parties". Every Friday night they gathered at one of the girl's homes and turned her unfinished basement into a great creative space. They would work for hours with the music cranked, order in food, talk, laugh, discuss ideas and create. They were incredibly productive. These times became so beneficial and fun that the Friday night Art Party often became a weekend event.

Sometimes if you're lucky your peers or fellow artists and creators will

also be your best friends as the case above illustrates, but it's not always that way. I feel so fortunate that three of my closest friends are also outstanding artists and art teachers. Going to work with them is one of my greatest joys. Together we inspire, influence, encourage, correct, critique, disagree, love, laugh and cry with one another. We hold each other accountable to become the best we can be as people and as artists. For such friends I am eternally grateful.

I also have close friends who have little or no understanding of what they refer to as "artsy fartsy" stuff, but they are also truly outstanding people who add other dimensions and richness to my life. Your friends don't have to be artists to support you and value what you do, just as you might not understand what makes them tick. As Carl Jung said, "The meeting of two personalities is like the contact of two chemical substances: if there is any reaction, both are transformed." Great friends add levity, fun and laughter to your life. Friends add honesty, connection and interest. With friends at your side terrible days are made bearable and great days become outstanding! Make sure you foster and develop your close friendships – you will have them for life.

 Action Steps

> "There is no wilderness like a life without friends; friendship multiplies blessings and minimizes misfortunes, it is a unique remedy against adversity and it soothes the soul."
> —BALTASAR GRACIAN

1. I challenge you to think of some creative and fun ways that you could get yourself to produce more works, build your skills and your portfolio while encouraging the development of others.

2. How about planning a field trip to go and draw at the local farmers

market with friends, or find the time to do some *plen air* painting in the landscape. Could a trip into the city or to the beach be a time to collect found objects to make into an abstract assemblage? You get the idea – get creative and get going with some friends

3. Go to www.nancycrawfordartist.com or www.gettinginbook.com for more information on online creative communities that you might want to get involved with.

4. Could you create your own local creative community of peers and friends, perhaps an artist coop?

5. What could you make as a simple gift for a special friend to show how much you value their friendship?

6. Brainstorm some ways that you could be a better friend to the important people in your life, and then take action!

7. With the help of your friends and a teacher, start a Creativity Club, or Studio Night drop-in program at your school, where you can work on your artwork while having fun in the process.

8. Perhaps you and your friends could plan an exhibition of works. This not only gets your art out into the world, but it also establishes another valuable skillset.

GETTING IN! – PUTTING IT ALL TOGETHER

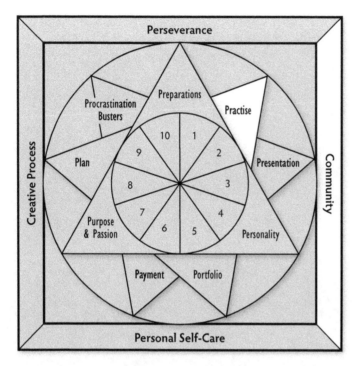

That's another section completed. I hope that it has helped you to re-examine the critical role of practise in your artistic and creative development, and inspired you to set up a studio space where you feel compelled to work freely.

Chapter 9

Procrastination Busters:
How to Get Yourself Creating Your Art!

"Procrastination is the thief of time."

—EDWARD YOUNG

procrastinate: **v.** defer action

resistance: **n.** resisting; refusal to comply, impeding or stopping effect exerted by one thing on another, to oppose, to strive against, hindrance

It seems almost foolish to define these words that most of us know only too well, but I think it is essential for us to define and understand our habits if we are going to change them. And that's exactly what procrastination and resistance are – habits – and bad habits at that!

What is Resistance? What is Procrastination?

"Most of us have two lives. The life we live, and the unlived life within us. Between the two stands Resistance."

—STEVEN PRESSFIELD

This powerful quote comes from a great book that is featured in the Recommended Readings List in Appendix 1. The book is called *The War of Art: Break Through the Blocks and Win Your Inner Creative Battles* by Steven Pressfield. The entire book is devoted to Resistance, describing its nature, most common targets, varied forms, and, most importantly, how to combat it.

The most important thing to realize, if it hasn't already occurred to you, is that you will at some point have to deal with procrastination and resistance. Regardless of what you call it, the question is not if it will strike but when will it strike. By being prepared, you've won half the battle. The forces of procrastination and resistance to your artistic development will likely be fierce because you are pursuing your passion, developing your creativity and improving yourself, which are all activities that require discipline, patience and courage.

Pressfield calls resistance the enemy of creativity, and I think he is right. It sucks out our energy, kills our excitement and curiosity and creates fear and doubt where there should be joy and faith.

Low Ceilings and Sticky Floors

"He who controls others may be powerful, but he who has mastered himself is mightier still."

—LAO-TZU

Low ceilings result when we make excuses that lower the expectations we have for our art or our lives. Some of the common excuses you might use include things like, "I don't have the time to... _____", "I don't have the money to go to... _____", "I didn't come from the right family to... _____", or "I don't have what it takes to ... _____" or "I'm too young to... _____" or I'll never be able to... _____". When we start believing these false statements we lower our standards and as a result we reduce the scale of our lives.

Sticky floors work in a different way to reduce the impact you can have with your art and your life in that they restrict your movements and opportunities. They keep you stuck, they pull you down. Sticky floors include a myriad of bad habits, along with procrastination. I like to refer to procrastination as "The Tomorrow Syndrome", where one day at a time you rationalize away your inactivity on the tasks or activities you value the most.

I'll share with you one of my own favourite personal forms of procrastination that I used while I was doing my bachelor's degree. (You see, by the time I was doing my master's degree it had changed forms into something else – but I digress.) If I had a major project due, perhaps a series of paintings to create or an essay to write, I would feel an overwhelming desire to wash my car. I would start by washing the outside of my car, taking great care to be thorough. Once the outside was clean I 'had to' vacuum the inside of the car and clean the interior. By the time I had moved under the hood to clean the engine compartment (yes, sadly I am serious!) my dad would approach me and ask, "What's due?" He was onto my procrastination technique even when I didn't recognize it for what it was. Subconsciously I had rationalized my much needed car maintenance, while my easel and canvases sat waiting.

Another powerful force that can pull you down is developing poor quality relationships. What do I mean by this? Well, have you ever found yourself in this kind of situation? Your art production is going well, your application process is well underway and you decide that you can take some time off to hang out and maybe even start dating someone new. The next thing you know you are in a relationship with "Danger Boy", the "Drama Queen", or the "Victim". These people can become a sucking vortex of your energy and creativity – so do yourself a favour and move on.

The problem can become more challenging if you realize that the toxic relationships in your life that are draining your much needed vitality and energy are some of your closest friends or family members. Obviously, I'm not recommending that you ditch your family or even some of your closest friends, but definitely address the situation by minimizing your time with them during crucial work periods and build new supportive and positive relationships that will encourage your development.

 Action Steps

1. Reflect on your own life and describe how you resist your work. Do you rationalize or make excuses, something that I refer to as "low ceilings", or do you engage in bad habits such as overeating, taking drugs, compulsively shopping, playing video games for hours or talking on the phone to avoid getting down to work? These bad habits I call "sticky floors". Remember, be honest.

2. Consult with your family members and closest friends to see if they can help identify some of your "procrastination tendencies". Write them in your sketchbook.

3. Draft up a list of positive actions you will take instead of giving in to your bad habits and procrastination.

4. Purchase a small kitchen timer. Whenever you feel like procrastinating on your artwork and other important projects, **procrastinate on the procrastination**. Tell yourself to work for 15 minutes and then give yourself permission to procrastinate. Time yourself. After 15 minutes you will likely be engaged in your work, and you've made a positive step to take control.

So now that you're clear on your personal forms of resistance and techniques of procrastination and have written about them in your sketchbook it is time to move on. Now you can be prepared to act when you find yourself moving in the direction of your personal forms of resistance. The way to push through your resistance is to become 100% committed to your vision and make a clear decision to change your patterns of behaviours. Pressfield calls it turning "pro".

Turning professional is the opposite of being an amateur. It means that you show up and do the work regardless of how you feel in the moment. It means you dedicate your life to it, rather than dabbling. As Somerset Maugham said, "I write only when inspiration strikes, fortunately it strikes every morning at nine o'clock sharp." My dear friend and colleague Peter would say, "Don't wait to be inspired, be inspiring." You see, the truth of the matter is that when you commit to your art, establish the time and the place to work, and then show up and work, incredible things will start to happen.

> "Until one is committed, there is hesitancy, the chance to draw back, always ineffectiveness. Concerning all acts of initiative (and creation), there is one elementary truth the ignorance of which kills countless ideas and splendid plans.

The moment one definitely commits oneself, then providence moves too. All sorts of things occur to help one that would never otherwise have occurred. A whole stream of events issues from the decision, raising in one's favor all manner of unforeseen incidents and meetings and material assistance, which no man could have dreamed would have come his way. Whatever you can do, or dream you can, begin it. Boldness has genius, power and magic in it. Begin it now."

Although there are some concerns about the correct attribution of the passage above, it is usually attributed to Johann Wolfgang Von Goethe, who ruminated on the power of action and the good fortune that results from daring to begin. Despite the attribution debate I feel it is an important quote to include in this section.

One last note before we move on, I'd like to address the word 'try.' Try is a word for amateurs; so rid that word from your vocabulary. You can **experiment** with different media, you can **explore** various techniques, and you can **take action.** Whenever you say, "I'll try" you give yourself too much room to give up. Commit to doing – not to trying. As Yoda said, "Do or do not. There is no try." Make it your motto.

GETTING IN! – PUTTING IT ALL TOGETHER

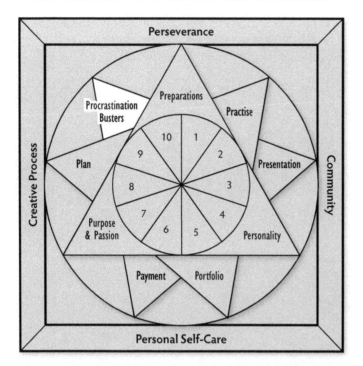

Procrastination Busters – DONE! Congratulations, I'll assume you are heading immediately to your studio for a few hours of creativity and artistic adventure. Happy Creating!

Part 3
The Power of Sharing
Your Art

Chapter 10

Presentation:
Multiple Modalities for Sharing Your Work

"To be nobody but yourself in a world that is doing its best to make you just like everybody else means to fight the greatest battle there is to fight and to never stop fighting."

—E. E. Cummings

Once you have completed some of the works for your portfolio it's a good idea to start considering the steps you must take to present your works to others – visually, digitally, verbally and in written form. In this chapter we will also consider how to edit and sequence your portfolio and the do's and don'ts of a portfolio review or personal interview.

Visual Preparation

"Too many people overvalue what they are not and undervalue what they are."

—MALCOM FORBES

We often assume that our work is done once the pieces have been completed. We can't forget that there is another phase of preparation to complete before we can share our works in a powerful way with others. At this point you may need to:

- Crop or trim your pieces
- Paint the edges of a canvas
- Matt or mount a drawing or design
- Measure the works
- Title the works
- Spray fix pieces so they won't smudge
- Photograph all artworks including 2D and 3D pieces, installations, site specific sculpture and environmental art works

As you complete works that might be possible pieces for your portfolio add them to your ongoing Record of Artwork template. This template can be downloaded from www.gettinginbook.com. As you may recall, these sheets give you an area to record the title or description of the work, medium and size. It also gives you a box to tick when you have started, completed and photographed the work. I would keep these lists in your sketchbook or post them in your studio.

Editing and Sequencing the Portfolio

"All painting is an accident. But it's also not an accident, because one must select what part of the accident one chooses to preserve."

—FRANCIS BACON

Earlier I talked about the fact that you will likely be preparing several different portfolios based on the focus and criteria for each school that you are applying to. As a result, I want you to think of custom designing a unique portfolio for each institution rather than creating one portfolio to send out en masse.

For each school, review their portfolio requirements, number of works requested and home exams. Some schools only want to see your self-initiated works or personal series while others will want to see a combination that includes range works. Consult your portfolio list and choose your very best works to submit. You can also use the feedback that you received if you attended a National Portfolio Day event to help you decide what should be included or left out of each portfolio submission. It's often helpful to get some advice from your art teacher at this point to help you make your selections.

I would organize your portfolio as follows:

1. Start with the home exams required by certain schools and sequence them opening with the strongest. You want to open with a WOW! If the college does not require home tests, start with your best work.

2. Start and end your range section with your strongest works, sandwiching any of your weaker pieces in between. You are better off to include strong works that are fewer in number than lowering your average by including more works of lesser quality. Remember it is always quality over quantity! Meet the required number of works, but edit!

3. Group images within your range section. For example put all your figure drawings together, and look for other mini bodies of unified works based on either subject, media or treatment.

4. Close with your personal series and organize it in a way that reinforces what you have to say. You might choose to start with your latest, most successful pieces and then show and describe your creative journey to that point. Conversely, you might start at the beginning and share your works chronologically in the order that they were created. This is all part of your creative decision making process. While it is good to include and show some process pieces be sure to edit out any works that are not necessary to tell your story – again quality over quantity.

Digital Preparation

"There are no shortcuts to any place worth going."
—BEVERLY SILLS

Although there are one or two schools that require your works to be submitted either as originals or slides, the vast majority of institutions now accept or request digital images. These files are either submitted on a CD that accompanies the application or uploaded to a specific site or Slide Room. Again, each school will have very specific requirements about image size, format and dpi so be sure to check and record that information in your sketchbook.

With the advent of digital photography my life has become much easier, and submitting a portfolio is much more affordable for students. Gone are the costs of expensive film, studio lights and backdrops. Having said that it is important to note that photographing and preparing a great digital portfolio also takes time and care. Below are some tips for taking good quality images for your portfolio.

1. Use the best quality camera you can get access to – such as a digital SLR by Nikon®, Pentax® or Canon®.

2. Set up your works either in a well-lit room or outdoors (but not in direct sunlight) to photograph them.

3. Try to photograph all of your works with similar lighting conditions.

4. 2D works should be photographed against a white or neutral coloured wall or on a vertical easel.

5. Using either the camera or computer crop out as much negative space around the image as possible.

6. For 3D works try to photograph them against a neutral background of either white, grey or black walls, paper or fabric. Be sure to iron the fabric thoroughly - don't let wrinkles steal the show! You might also consider an interesting context for your work. Include 3-4 images of each 3D piece photographing it from a variety of angles.

7. For site specifice installations or environmental works try to edit out all distracting details in the background or context that do not add to the piece.

Verbal Preparation

> *"Men without joy seem like corpses."*
> —KÄTHE KOLLWITZ

Hopefully, each of you will get the opportunity to share your portfolio with your classmates and with some admission representatives at portfolio fairs. Be sure to check out the National Portfolio Day web site at www.portfolioday.net to see when an event will be happening in your area. You might also get the chance to share your works with an admission representative if they visit your school to do an information presentation.

It is very important that you learn to speak about your ideas, your work and your process in an articulate manner. Once you have edited and sequenced your portfolio I would write out your thoughts about the works. It is not necessary to mention in a personal interview the medium or subject of the piece – admission reps can figure out that your work is a stylized landscape drawn in charcoal all on their own. They're professionals who do this for a living. They've seen thousands of student portfolios so don't waste precious time by stating the obvious. Instead, talk about why you drew that particular landscape, what emotion or feeling you were trying to convey and perhaps why you chose the medium that you did. And one final note, don't talk to the admission reps about trying to "capture the moment" in your piece regardless of the medium of the work. I have it from a very reliable source that these 3 words are the most overused statement in portfolio interviews! Avoid this cliché!

Collect and record your thoughts and ideas about the individual works in your range section and then write your brief story about your personal series. Review your write-ups frequently to remind yourself about key points that you want to make about the works.

The Do's and Don'ts of a Portfolio Review or Interview

> *"I've learned that people will forget what you said, people will forget what you did, but people will never forget how you made them feel."*
>
> —MAYA ANGELOU

Having a portfolio review or interview is exciting! It is an amazing opportunity to build your relationship with admission personnel and by extension, the school itself. It is a time for you to share information about yourself and collect information about the school and its pro-

grams to see if it's a good match. Essentially, you are shopping for a school, and the schools are shopping for outstanding candidates.

In order to get prepared for your review, I've included a checklist of do's and don'ts

Do!

- Research the schools you will interview with ahead of time to know what programs they offer. It makes no sense to interview with a fine arts school if your goal is to be a transportation designer. Don't waste their time and yours – do your research
- Be on time
- Have a well prepared and sequenced portfolio with all the works organized to face their direction
- Shake their hand when you meet them (No limp fish please!)
- Introduce yourself with a smile
- Relax and be friendly
- Maintain eye contact
- Sit or stand tall, have good posture
- Dress well
- Have some well prepared thoughts about your work that you can share
- Have some questions prepared ahead of time, this is a great information gathering time for you (more on this to follow)
- Listen carefully and take notes in your sketchbook immediately following your interview. Their comments and guidance will be helpful when you prepare your final submission
- Ask for direct feedback and critique. Ask the admission representative what they would recommend you include or edit out of the portfolio. Also, ask them what pieces they feel you might want to push or rework. Use the opportunity to strengthen your portfolio
- Be yourself, be genuine

- Follow Up! Contact the rep after the interview and follow up with new works

Don't!

- Wear inappropriate or offensive clothing or graphics
- Use offensive language
- Have your cell-phone turned on
- Chew gum, drink or eat during the interview
- Mumble or speak quietly
- Answer their questions in single word answer
- Complain or make excuses about anything including your current art program
- Portray a negative attitude including frustration, boredom, anger or arrogance
- Bring actual 3D works to an interview, photographs of those works should be included as part of your portfolio
- Compare their school with other schools

Questions to Prepare Ahead of Time

"Always dream and shoot higher than you know how to. Don't bother just to be better than your contemporaries or predecessors. Try to be better than yourself."
—William Faulkner

While you are doing your research on each school that you are applying to it's a good idea to keep a running list of questions that you will either ask an admissions person directly or email to the school. Some of the questions you might want to prepare may include the topics of:

- Exhibition opportunities on campus
- Student government activities

- Extracurricular activities and opportunities for student involvement
- Opportunities for campus work programs
- Internships and career placement services
- Study abroad programs and student exchanges
- Upcoming changes at the school – with programs, services or housing
- Most important changes that have taken place over the past 3-5 years at the school including programs that have been cut or added
- Largest area of growth at the school
- Largest departments at the school
- Smallest departments at the school
- Names of successful alumni
- Alumni involvement
- Success rate of student career placements upon graduation (if that is relevant to the area that you are studying)

In addition to formulating your own questions I think it is wise to anticipate some of the questions that you may be asked in an interview situation as well. Here are a few questions you might want to think about and answer in preparation.

1. What has been one of your best high school experiences and why?

2. What has been one of your best creative, artistic experiences and why?

3. What qualities or attributes do you think will make you successful as an artist or designer?

4. What qualities or attributes will make you an asset to the school you are applying to?

5. What words would your friends use to describe you as a person and as an artist, and what words would your family use to describe you?

6. What are your hobbies or favourite activities?

7. What has been your most interesting travel experience? If you could go anywhere in the world right now, where would you go and what would you do there?

8. Name three of your favourite artists and what it is that you admire about them and their work.

9. What is one of your favourite movies and why? Do you have a favourite movie genre?

10. What is one of your favourite books and why? How many books do you read a year?

11. What are the most important relationships in your life and how do you celebrate or honour those relationships?

12. What are your goals and objectives in studying at post-secondary?

13. If you could change one thing in the world – immediately – what would you change?

14. If you could change one thing about yourself – immediately – what would you change?

15. What club or school organization would you want to get involved with?

16. What club or school organization would you like to start?

Like all skills, learning to present yourself and your portfolio well requires practise. Take the time to 'rehearse' with your friends, art teacher, family and other willing parties. It's not that you're memorizing a

script, but you do want your ideas and comments to flow and that takes thought and practise.

Finally, don't underestimate the value of a personal interview. I have seen this one 15 – 45 minute meeting lead to acceptance offers, scholarships, job offers and much more. Conversely, these same interview opportunities can also result in rejections. Make sure that you put your best self forward!

Written Preparation

> *"High expectations are the key to everything."*
> —SAM WALTON

Writing the statement to accompany your personal series is very similar to the process I reviewed in Chapter 3 on Preparations: Writing Artist Statements and Essays. I recommend reviewing that material before you sit down to craft your statement about your personal series.

Your PS write up should be brief, interesting and illuminating. Ideally, it should accompany your works when they are exhibited or in your portfolio. Writing this statement is an ideal way to clarify your thoughts and prepare for your portfolio review.

Go Above and Beyond

> *"The greater danger for most of us lies not in setting our aim too high and falling short, but in setting our aim too low, and achieving our mark."*
> —MICHELANGELO BUONARROTI

As always, I want to encourage you to think of exciting and creative ways to do something extra, to go above and beyond what is expected.

Brainstorm ways that you can present your portfolio in ways that will make it stand out. Perhaps it's as simple as custom designing some letterhead for your paperwork or making a custom envelope or folder that features your artwork and contains your portfolio. Do you have an artistic business card that you could attach that features all of your contact information and perhaps some reference to your philosophy of art or life? Could you create a small piece of art that is visually related to your personal series as a small gift for the admission reps you interview with, and how could you include your contact information on it in a creative way? What else could you do to create excitement, intrigue, laughter and delight? Imagine yourself on the receiving end of thousands of portfolio submissions and applications – what would you want to see?

GETTING IN! – PUTTING IT ALL TOGETHER

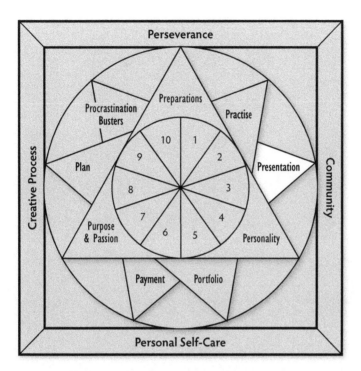

So, do you have some awesome ideas about how you are going to present your portfolio? Are you excited about your upcoming portfolio reviews and interviews with post-secondary admission representatives? I sure hope so! You've worked so hard, and so creatively – now is your time to shine! People want to share your experience, and your artwork is the ideal vehicle for the journey.

Chapter 11

Payment:
Funding Your Art School Dream

*"Optimism is the faith that leads to achievement.
Nothing can be done without hope and confidence."*

—HELEN KELLER

I realize that it is a rather unfortunate coincidence that the chapter exploring funding your art school dream is Chapter 11. As you may know Chapter 11 is a chapter of the United States Bankruptcy Code which allows for individuals or corporations to reorganize under bankruptcy laws. Let me assure you, my goal is to have you complete your post-secondary schooling with as little debt as possible and help you to secure a personally rewarding and successful future.

Having said that, organizing how to pay for your post-secondary education is one of the most important and time consuming decisions that you and your family will make. Putting together an effective financial plan is a group effort involving several parties, namely you, your family, your schools of choice and a variety of financial institutions.

While the primary responsibility to pay for post-secondary education lies with you and your family there are many forms of financial assistance that you can consider including scholarships, work opportunities, and grant and loan programs.

The first step is to prepare an accurate budget that covers all of your educational costs. This will include everything from the obvious tuition and room and board if that is necessary, to art materials, books, other supplies, medical insurance, travel costs, communication expenses, computer and computer program costs, student fees, along with miscellaneous expenses. It's very important to know the amount that you have to budget for before you start. Ideally, you should include your parents in this process.

The next step is to have an open and honest discussion with your family members to see if there have been any funds put away for your education. This might include talks with your parents, grandparents, aunts and uncles. Assistance from your family may come in the form of gifts or loans that can be paid back once you have graduated. I affectionately refer to this source of funding as BOMAD – the Bank of Mom and Dad. If your experience is anything like mine, the interest rates are very low and the service is amazing!

Another important source to consider is the money that you have saved through part time employment, allowance, sales of your artwork or other sources. I feel that it is very important that you invest in your

own education - so start saving today! This is your education – for your future – and it is one of the most wonderful investments you can make in yourself. Show initiative and take responsibility to make your education a priority.

Financial Aid

If you are like most students once you have totalled your educational expenses and subtracted the money that you and your family have saved, there is still a balance owing. Fortunately, there are many sources that you can consider to help you pay for your education. Most art schools have two major types of financial aid packages available to students. It is important to read their catalogues for an overview of the sources of funding that you might be qualified to receive.

Merit-based Scholarship

One of your best options for funding is merit-based scholarship. These scholarships are awarded to first-year or freshmen students along with college transfer students. As the name implies these funds are given to students with outstanding portfolios and applications. From my experience with students these scholarships can range from several hundred dollars per year to full tuition scholarships in excess of $130,000.00

In order to be eligible for these scholarships you must be a full-time, degree-seeking student who maintains a stated grade point average – usually around 3.0. In many schools you don't have to apply for these scholarships but are automatically considered when you submit your portfolio and complete application. Again, it is best practice to thoroughly read each school's literature for specific details.

Need-based Scholarship

In addition to merit-based scholarships many schools have funding programs to support families by providing scholarships to full-time students who demonstrate financial need. You will be required to fill out an application package that is made available through the school to be considered for these funds.

Other Scholarships

While the schools that you are applying to are a great place to start your scholarship search you should also consider other opportunities for funding. There are many scholarships available to you based on:

- Your community involvement and service
- Religious affiliations you may have
- Your ethnic or racial heritage
- Your parents' places of employment
- Community based art scholarships (either in your city or town, state or province, and even national art awards)

I would encourage you to set up an appointment with your school counsellor and let them know about your educational plans and desire for scholarships. They may know of sources you may not have considered.

I would also encourage you to check the web sites of the schools you are applying to. In addition to their school based scholarships they also frequently list private scholarships and awards that you can apply for.

Other useful resources when searching for financial aid and scholarships include www.gotoartcollege.org and www.petersons.com/finaid. On the Petersons site in 3 simple steps you can register and complete a

customized profile outlining your academic and personal background. With this profile you can search their extensive database (which references almost $8 billion in scholarships, grants and prizes) for scholarships where you may be eligible.

Scholarships are in essence the closest thing you will ever find to "free money". You are honoured with funds that you don't have to pay back based on your skills, abilities, achievements and effort. What an amazing gift!

Campus Employment Opportunities

Another source of funding is securing a job on campus. These part-time jobs pay hourly rates, that are usually paid monthly, and can be set up through the Career Services Office on campus when you arrive in the fall. If you are interested in these opportunities I would recommend that you let them know as soon as you have officially accepted their admission offer as there will be competition for these positions.

Government/Federal Grants and Loans

Other sources of funding to consider are grants and loans made available by various levels of government including local, provincial or state, and federal, along with loans from a variety of financial institutions. Student loans are funds that have to be paid back, usually when you graduate from school, and often have very low interest rates. Again, it will be important for you and your family to spend some time researching the different types of aid (private scholarships, state, province or government grants, etc.) along with the different criteria for eligibility. Enrolling as a domestic or international student will have consequences as to what sources of funding you will be eligible for. Do your research and apply early!

Other Options – Get Creative

Like all other areas of the application process I encourage you to get creative with how you can raise funds for your education. Have you considered finding a patron or private sponsor? How about hosting a major art event in your community to raise awareness and funds for a worthy charity and your educational aspirations at the same time? What about you and your art friends holding an art and print show and sale? You could also hold a group art-a-thon where you receive the funds from the people that sponsor your art efforts; then you could sell or auction off all the works created during that 24 hour time period, giving the money raised to one of your favourite charities. This would be an incredible win-win situation, and a powerful way for you to use your art in a way to make a difference in the world and feel great through the process. Create a web exploring how to raise the money for post-secondary just like you would brainstorm concept development. Get creative with this and have fun!

GETTING IN! – PUTTING IT ALL TOGETHER

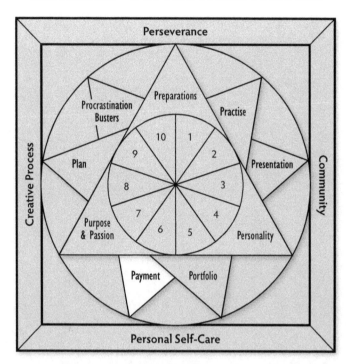

You're quickly approaching the final chapter of the book, having just finished chapter 11 exploring ways to fund your art school dreams. I hope you are feeling energized and optimistic.

Chapter 12

Perseverance:
10 Ways to Enhance
Your Ability to Carry On

"If you can find a path with no obstacles,
it probably doesn't lead anywhere."

—Frank A. Clark

It might seem strange that I devoted one chapter to all the art school preparations, one chapter to the portfolio, and now one chapter to perseverance. Perseverance?

According to my *Canadian Oxford Paperback Thesaurus* the verb to persevere is synonymous with the following - to persist, continue, carry on, go on, keep on, keep going, struggle on, hammer away, be persistent, be determined, see/follow something through, keep at it, press on/ahead, not take no for an answer, be tenacious, stand one's ground, stand fast/firm, hold on, go the distance, stay the course, plod on, stop at nothing and leave no stone unturned. Informally, it means to hang on, plug away, stick to one's guns, stick it out, and hang in there.

Regardless of what you call it, your ability to persevere throughout the process of applying to art school and more importantly persevering with your creative work in general will determine your ultimate success as an artist now and in the future. You see, perseverance and failure cannot coexist.

Perseverance is your ability to carry on when yet another painting turns out a mess, when a power failure causes you to lose your beautifully crafted artist statement before you saved it, when you receive a letter from your dream school that starts with the words "We regret to inform you..." In those moments you can get discouraged, quit, give up or you can persevere. You can push on in the face of disappointment, discouragement and feelings of defeat by flexing your perseverance muscle. Fortunately, perseverance is a skill and like all skills it can be learned, fostered and developed.

A couple of years ago one of the students in my Portfolio Program was applying to the Rhode Island School of Design. She had already started her personal series and wanted to use some of her time in the summer to work on her home exam drawings that accompany the portfolio. For her PS works she explored the impact that moving 14 times in her young life had on her character development. To express her idea she created a large-scale symbolic sculptural installation using plexiglas and other transparent construction materials. As contrast, for one of her drawings – the "infamous bike drawing' – she decided to challenge herself to draw a highly representational drawing of a bike done from direct observation. As she had never learned to ride a bike because of childhood fear she wanted to portray this concept and express her bike-riding phobia. She set up her mother's bike on their balcony where it received dramatic sunlight casting ominous shadows across their deck. The bike was confined in a small, cramped man-made space and was resting on its kickstand.

Each day she would draw for a couple of hours in the morning to capture a consistent daytime sunlight and the shadows it produced in concert with the bike. She struggled to accurately depict the ellipses of the wheels, the angles of the spokes, the dramatic and threatening foreshortening of the bike along with the incredible shadow shape that filled the deck. She worked for weeks. Finally, her rough draft was done and it looked amazing! She transferred it to her good copy paper and was about to start working up the image tonally.

Then, as the saying goes, "$#!% happened." Sometime during the night someone scaled her apartment building to the second floor and stole the bike off their balcony. The next day, she and her mother searched the neighbourhood to no avail. How she handled this setback spoke a lot about her as a person and her ability to persevere. Rather than throwing her energy into sorrow, depression or rage (which would have been understandable) she put her energy into getting creative. After offering her my condolences, all I did was ask her one simple question. I asked her "What's your bike story now?"

She got very still, thought for a little bit and then looked at me and said, "Someone stole my bike!" With that, she was off to work again. Her new drawing pictured her apartment building and empty balcony in the background. In the foreground was the telephone pole across the street featuring her "Reward" poster requesting the return of her stolen bike. The poster, which looked incredibly believable, featured a scaled down version of her original bike drawing (to identify the missing bike) along with some vertical tear-off strips with her phone number at the bottom. One of the phone numbers was torn off while others were crinkled and bent. The poster was stapled to a wooden telephone pole along with hundreds of other abandoned staples. She was able to convey her story with a very powerful composition and show her ability to not only handle the challenge of the bike but her ability to convey the illu-

sion of roughly textured wood, metal staples, torn and crumpled paper, text and architecture. Her second drawing was much richer, visually appealing and definitely had more of a story to tell.

Most importantly though her drawing spoke about her ability to persevere, to pick herself up and carry on when the unexpected happens. She inspired me, and she inspired her peers, and I know she impressed the school representatives that she met. Einstein said, "In the middle of every difficulty comes opportunity" and, fortunately, she was able to see that.

Some of the things that you will have to learn to persevere through will include:

- Fears about yourself as an artist, questioning your abilities
- Fears that your artwork isn't good enough and feeling like a fraud
- Critique from others and negative self-talk
- Fears about the reception of others, wondering whether people will value, appreciate and like your work
- Setbacks of a variety of sorts
- The slow process of developing your skills, ideas and work, essentially developing patience

As mentioned earlier, perseverance is a skill and, like all skills, it can be fostered and developed through conscious effort. Below are 10 ways that you can raise your perseverance quotient to become more resilient and ultimately more self-confident and successful.

10 Ways to Enhance Your Ability to Persevere

It's in the struggle itself that you define yourself.
—PAT BUCHANAN

1. **BE YOUR OWN BOSS**. Take full responsibility for yourself and your actions. Don't play the blame game.

2. **REVIEW YOUR VISION AND PERSONAL CHALLENGES REGU-LARLY** to reinforce your dreams. Keep your dreams alive and clearly in your mind. You cannot help but move in the direction of the things you think about most of the time.

3. **CONSULT YOUR MENTORS** and other encouraging people who are aware of your vision and goals. Listen to their counsel, but always act on your own decisions.

4. **REMEMBER, YOU CAN'T PLEASE EVERYONE**. Many people will have things to say about you and your work, and some of it might be negative or discouraging. Remember; focus on being real and authentic. Try to rely more and more on your own feelings, intuition and critique. Be open to the advice of others but ultimately make your own decisions.

5. **MAINTAIN HIGH STANDARDS OF SELF-CARE**. When the going gets tough you want to be physically strong and filled with vibrant energy to deal with your challenges, whatever they may be.

6. **CREATE BLOCKS OF UNINTERRUPTED TIME** to create, play, experiment and explore.

7. **SET ADDITIONAL CHALLENGES** Rather than waiting for life to hand you a curve ball, give yourself some challenges to test your resilience and ability to persevere. Compress a time line that you've established for one of your projects – giving yourself half the time to complete it. Add a couple of additional restrictions to a creative problem you are trying to solve. Create your next artwork with your non-dominant drawing hand. Challenge yourself to smile or laugh the next time you feel like crying.

8. **DON'T MAKE EXCUSES** or engage in any other negative self-talk or

behaviours that are detrimental to your ability to persevere. Don't rehearse the past, worry obsessively about the future, dwell on what others are doing – getting caught up in competition – feel sorry for yourself, or turn small setbacks into huge obstacles or personal melodramas. Focus on what you can do and do it!

9. **FORGIVE AND FORGET.** All of us make mistakes including you. Learn to be gentle with yourself and others when they frustrate, anger or disappoint you. Negative emotions such as frustration, rage and disappointment will only dampen your spirits and negatively affect both your mental and physical health. For your own well being let go of any negativity and move on.

10. **NEVER QUIT! DON'T GIVE UP!** Even when things go wrong – don't quit. When something doesn't turn out according to plan – keep trying. When you feel that you've exhausted all ideas – commit to creating two more. When you get rejected – have your cry and then carry on with a smile knowing that you will never give up on your creative aspirations and you will never give up on your dreams.

Remember, failure and perseverance cannot coexist. If you commit to persevere you will succeed.

Wow – you did it! You have completed all aspects of preparing for Getting In! You must be feeling proud of your accomplishments. I hope that you have implemented many of the strategies in this book with amazing results. I hope that you feel confident with the tasks that lay ahead as you continue your efforts to secure your spot at art school. I also hope that you are producing art works that are both meaningful and powerful. Finally, I hope that you have felt challenged by this process and have grown as a person and artist.

GETTING IN! – PUTTING IT ALL TOGETHER

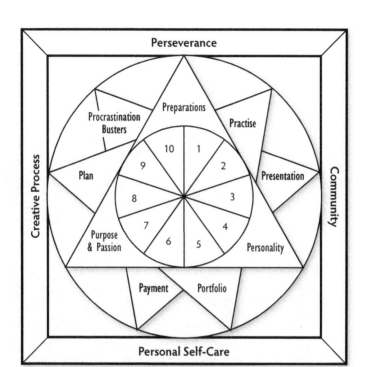

10 KEY INGREDIENTS TO GETTING IN!

1 Post-Secondary Research	6 Letters of Recommendation
2 Application	7 Home Exams
3 Academic Records/Transcripts	8 Portfolio
4 Exams	9 Declaration of Finances
5 Artist Statements and Essays	10 Scholarships & Financial Aid

Final Thoughts

Who You Become Through the Process

"There is no passion to be found playing small
– in settling for a life that is less than what
you are capable of living."

—Nelson Mandela

Although my students rarely believe me when I say this – there are worse things than the stress and pressure of preparing their portfolios and college applications. The worst part is the waiting. Learning to be patient and productive during the waiting period is an art unto itself. Following your fervour of creating, writing, editing, and preparing, the waiting can be painful. But you must wait – wait for acceptance or rejection, and wait for scholarship offers. It can be an incredibly frustrating time. The days and weeks that once flew by too quickly now drag on. What can you do?

My best advice is twofold. First of all, once all your applications have been couriered or uploaded take a couple of days off to celebrate and play. Reward yourself for a job well done and then get right back to your creating. Applying to art school is a momentous step – but it is only a step – keep going. Set up a new practice schedule to work on improving a couple of your skills and return to your personal series or start a new one. Things are now out of your hands and the less you think about it, the better you will feel.

Admission Outcomes

> *"There are some days when I think I'm going to die from an overdose of satisfaction"*
>
> —SALVADOR DALI

One of the lessons that I have learned over the years is that things happen for a reason. Whether or not we understand those reasons, only time will tell. I have experienced this in my own life and I have witnessed it in the lives of my students. When applying to art school you need to give it your all, and then try to disconnect from the outcome. You might get accepted or rejected, you might be offered a lot of scholarship money or none at all, so it's good to prepare yourself for any result. I realize that this is easier said than done.

What I've come to believe is that if you don't get accepted at a particular school for your first year it means that you are not supposed to be there. It's as simple as that. Perhaps a professor that you need to work with is going on sabbatical, or the group of students you should be connecting with will be there the following year. Perhaps it means that you should study somewhere else or live in a different city. Perhaps it means you need to spend more time developing your skills so that you

could excel when you attend. You may also recall that the school you attend will not make or break you as an artist – you and you alone are responsible for your ultimate success.

It's also important to realize that no decision – acceptance or rejection – is final, and if your heart is set on attending a particular school you can always reapply the following year as a transfer student. Sometimes it's the events in our lives that we perceive as defeats, set backs or negatives that are actually blessings in disguise. To accept any verdict is a major step in trusting the process.

Fortunately, most of the students that I have worked with over the years didn't receive rejection letters; their challenge was of a different nature. They had to make the decision as to which school to attend from their several offers and scholarships. This can be an agonizing time for both the students and their families, as they have to carefully weigh the pros and cons and arrive at a decision.

Once you have made up your mind, be sure to communicate your decision to all the schools involved. I also think it is very important to acknowledge your gratitude for any scholarship offers as well.

What's Next?

> *"Happy are those who dream dreams and are ready to pay the price to make them come true."*
>
> —LEON SUENENS

When you receive your acceptance package there will usually be several other materials sent along including an official acceptance form to fill out, forms to apply for student housing and information as to how to apply for a student Visa if necessary. Be sure to fill out all the necessary forms and return them promptly.

Also, as more and more schools are going digital with their coorespondance make sure that you check your email or the college email portal frequently.

Deferring Admission

> *"We are not creatures of circumstance, we are creators of circumstance."*
>
> —BENJAMIN DISRAELI

What if over the course of your senior year your plans change and for whatever reasons you will not be attending school in the fall. Perhaps you plan on going backpacking around Europe or working for a year to save some additional funds, or maybe a little of both. Many institutions will allow you to defer your admission along with any scholarships you were awarded for a one-year period. However, you would need to arrange that with your school ahead of time, completing the necessary paperwork.

Who You Become Through the Process

> *"Success is waking up in the morning and bounding out of bed because there's something out there that you love to do, that you believe in, that you're good at - something that's bigger than you are, and you can hardly wait to get at it again."*
>
> —WHIT HOBBS

At the end of the day it's not the school that you attend that counts. It's not the scholarships that are most important or even the works that you created. The biggest satisfaction comes from who you have become over the weeks, months and years of this process. It is how you have

learned and grown as an individual and an artist. It is how you have expanded your potential to share and contribute with your gifts and service. Think back to your big, exciting vision for the future and the lofty challenges that you set. You are realizing your dreams and that is very powerful!

Through this process you've been courageous, attentive and curious. You've disciplined yourself to create freely, reflect and rework. You've overcome fears and doubt in an attempt to be true to yourself, while developing and maintaining powerful rituals of self-care. You've become more proactive, self-confident and a contributor who is determined to make a difference in the world. You are more creative, grateful and inspiring. And that is what is important.

I congratulate you on your success!

Acknowledgements

"Gratitude is the memory of the heart"
—French Proverb

Writing Getting In! was easy compared to writing the acknowledgment section of this book. It was daunting to imagine how to thank all those who have played a significant role in shaping this book, encouraging me to teach and supporting my creative endeavors over the years.

First and foremost, I want to thank my family. Your love, enthusiasm and support throughout my life and for this project have been amazing. Thank you Mom, Dad, Cindy, Rick, Boyd, Jenn, Jacob, Makenna, Carter, Konrad and Eric. Collectively, you are the foundation of my life, providing me with inspiration, joy, love, lots of laughter and fun! I love you all! A special thank you goes to my dad and sister who were the first readers of the initial text. You provided valuable feedback and critique, along with boundless encouragement. Thank you.

To my husband Konrad, words cannot express the love and gratitude I feel for you and your unwavering kindness, love and assistance. I'm so grateful that we're together. This book and so many other creative endeavors would not exist without your input, prodding and help. You make the work more enjoyable, the technology issues manageable and the play times awesome. Thank you sweetie!

As an avid reader and book lover, the desire to write a book has been a dream of mine for as long as I can remember. I am so thrilled that I have had the opportunity to work with an exceptional team at Morgan James Publishing to realize this vision. Working with each of you has been an enjoyable and exciting learning experience. Special thanks goes to Acquisition Editor, Terry Whalin who was the first to review the manuscript and get the ball rolling. Thank you to my former Managing Editor Lyza Poulin, Managing Editor Tiffany Gibson, and Marketing and Publicity Liaison, Bethany Marshall, for your expertise, enthusiasm and support. Publishing Director Jim Howard was also a wealth of information who brought his energy and expertise to this project. To founder David Hancock, thank you for your vision, dedication and humor. You are an inspiration, and your team at Morgan James was a pleasure to work with!

While I may have had the desire to write books throughout my life, I'm not sure if it would have come to fruition without the teachings and mentorship of Brendon Burchard. Thank you Brendon for your generous spirit, your over-the-top energy and for being an amazing teacher. Your encouragement and expertise, along with the efforts of powerhouse Jenni Robbins have been exceptional. I couldn't have done it without you two! Thank you.

Over the past few years, there are also been several other people who have been instrumental in mentoring my ideas. I send a heartfelt thank you to Scott Humpfrey, Sage and Tony Robbins, and Rick Frishman. Your ideas and teachings have had a major impact.

Oddly enough, the only career I knew I didn't want when I was a teenager was to be a teacher. There is a Chinese proverb that states, "You often find your destiny on the path you take to avoid it," and that was certainly the case with me. I'd like to thank my canoeing and kayaking coach Tony Hall, for being the first to put me in a teaching role. Spending delightful hours on Burnaby Lake at the age of seventeen, teaching children, teens and adults how to canoe provided me the first opportunity to witness the magic that can happen when you help people learn, grow and challenge themselves. It was really fun! That experience planted the seed as to how I might be able to combine my love for art and creating with the world of education. Fortunately, I was also blessed with many outstanding mentors over the years who further inspired me to teach. In particular I'd like to thank Charlie Hou, Steve Bailey, Dr. Kate Sirluck, Dr. Bob Steele, Dr. Ron McGregor, Dr. Kit Grauer and Dr. Rita Irwin. Your passion for life and learning along with your subject areas turned every day in your classrooms and studios into a challenging adventure. I think your passionate approach to teaching influenced me a great deal and is echoed in my own practice. That makes me very happy. Thank you.

Schools are interesting, dynamic spaces teaming with students, teachers, parents, administrators, secretarial and office staff, counselors, support staff, and custodians. All these groups work together in an attempt to provide the best learning environment possible. I feel most fortunate that I get to work closely with three outstanding art teachers, who are also three of my closest friends - Kayla Preston, Julia Bennett and Peter Sarganis. What an amazing team! You delight

and inspire, challenge and critique, and get me laughing to the point of tears on a regular basis. My years with you have been most memorable. Thank you guys! Special thanks to you Peter for taking the time out of your crazy busy schedule to read the manuscript and provide your thoughts. You and I have taught together for twenty years now, and it has been intense and magical. Your influence has transcended the classroom and studio and I am so glad that you are in my life! Thank you.

Outside of our secondary art department I have been continually inspired and impressed with the caliber and dedication of my numerous teaching colleagues both within the arts and other fields. Thank you for motivating me and enriching my life along with those of your students. While a great deal of fun and support was to be found with my students and colleagues, several principals were also instrumental in my growth and development, along with the success of our visual art programs. I'd like to thank Graham Leask, Rob Ross, Dan Peebles, Peter Beckett, Kerri Gregory, Percy Pavey, Balan Moorthy and my current principal Jon Bonnar. Your support, encouragement and passion for life and learning have been tremendous and very much appreciated! Thank you.

In addition to the amazing colleagues that I've had the pleasure to work with, I would like to thank several of the numerous art college and university admissions representatives that I've had the opportunity to get to know over the years. I really appreciate the time, care, energy and effort that you put into the students, reviewing their portfolios, giving them constructive critique, assisting them with their application process, along with helping them get settled when they arrived at your door. I'd also like to thank you for your willingness to give me feedback on my teaching and programs. You have been essential to my professional growth and I really value your friendship. Many of you also read sections of this book and provided me with your ideas and comments for which I am very grateful. Thank you Jonathon Neeley, Molly Ryan, Nicola Vruwink, Marsha Lynn, Lauren Hogan, Kenneth Yee, Matthew Gallagher, Brenda Hung, Matthew Farina and Quinn Dukes. Thank you Quinn for your thoughtful critique and feedback on this book. Getting In! is a much better work as a result of your influence and I am honored to be your friend. Thank you.

While there have been countless artists and creators who have influenced my thinking and creative work both as an artist and teacher, I am most grateful to my friends Suzanne Northcott and Oliviero Olivieri. Your passion for creating is palpable and I treasure the hours of conversation we've shared around life, love and the creative process. You are both the most spookey-doo friends and I love you! Thank you.

Prior to thanking my other students I want to acknowledge Darren Tokaryk. Without knowing it, you kept me in the teaching game with a few pivotal words when my path was about to head in a different direction. You and principal Graham Leask were instrumental in an early career decision that made the world of difference in my life. Thank you.

Finally, my largest thank you goes to all my students over the past thirty years, without whom there would be no book. I feel so fortunate to have worked with such exceptional individuals too numerous to name. I am so grateful for the ways that you pushed yourselves to take risks, to tell your stories, to be innovative, courageous and creative. Thank you for confiding your thoughts and ideas, pushing through your fears and struggles, and ultimately sharing your joys and successes with me. You taught me so much and I feel very privileged to have been a part of your creative and artistic path. You inspired me to become a more effective teacher and a more authentic artist. I am so honored to be able to call so many of you my friends. Thank you, I am eternally grateful!

Appendix 1

Where to from here?

"Destiny is not a matter of chance, it's a matter of choice; it is not a thing to be waited for, it is a thing to be achieved."

—WILLIAM JENNINGS BRYAN

Appendix 1 includes the descriptions of a variety of additional resources and programs that might interest you as you create your personal program for artistic growth and development, along with preparing for admission to art school.

Additional Online Resources with the **Getting In!** Book

With this book you have free access to a variety of resources on the www.gettinginbook.com web site. Some of the features of that web site include:

- over 20 downloads and printable templates referred to in this book that will help you in organizing yourself for applying to art school.
- a printable poster of assorted Image Development Strategies along with their definitions
- access to a gallery of student images exploring great examples of Range artworks
- access to a gallery of images exploring Personal Series, along with their descriptions
- Sketchbook samples
- examples of brainstorming and mind mapping pages
- along with much, much more!

Getting In! Live Events

Be sure to check out the www.gettinginbook.com website for **LIVE** events that will be taking place at a location near you.

Creativity Coaching

While the *Getting In!* book deals with all of the facets of applying to art school, you might also be looking for some great coaching with your artistic development and portfolio production. By registering for our coaching programs you will literally have in-depth and intensive art instruction coming into your home (or wherever you and your computer are) that features the most outstanding, interesting and relevant art

training you could receive. These programs includes different projects and art skill enrichment strategies, along with exercises and prompts to foster your conceptual thinking skills and the production of your personal series of works, fun sketchbook assignments and *Art Adventures* to break you out of your mental and physical ruts. To learn more about our coaching programs please visit the www.gettinginbook.com website.

The Creative Commitment Blog

Finally, you might want to sign up for the Creative Commitment blog. It will provide you with a myriad of strategies, techniques and tips to foster and enhance your creativity through mind, body, spirit and action. It will also provide you with great opportunities to network with other creative people like yourself. Please visit our blog site at www.thecreativecommitment.com to learn more.

Happy Creating!

Appendix 2

References and Recommended Readings

"There are worse crimes than burning books.
One of them is not reading them."

—JOSEPH BRODSKY

Appendix 2 outlines both the books that I used as reference material for this book, along with other books that I think are awesome resources. I treasure books and hope that this list may inspire you to start a library of your own.

I am a part of all I have read.
—JOHN KIERAN

PURPOSE AND PASSION

Pink, Daniel. *A Whole New Mind:Why Right-Brainers Will Rule the Future.* New York: Riverhead Books, 2006.

Robbins, Anthony. *Awaken the Giant Within: How to Take Immediate Control of Your Mental, Emotional, Physical and Financial Destiny!* New York: Free Press, 1991.

PROACTIVE SELF CARE

Batmanghelidj, Ferrydoon. *Your Body's Many Cries For Water: You're Not Sick; You're Thirsty; Don't Treat Thirst with Medications.* USA: Global Health Solutions Inc., 2008.

Brazier, Brendan. *The Thrive Diet: The Whole Foods Way to Losing Weight, Reducing Stress, and Staying Healthy for Life.* Toronto: Penguin Canada, 2007.

Brazier, Brendan. *Thrive Fitness: The Vegan-Based Training Program for Maximum Strength, Health, and Fitness.* Cambridge: Da Capo Press, 2009.

Campbell, Colin PhD. And Campbell, Thomas M II. *The China Study: Startling Implications for Diet, Weight Loss and Long-Term Health.* Dallas: BenBella Books, 2006.

Fontana, David. *Meditation Week by Week.* Vancouver: Blue Heron Books, 2004.

Robbins, John. *Diet For a New America.* Walpole: Stillpoint Publishing, 1987.

PORTFOLIO: PROCESS AND PRODUCT

Aimone, Steven. *Expressive Drawing: A Practical Guide to Freeing the Artist Within.* New York: Lark Books, 2009.

Creevy, Bill. *The Oil Painting Book: Materials and Techniques for Today's Artist.* New York: Watson-Guptill Publications, 1994.

Edwards, Betty. *Drawing on the Artist Within.* New York: Simon & Schuster Inc., 1986.

Hale, Robert Beverly. *Drawing Lessons From the Great Masters: 100 Great Drawings Analyzed.* New York: Watson-Guptill Publications,1989.

Hale, Robert Beverly and Coyle, Terence. *Anatomy Lessons from the Great Masters: 100 Great Figure Drawings Analyzed.* New York: Watson-Guptill Publications, 2000.

Kaupelis, Robert. *Experimental Drawing.* New York: Watson-Guptill Publications, 1980.

Nicolaides, Kimon. *The Natural Way to Draw.* Boston: Houghton Mifflin Company, 1969.

Simblet, Sarah. *Anatomy for the Artist.* New York: DK Publishing, 2001.

Simblet, Sarah. *Sketchbook for the Artist.* New York: DK Publishing, 2005.

PRACTICE

Tharp, Twyla, *The Creative Habit: Learn It and Use It For Life.* New York: Simon & Schuster, 2003.

257

PROCRASTINATION BUSTERS

Pressfield, Steven. *The War of Art: Break Through the Blocks and Win Your Inner Creative Battles.* New York: Warner Books Inc., 2002.

Tracy, Brian. *Eat That Frog! 21 Great Ways to Stop Procrastinating and Get More Done in Less Time.* San Francisco: Berrett-Koehler Publishers Inc., 2007.

PRESENTATION

Love, Roger with Donna Frazier. *Set Your Voice Free: How to Get the Singing or Speaking Voice You Want.* New York: Little, Brown and Company, 1999.

Tracy, Brian. *Speak to Win: How To Present With Power in Any Situation.* New York: Amacom American Management Association, 2008.

OTHER GREAT BOOKS ON ASSORTED TOPICS

Ackerman, Diane. *A Natural History of the Senses.* New York: Random House, 1990.

Arden, Paul. *It's Not How Good You Are, It's How Good You Want To Be.* New York: Phaidon Press Inc., 2003.

Arden, Paul. *Whatever You Think-Think The Opposite.* New York: Penguin Group, 2006.

Cameron, Julia. *The Artist's Way – A Spiritual Path to Higher Creativity.* New York: Jeremy P. Tarcher/Putnam, 1992.

Daido Loori, John. *The Zen of Creativity: Cultivating Your Artistic Life.* New York: Ballantine Books, 2005.

Gelb, Michael J. *How to Think Like Leonardo da Vinci.* New York: Delacort Press, 1998.

Greene, Robert, *Mastery*. New York: Viking, Penguin Group (USA), 2012.

Jordan, Michael. *Driven From Within*. Edited by Mark Vancil. New York: Atria Books, 2005.

Maisel, Eric. *Fearless Creating: A Step-by-Step Guide to Starting and Completing Your Work of Art*. New York: Jeremy P. Tarcher/Putnam, 1995.

McGonigal, Kelly. *The Willpower Instinct: How Self-Control Works, Why It Matters, and What You Can Do to Get More of It*. New York: Avery, Penguin Group (USA), 2012.

Spence, Gerry. *How to Argue and Win Every Time: At Home, At Work, In Court, Everywhere, Every Day*. New York: St. Martin's Griffin, 1995.

About the Author

Nancy Crawford is one of North America's leaders on the topics of creative and artistic development along with strategies for success at post secondary school and beyond. With over 30 years of experience as an artist and art instructor, Nancy has helped hundreds of students fulfill their dreams of getting into the post-secondary institutions of their choice. Her students have gone on to study at some of the most prestigious art schools in the world, collectively earning millions of dollars in scholarship offers, and thriving as successful artists and designers.

Nancy is the founder of Personal Renaissance Coaching Inc.; a company dedicated to fostering personal reinvention through the creative process, providing workshops, programs and creative travel opportunities for both youth and adults.

Nancy currently resides in Langley, British Columbia, Canada with her husband Konrad Breuers. To find out more about Nancy, her teaching and programs, artwork or creative travel opportunities, please visit her at www.nancycrawfordartist.com or www.thecreativecommitment.com To learn more about this book and gain access to a myriad of resources to help support your application to art school visit www.gettinginbook.com